PHOTOGRAPHING PEOPLE

AMPHOTO BOOKS
American Photographic Book Publishing
An Imprint of Watson-Guptill Publications
New York

PHOTOGRAPHING PEOPLE

BY GUGLIELMO IZZI

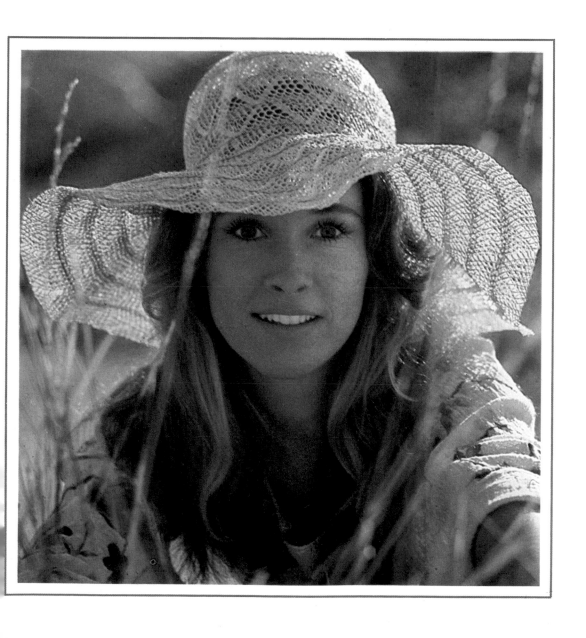

ACKNOWLEDGMENTS

I would like to thank all those who cooperated in the production of this book, in particular Carlo delle Cese of Arnoldo Mondadori Editore, for his useful and patient contributions, and Luciano Morrone, for his constructive assistance in the preparation of the diagrams and tables.

Among the numerous others I wish to thank, I would like to mention the following, with apologies for any inadvertent omissions: Dianne Marti and Tiziana Morrone, for their unflagging and indispensable efforts; Ròsa, Marco, and Raffaela Izzi, for their continuous and enthusiastic support; and particularly Giancarlo and Alfreda Izzi for their invaluable and constructive advice; colleagues from 3M Italia and friends from the 3M Photography Club of Ferrania (Savona), especially Piero Capponi, Lilli De Martis, Franco Languasco, Daria Bertolotto, Ferdinando Orengo, Giorgio Piccardi, Vincenzo Polla, and Ivano Suffia; photographer friends who gave permission to use their photographs, namely, Gian Paolo Cavallero, Valentino Torello, Paolo Bonciani, Stephanie Haack, and Maurizio Bagnasco; and those who patiently lent themselves as subjects, including Cristina Balestrini, Elena Lombardi, Kati Moi, Franca Paccagnella, and Daniela Borigazzi.

Guglielmo Izzi

English language text © 1982 Arnoldo Mondadori Editore S.p.A., Milano

Originally published in Italian by Arnoldo Mondadori Editore S.p.A, under the title *I Manuali Del Fotografo—Il Ritratto*

First published 1982 in the United States and Canada by Watson-Guptill Publications, a division of Billboard Publications, Inc., 1515 Broadway, New York, N.Y. 10036

Library of Congress Cataloging in Publication Data
Izzi, Guglielmo.
 Photographing people
 Translation of: Il ritratto.
 Includes index.
 1. Photography—Portraits. I. Title.
TR575.19813 778.9'2 82–6827
ISBN 0-8174-5431-4 AACR2

Printed and bound in Italy by Officine Grafiche, Arnoldo Mondadori Editore, Verona

First U.S. Printing, 1982

CONTENTS

CHOOSING A CAMERA

The function of a camera is to convert an idea into an image as practically and effectively as possible. A good manual camera can produce results comparable to those produced by any sophisticated automatic-exposure camera.

Automatic-exposure cameras are particularly useful when speed is an important factor. With them you can concentrate on the subject and the frame rather than the exposure settings, which is especially helpful to beginners. These cameras are also extremely useful when you want to capture a fleeting gesture or a particular facial expression. There are times,

however—if the subject is in bad light, for example—when the ability to disconnect the automatic-exposure mechanism proves invaluable. In these cases there is no substitute for the photographer's own judgment in setting the shutter speed and lens aperture.

Cameras are being continuously improved technologically, but not all the new developments are actually practical or useful. For example, too many colored LED displays lighting up in the viewfinder, or audible signals indicating even the slightest under- or overexposure, can prove to be less effective than much simpler systems

and can be dangerously distracting at the critical moment of taking the shot.

The factors to consider when you buy a camera are, first of all, quality, then practicality and the scope of the system to which the camera belongs—the availability of interchangeable lenses and other accessories—compared with its price and your photographic needs. A professional or semiprofessional outfit is a waste for the Sunday photographer who takes only a few pictures a year when the family is on vacation. By the same token, a cheap camera soon proves its limitations to the photographer who uses it every day and wants equipment that will

help get better, more interesting, and more satisfying results.

The Nikon system, shown with all the accessories available for the single-lens-reflex camera. The equipment constitutes a system with which you could tackle any professional assignment.

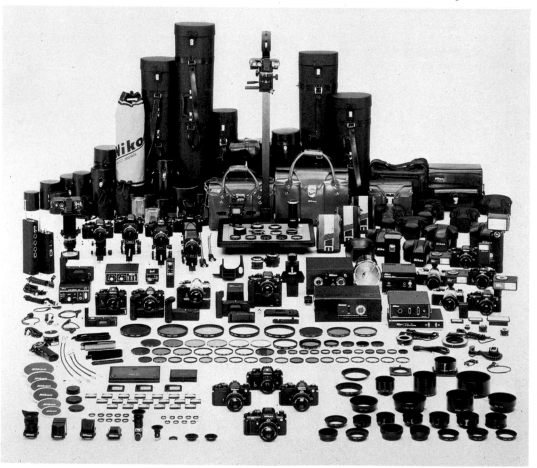

THE 35mm SINGLE-LENS-REFLEX SYSTEM

The 35mm single-lens reflex (SLR) is the ideal camera for most amateur photographers. It is also one of the most versatile types of camera. Its most distinctive feature is through-the-lens (TTL) viewing, which allows you to see the exact picture you are taking and provides complete control over composition, depth of field, and focus. Using different-focal-length lenses or attachments (additional lenses, range extenders, and so on) presents no problems with a reflex system.

Manual-Exposure Cameras

In the manual-exposure camera, the exposure in-

formation is provided by a built-in exposure meter, but the photographer sets the shutter speed and lens aperture. With this type of camera, it is easy to make any exposure adjustments that the photographer knows to be effective from experience. This can be particularly useful when color film is used.

Manual exposure is, in fact, safer and more practical than automatic exposure in scenes with a high contrast between light and dark areas. It is also preferable when constant metering is not important (as in studio work), or if an electronic flash is being used, or in other situations not suit-

able for traditional exposure-metering systems.

Automatic-Exposure Cameras

As we have already said, automatic-exposure systems can prove very useful in situations where the photographer wants to concentrate on the picture and not have to worry about making continual exposure adjustments. The quick response of automatic metering systems is also a valuable asset for photographs of moving subjects or for motor-driven sequence shots. Without this facility, the most critical images and decisive moments can easily be lost.

The mechanisms of automatic-exposure SLR cameras fall into three categories: automatic aperture selection (shutter priority), automatic shutter-speed selection (aperture priority), or various combinations of both.

Shutter-Priority Systems

In shutter-priority systems the photographer sets the shutter speed, and the camera selects the lens aperture. This is closest to the traditional method. The shutter speed is chosen to freeze the movement of a subject, and the aperture is set according to the readings of the built-in exposure meter. The aperture can

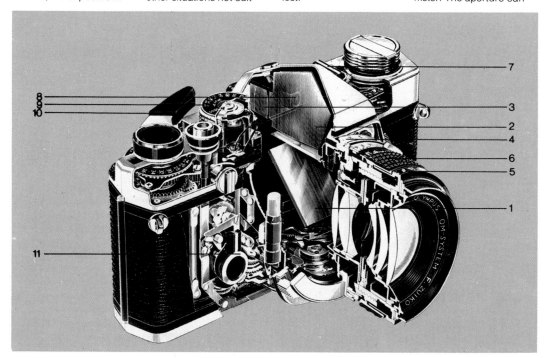

An important feature of single-lens-reflex cameras is that you can check the framing directly through the lens, thus eliminating the possibility of parallax error in close-range shots caused by the difference be-

tween the image viewed through a normal viewfinder and the image effectively registered on film. This highly accurate framing is achieved by means of a mirror angled at 45 degrees which reflects the image projected

through the lens onto a ground-glass screen. A pentaprism corrects the image seen.
The diagram above shows the mirror (1) and the pentaprism (2), as well as the viewfinder eyepiece (3), the shutter-

speed ring (4), the aperture ring (5), the focusing ring (6), the function-selector switch (7), the exposure-metering photoelectric cell (8), the film-speed dial (9), the film-advance lever (10), and self-timer lever (11).

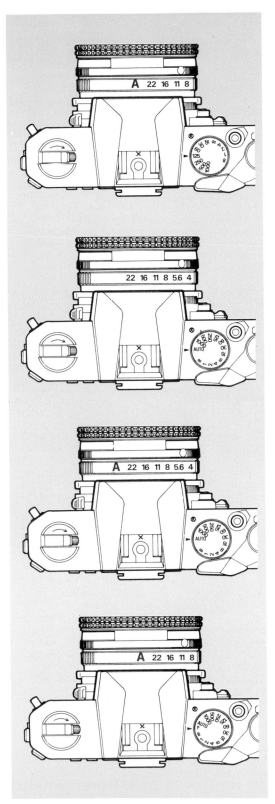

The single-lens-reflex
with automatic aperture
selection. There is an A
position (or similar) on
the aperture ring of every
lens for the automatic
function. The photogra-
pher selects the shutter
speed, and the camera
sets the correct aperture.

On models with auto-
matic shutter-speed se-
lection, the photographer
selects the aperture, and
the automatic mechanism
determines the correct
exposure time. The shut-
ter-speed selector has an
"auto" position at which
the camera functions
automatically.

Cameras that operate on
a fully automatic system
have automatic settings
on both the shutter-speed
selector and the aperture
ring, so you can choose
either method. You can-
not use both at the same
time, however.

A reflex camera with pro-
grammed automation.
When you set the aper-
ture ring on automatic (A)
and the shutter-speed se-
lector on the pro-
grammed mode (P), the
camera "decides" both
parameters in accor-
dance with a predeter-
mined program.

vary within a certain
range without adversely
affecting the picture, that
is, without any significant
change due to the
change in depth of field.

This type of automatic-
exposure system has two
disadvantages in prac-
tice, however. First, the
lens mechanism is much
more complex, so only
lenses that have been
specially designed for the
system can be used; and
second, the range of au-
tomatic-exposure settings
depends on the lens
stops available. For ex-
ample, on a telephoto
lens the range of auto-
matic-exposure selec-
tions is significantly
reduced. Only a few cam-
eras use this system,
among them the Konica
TC-1 and FS-1, the
Canon AE-1, and the
Mamiya ZE-2.

**Aperture-Priority
Systems**
In the aperture-priority
system the photographer
sets the aperture, and the
camera's electronics au-
tomatically select the
shutter speed. Most man-
ufacturers use this
system and for good rea-
son—it is fully compatible
with most existing lenses,
so no special lens modifi-
cation is necessary if the
lens operates at full aper-
ture. The mechanism is
also simple and highly
accurate, because the
electronic shutters used
can reach speeds of
1/1000 or 1/2000 sec.
and have continuously
variable intervals. The au-
tomatic-exposure range
does not depend on the
lenses or accessories at-
tached, so even non-
automatic lenses can be
used, as well as accesso-
ries such as matte boxes.

**Fully Automatic
Systems**
Cameras that combine
both types of automatic-
exposure mechanism

with the option of manual override give maximum freedom of operation. Depending on the subject, you have the choice of having the lens aperture or the shutter speed automatically set, or of cutting out the automatic mechanism altogether. The lenses used must have an automatic position (indicated by A, AE, or EE) so that they can operate with automatic aperture selection as already discussed. In practice, reflex systems designed for this type of automatic-exposure mechanism can easily be adapted to fully automatic systems because the lenses are compatible.

Certain cameras offer a further possibility with programmed automation. This means that a built-in computer sets both photographic parameters (shutter speed and aperture). The Canon A-1 is the first camera to incorporate this feature. Under normal circumstances, it means that the photographer does not have to worry about exposure settings at all, but it does take away a great deal of control.

Automatic Systems with Override and Completely Automatic Systems
More expensive and sophisticated cameras offer a facility for manual exposure setting at all shutter speeds as well as some form of automatic exposure. These cameras thus offer all the usual advantages of a traditional camera, which in certain situations can be useful.

Almost all manufacturers, however, are bringing out new, lighter, and simpler camera models that·do not have a shutter-speed selector. These cameras are much simpler in construction and highly competitive

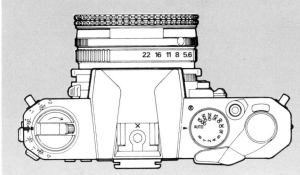

from the point of view of both price and ease of operation. They usually offer only three possible exposure methods: automatic, time exposure, and fixed speed (about 1 / 100 sec.) for use with electronic flash or for times when batteries run out.

Automatic Exposure Correction
Automatic-exposure systems are effective in most shooting conditions, but there are times when you may deliberately wish to create a different image, either darker or lighter than normal. The simplest way of doing this is to use the manual override, if your camera has one, and shut off the automatic mechanism, or to "fool" the photoelectric cell by changing the film-speed setting on the camera. You can do this on almost any camera, but its application is very limited when you are using low-sensitivity film because the camera may have few settings below the speed of your film. Of course it is important to remember to reset the selector when you no longer need the special effect. If you don't, all the other frames on the roll of film will be under- or overexposed. To avoid having to use this kind of trick, many SLR cameras offer a special device for deliberate over- or

underexposure.

Compensation dials are usually located on the film-speed setting ring. They allow exposure correction up to ±2 EV (exposure values) and are very useful for bracketing, a technique that will be discussed later. Some of these cameras also include a warning signal of some kind in the viewfinder to indicate that the device is switched on.

Memory-freeze control freezes the exposure-meter reading until the control is released, making it possible to measure the exposure of the subject from close up and then frame and take the image from a more suitable distance. In many cases this method of exposure metering is the most accurate, particularly for backlit scenes, because measuring only the light reflected from a person's face at close range prevents the exposure meter from being overly influenced by the intensity of the background.

Some less expensive cameras have a *backlight device,* a button that when pressed increases the exposure by a fixed amount (usually 1.5 EV), which is enough to correct the exposure for an average backlit scene. Releasing the button restores normal exposure.

Built-in SLR Exposure Meters
A TTL exposure meter makes exposure a simple and accurate process. In this type of system the brightness of the actual image is what affects the exposure-meter cells. All recent SLR cameras use this type of exposure-metering system. They usually measure the light at full aperture, meaning the light is, in fact, measured with the aperture fully open, even if it has been set at, say, f/11. An electric circuit selects the correct exposure based on the camera settings. The advantage of this system is that it allows the image in the viewfinder to be the brightest possible, and it allows the metering cells, which are constantly receiving all available light, to give a wider range of measurement in low-intensity light, independent of the selected lens aperture. Some lenses or accessories, however, do not have any mechanical connection between the camera and the lens to transmit the information to the metering cells and must measure the light with the lens closed to the proper aperture. This type of metering is called "stopped-down metering."

TTL Metering Systems
Three different types of

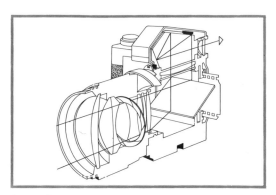

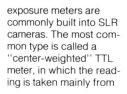

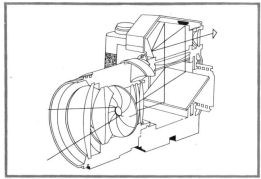

exposure meters are commonly built into SLR cameras. The most common type is called a "center-weighted" TTL meter, in which the reading is taken mainly from

Above left: The outlined areas indicate what the exposure-meter cell reads with the center-spot system (top) and the center-weighted system (bottom).
Above right: The method for measuring light at full aperture. Top: The diaphragm remains open while the exposure is determined so that the cell receives the maximum amount of light available. This is the method commonly used on automatic SLR cameras. Bottom: Measuring light with the stop-down method—with the diaphragm closed at the effective stop set. This method must be used with lenses that cannot work on automatic.

the central area of the frame, which is usually the most important area of the image. It prevents peripheral areas of intense light, such as the sky or a deep shadow, from adversely affecting the accuracy of the exposure. This metering system is a good compromise between the other two types.

The second type of metering system is called a "spot" metering system, in which the cells read only a limited central area of the image marked on the focusing screen. This system is used on only a few cameras. It is useful for high-contrast scenes or when the subject makes up only a limited part of the image.

The third type of system is called an "averaging" meter, which takes an integrated measurement of the entire focusing area. This is the least common type of metering system found in modern 35mm SLR cameras.

PROFESSIONAL REFLEX CAMERAS

Although 35mm SLR cameras are used by both professional and amateur photographers, 120-format SLR cameras are mainly used by professionals. These professional reflex cameras use 120-type roll film and are heavier, larger, and more expensive than most 35mm SLR cameras. There are not many models on the market, and accessories are also less common and more expensive. For example, a zoom lens is now a common accessory for a 35mm SLR, but a costly rarity for a larger-format camera; even automatic 2¼-square slide projectors are not common and are much more expensive than the equivalent projectors for 35mm slides.

You should probably choose a larger-format reflex system only if you already have a certain amount of experience

with the classic 35mm and if you have a specific need for superior image quality. If the need exists and you already know how to use a camera well, buying a 120-format SLR can open up new roads to creativity and give you a lot of satisfaction. The studio portrait is one area where the use of this format can produce breathtaking results.

The advantages of larger film formats are particularly evident with negative film; enlargements are more vivid and better defined, and the processing is less critical. There are three types of 120-format SLR cameras: 2¼-square, 4.5 × 6cm, and 6 × 7cm. The numbers refer to the image size recorded on the roll film.

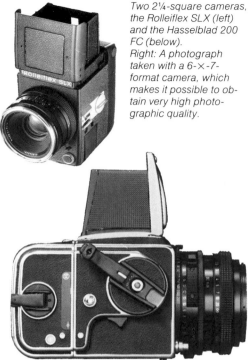

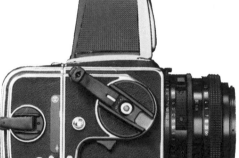

Two 2¼-square cameras, the Rolleiflex SLX (left) and the Hasselblad 200 FC (below).
Right: A photograph taken with a 6-×-7-format camera, which makes it possible to obtain very high photographic quality.

2¼-square Reflex Cameras

The classic square format, used in Rolleiflex twin-lens 120 cameras, was once the standby of all portrait photographers. The square format makes framing easy, because the photographer can decide on the vertical and horizontal composition during printing, after taking the shot. However, the chamber-type viewfinder used on most cameras with this format gives a laterally reversed image on the focusing screen, significantly complicating shots of moving subjects. Consequently, it is better to use an accessory pentaprism viewfinder for action shots.

There are not many cameras available that use this format, but one is the Hasselblad—a valuable, sturdy instrument with a vast range of accessories, but with a price as high as its quality. Another 2¼-square camera is the Rolleiflex

SLX, which offers the most advanced electronic technology with automatic shutter priority and a motor-driven winder.

4.5 × 6cm Cameras

The availability of cameras such as the Mamiya 645 and the Bronica ETR has been regenerating a certain interest in the 4.5 × 6 format for some years now. These cameras are comparable in price to mid-range 35mm SLR cameras and are only slightly larger and heavier. This type of camera combines the advantages of a larger format with the practical features of a 35mm SLR.

The Ideal Format: 6 × 7cm

This is currently the largest format available in a SLR camera. It produces a rectangular image, almost doubles the effective surface area of a 4.5 × 6cm camera, and as a result is considered

the ideal format for the professional. There are two 6 × 7cm cameras currently available: the Pentax 6 × 7, which is built like a traditional pentaprism reflex camera, but larger; and the Mamiya RB 67, which has the traditional Hasselblad structure with a chamber viewfinder. Both are very heavy and expensive compared to the 35mm SLR, but light and practical in comparison to rangefinder cameras of only a slightly larger format.

Think carefully before choosing a 6 × 7 format camera. Just holding one tells you that it is not the sort of equipment to take on a Sunday outing. On the other hand, if you want optimum photographic quality, and size and weight pose no problem, you can obtain very satisfying results with this format without too great a financial outlay.

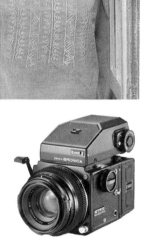

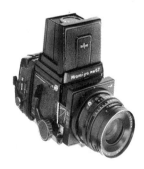

Above: The Zenza Bronica ETRS (4.5 × 6) and the Mamiya RB 67 (6 × 7) below. Professional reflex cameras are the most suitable for studio work, where image quality is a priority and the increased size of the camera is not a problem.

35mm RANGEFINDER CAMERAS

Medium- or large-format cameras may be best for studio portraiture, but you need something completely different to photograph strangers in various locations, or to capture spontaneous gestures, expressions, and attitudes. In these situations there is almost always one basic requirement: the subject should not be aware of being the focus of attention; otherwise he or she will probably react unnaturally or, worse still, refuse to be photographed. Even a 35mm SLR can

and Leica has long offered a compact rangefinder camera with interchangeable lenses. This new type of camera is pocket-size, of limited weight (averaging less than 300 grams or 10½ ounces), with a standard 35mm film format for image quality, and with fast, fixed-focal-length lenses. Many of these cameras come with a moderately wide-angle lens whose field of view includes objects and people with no perspective problems. Some of these cameras offer automatic exposure

among amateur photographers. It does away with the last manual operation prior to taking the shot and thus simplifies the process even further.

Among the autofocus systems currently available are: Honeywell's Visitronic 2, the two Canon systems (using infrared rays and CCD photodiode), and Polaroid and Seiko's Sonar, which was produced in collaboration with Olympus. Automatic focusing is an advantage if you need to focus quickly or when bad light makes it difficult to check the focus through the

The two small photographs at the bottom of the page show the automatic Canon AF with autofocus and built-in motor and flash (top) and the automatic Minox GL (bottom), which is very small and light.
Below: A nude on the seabed, illuminated with flash light. A suitable underwater housing for the camera is necessary for this kind of shot.
Opposite: A beautiful and unusual image of a model half in and half out of the water, taken with a wide-angle lens immersed a little below the surface.

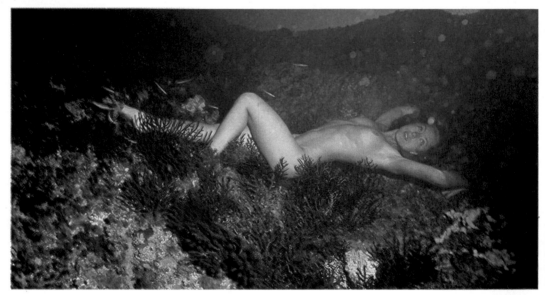

prove too cumbersome for this kind of photography, a fact that explains the revival of interest on the part of amateur photographers (and even some professionals) in nonreflex cameras, particularly the new generation of these cameras offering important new features in smaller and smaller sizes.

The idea of featuring smaller size in a 35mm camera is not a new one; Rollei launched its compact Rollei 35 onto the market many years ago,

using electronic shutters with speeds ranging from 1/500 sec. to several seconds and smooth, quiet release. Altogether, because of their lightness and compactness, they can easily be carried in a pocket and can capture images in unexpected and often never-to-be-repeated situations.

Automatic Focusing

This interesting and relatively recent technical innovation is already becoming very popular

viewfinder.

Waterproof Cameras

A photograph of a beautiful girl in the middle of ocean-wave spray can be very evocative, but seawater, or even just humidity, can seriously damage lenses and mechanisms of ordinary cameras. Good-quality cameras designed for use underwater, or in humid and dirty environments, are available, however.

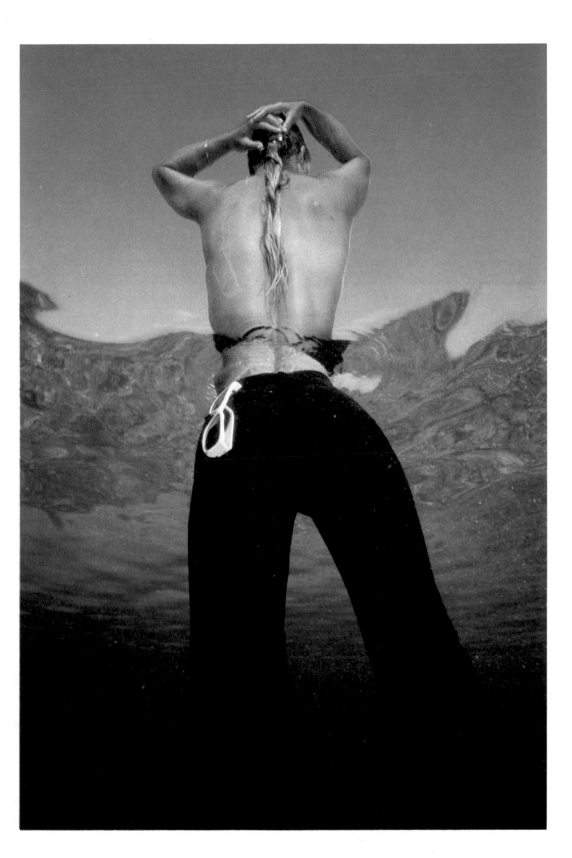

INSTANT-PICTURE CAMERAS

Until a few years ago, the only advantage of instant-picture cameras was that they eliminated the delay between taking the shot and seeing the result. Now, however, the extraordinary improvement in the quality of instant film, the development of technologically sophisticated instant-picture cameras, and the introduction of backs that can be used on normal-, medium-, and large-format conventional cameras have attracted the attention of serious photographers who have discovered that this type of photography can be used creatively.

Instant-picture film will be discussed later, but the cameras are worth discussing here. The professional Polaroid 600 SE with its interchangeable bayonet-mount lenses and shutter speeds ranging from 1 sec. to 1/500 sec. (plus a B setting) is a very interesting piece of equipment. It can take Polacolor 108 film, high-speed black-and-white 667 (ASA 3000) film, and

665 film, which also produces a negative. Traditional film can also be used with this camera by fitting the 6-×-9-cm (2-×-3.5-inch) back with a special adapter. The Polaroid EE-series cameras are inexpensive, rather bulky, and use peel-apart film in both black and white and color. After exposure (which is automatic) the film is manually extracted; the development process is stopped after the recommended number of seconds by peeling apart the two parts of the film "packet."

With the Polaroid SX70 camera, on the other hand, the photograph comes out of the camera automatically after the shot has been taken and develops before your eyes in a matter of minutes. Some of the SX-series cameras are folding reflex cameras with a unique shape that makes them easily portable. The more sophisticated SX models have automatic focusing, making the picture-taking process ex-

traordinarily simple.

Kodak's EK-series cameras are compact rangefinders with a rigid structure. All versions use an automatic-exposure system. The photographs, on Kodak PR-10 film, are automatically ejected from the camera (as in the Polaroid SX70) and develop in full light.

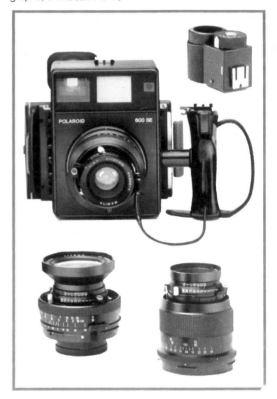

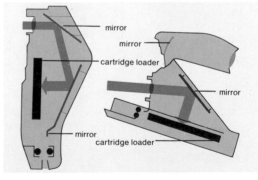

Left: A Polaroid photograph taken by Stephanie Haack with an SX 70 using Time Zero film. Top: The professional Polaroid 600 SE camera with interchangeable lenses. Above left: The Kodak EK 2000 uses two mirrors solely to reduce the size of the camera; there is no reflex vision through the lens. Above right: Diagram of the SX-70 reflex, with the vision through the lens.

FILM

There are many different types of film, with various characteristics, formats, and uses, but basically there are only four categories used by the amateur photographer: black-and-white-negative film, color-negative film, reversal (or slide) film, and instant film. There is a great difference between the first three types of film and the last: instant-picture films usually require the use of special cameras, or at least special adapters, whereas the other three types are available in formats suitable for conventional cameras. Choosing a particular kind of film not only determines the type of photography and the type of picture produced at the end of the process, but also the type of operation and processing necessary to produce it. Consequently, the choice of film is not so much a technical one as an aesthetic, practical, and operational one. The four photographic techniques using the four categories of film are known as photographic systems.

General Characteristics of Film

Every kind of film is identified by a code which the photographer should know.

Format is indicated by a number on the box and film cartridge which gives the size of the film and cartridge: 110, 120, 126, 127, 135, 220, or disk. Almost all dedicated amateur photographers use either of two films—135 or 120—though many people use 110 or the new disk film for family snapshots. It should be noted that 220 film has characteristics identical to those of 120 film but is twice as long. Both in-

stant-picture and disk films form categories in their own right.

The *speed rating*, or light sensitivity, of film is determined on the basis of the processing normally required for that particular type of film and can, in many cases, be altered by modifying the development process. It was once designated by the ASA (American Standard Association) or DIN (Deutsche Industrie Norme) number, but the two systems have recently been unified by the International Standardizing Organization. Consequently, film speed is now designated by an ISO number which combines both ASA and DIN numbers separated by a slash (for example, ISO 100/21°). The higher the number of the film, the more light-sensitive it is.

The *expiration date* is the date after which the film will begin to deteriorate. Film stored under optimum conditions—cool and dry in its sealed package—keeps its characteristics well beyond

the given limit, however. The expiration date is always displayed on the box and wrapping; be sure to check it when you buy film.

The *emulsion number* identifies separate production lots. Films with the same emulsion num-

ber will have identical qualities as long as they are stored under the same conditions. If you have to produce a series of important photographs, buy film with the same emulsion number from the same shop. Make a preliminary qual-

ity test by exposing one roll normally and then examining the results carefully, to determine that the film has been kept in good condition and that there are no manufacturing faults, and to check the sensitivity, color rendition, and contrast.

EQUIVALENTS FOR SPEED RATINGS

ASA	DIN	ISO
6	9	6/9°
8	10	8/10°
10	11	10/11°
12	12	12/12°
16	13	16/13°
20	14	20/14°
25	15	25/15°
32	16	32/16°
40	17	40/17°
50	18	50/18°
64	19	64/19°
80	20	80/20°
100	21	100/21°
125	22	125/22°
160	23	160/23°
200	24	200/24°
250	25	250/25°
320	26	320/26°
400	27	400/27°
500	28	500/28°
640	29	640/29°
800	30	800/30°
1000	31	1000/31°
1250	32	1250/32°
1600	33	1600/33°
2000	34	2000/34°
2500	35	2500/35°
3200	36	3200/36°
4000	37	4000/37°
5000	38	5000/38°
6000	39	6000/39°

FORMATS

NUMBER	110	120 (220)	135	SX 70	PR 10
Image size in mm (inches)	13 × 17 (0.5 × 0.7)	60 × 45 (2.4 × 1.8) 60 × 60 (2.4 × 2.4) 60 × 70 (2.4 × 2.8)	24 × 36 (1 × 1.4)	78 × 79 (3.0 × 3.1)	67 × 91 (2.6 × 3.6)
Number of frames	12–24	15 12 10 (30) (24) (20)	24–36	10	10
Type of package	cartridge	roll	cartridge	magazine	magazine

17

BLACK-AND-WHITE FILM

As already stated, the choice of a particular type of film implies the choice of a specific shooting method, a special way of using the image, and an aesthetic approach. The positive-negative black-and-white system is most definitely the best for the skilled amateur photographer who knows how to build up an image not only when taking the shot, but also through accurate development of the negative and an awareness of the expressiveness of the shades of gray in printing. Each stage, from taking the shot to the final print, must be supervised with the personal photographic sensitivity that is so necessary to convert reality into individual expression.

In itself, the black-and-white image is an abstraction of reality, although it is familiar to the eye and is at times accepted instinctively in preference to color photographs, which we expect to be more chromatically faithful to reality. We are accustomed to seeing images in black and white in publications, and that is how we naturally see things at dusk and at night. When there is little light, color is lost and what we see is essentially based on the difference in light intensity, that is, on the contrast between dark and light.

Creativity in Black and White

A photograph that is intended to be only a memory image is usually more faithful if it is taken in color. In addition, the use of color helps to make a photograph that would be gray and monotonous in black and white quite pleasing, giving the picture an everyday quality free of abstraction or interpretation. It cannot be denied,

however, that knowing how to express yourself effectively and creatively is difficult with both color and black-and-white film. Yet, because there are far more "Sunday photographers" around now, it is easy to see why black and white has become the material of the elite, the chosen means of expression of the many skilled amateurs who are artists of the lens.

Because of the unique interpretational abilities of black-and-white film, it is hardly surprising that so many undisputed masters have used it to produce their best creative expressions. Anyone who intends to use black-and-white film as the basis of photographic work must

fully appreciate the following points:

1. It is essential to develop the negative yourself and, if possible, do the printing as well to guarantee consistent quality.

2. Black-and-white film is easier to check than any other type, during both developing and printing.

3. Because of its very nature, understanding the "language" of black and white is the first and most useful step toward acquiring a sensitivity that allows you to "see" photographically.

4. The mainstay of composition and the technique of visual com-

Above: The technique of printing with high contrast accentuates a deeply lined face and a serious, pensive expression.

Left: Images like this one, with its clear and simple structure in which the closed positive area stands out sharply from a clean, uniform background, have tremendous graphic effect, even in negative form.

munication are based on "single-dimension images" in black and white.

Choosing Film

Your choice of a black-and-white film depends essentially on the speed and the type of definition you require for a particular application.

Slow films (up to ASA 50) are used primarily for static subjects such as landscapes and interiors to produce a tactile effect and give excellent definition for enlargements.

Medium-speed films (ASA 50–200) are normally used in general conditions when high sensitivity is not needed.

Fast films (ASA 200–800) are most commonly used to photograph the human form, both in studio portraits and in natural surroundings. They combine a richness of tone with soft contrast and limited graininess. Because of their flexibility in development, fast films can cover a wide range of light sensitivity, from ASA 200 to 800, without problems.

Ultra-fast films (ASA 800 +) should be used when very high speed is necessary, such as in extremely low-light-level conditions. Very fast films usually have a pronounced grain pattern, but they capture images that would otherwise be impossible.

Processing Black-and-White Film

Processing (developing) exposed film is the first thing to learn if you want to control the image quality of a black-and-white photograph. In processing (as well as exposure) the photographer transfers the scale of light photographed in reality into a corresponding scale of grays on the negative and then on the print.

A comparison between black and white and color. A subject can be more suited to the language of black and white than to that of color. Compare the photograph by Paolo Bonciani (below) of an intensely expressive face, impeccable in black and white, with the same face in color (left); you can see that the graphic and communicative force is stronger in black and white.

A comparison of two black-and-white prints in which a different tone of gray has been used for the skin. A slightly lighter tone (below) alters the style and expressiveness of the image, although the complete tonal scale, from deep black to white,

exists in both photographs. The essential factor is the choice of gray tone on which to base the variations in skin tone.

In order to achieve maximum control over the black-and-white medium, the famous naturalist and photographer Ansel Adams devised a method known as the "zone system." This system of exposure and development sheds a great deal of light on the photographic process in general, as well as being practical in application. In order to become a truly creative photographer it is essential for you to understand the process of reproducing the full black-and-white tonal scale. A black-and-white photograph of a person is based completely on the balance of grays in the final image. The color of white skin corresponds to a reflected brightness lighter than middle gray, but the way it is reproduced on paper is a creative variable in the hands of the photographer. Changing the balance of gray tones means changing the look and poetry of the photograph.

The Principles of the Zone System

The concepts of the zone system are relatively simple and are based on the following essential points.

Tonal interval. Every object in a frame reflects a certain amount of light that can be measured by a spot meter and results in a certain tone. The difference between these amounts of reflection, usually measured in exposure values (EV), provides a key to the contrast scale of the final image. If the tonal interval of the subject is very wide (for example, nine steps on the scale), there is a lot of contrast in the image. Conversely, if there is a small interval of, say, two steps, the image has low contrast. Contrast can thus be defined as the ratio between the

maximum and minimum brightness values in the scene or frame. Normally, the lowest value corresponds to the darkest shade and the highest to the brightest.

The gray scale. In the zone system the various shades of gray possible in a photographic print have been arbitrarily divided into ten zones. Zone 0 corresponds to absolute black, and the last point of the scale, zone 9, corresponds to the white of the completely unexposed photographic paper.

Standard middle gray. In order to record the tonal scale of a subject on a piece of paper, you have to determine a point on the gray scale to serve as a reference for the other brightness values of gray. This middle-gray reference point (zone 5) has been defined as that which reflects 18 percent of the light, and it is the density reference on which the photographic process is based.

In practice, middle gray corresponds to the average density of a normal black-and-white image; exposure meters are graduated to indicate the amount of exposure necessary to reproduce middle gray with the same density. This means that if you point an exposure meter at a white wall, the exposure indicated will produce a middle gray in a normally processed print. Pointing a meter at a black surface will produce the same results. You can therefore use this gray value halfway between the two extremes of black and white to previsualize the final image on photographic paper in comparison to the actual subject.

Method. Once you have decided upon your starting point—the tonal scale of the subject—and

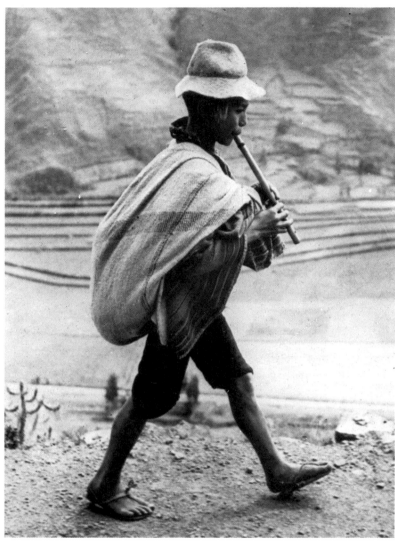

the final point—the tonal scale of the black-and-white image on photographic paper—you set about obtaining the end result through a controlled method. The zone system is such a method. It gives you complete control over the gray tones in the negative. It allows you to visualize the final black-and-white image when looking at the subject and to expose and develop the film to obtain the tonal reproduction you visualized. As a result, development becomes an integral part of the photographic process, allowing you to control the full range of the tonal scale. However, exposure and development are interrelated, and the quality of the black-and-white negative depends on both factors.

The procedures necessary to use the zone system are the following:

1. *Measuring the contrast* in the frame in exposure values to enable you to previsualize the print—to foresee which areas will be completely white (zone 9), which will be completely black (zone 0), and which will be areas of intermediate grays.

2. *Organization of the negative system* by controlling the two basic variables, the exposure and negative development times, and three constants: zone 0, which reflects no light at all (and is completely transparent on the negative and a deep black on the print); zone 9, which reflects the most light (and is black on the negative with maximum density and comes out completely white on the print); and the third key zone which is the area corresponding to middle gray. This middle gray is the keystone of the tonal scale. By photographing a gray card

Above: A famous image by Werner Bischof, rich in halftones.
Below: The gray scale photographed on automatic, first on a white card, then on a black one. The first case results in underexposure and the second in overexposure, as you can clearly see in the differing reproduc- tions of the gray areas. For the third photograph the exposure was increased by 1½ values to reproduce the gray scale accurately.

(available at most camera stores) with film exposed for its nominal sensitivity, you can produce a negative which, when developed and printed following the manufacturer's recommendations, should result in a faithful reproduction.

3. *Organization of the printing stage* by using the paper and processing recommended by the manufacturer. This is the final stage of the reproduction process. The two main variables are the "grade" (the contrast) of the chosen paper and the processing of the print.

Exposure and Development of the Negative:

Process and Testing

In order to be fully in control of the development and printing processes, you must organize and standardize your procedures. A method of operation which rationalizes and simplifies the process consists of photographing printed cards of known densities on the film normally used, under controlled conditions at different levels of ex-

posure, and then developing the exposures differently. To do this, place a smaller black-and-white card on a standard middle-gray card. Make eleven exposures of the cards at increasing exposure levels with ASA 400 film, and repeat the procedure with a Kodak gray scale (which can also be obtained easily). After exposing three rolls of film in this way, develop one at the manufacturer's recommended time and the other two for 40 percent more and less time respectively. The results

should show you (1) if the exposure and development process is satisfactory, (2) how to vary exposure and development time to increase or reduce the tonal scale, and (3) which densities of the negative should be used as reference—that is, what are the maximum and minimum densities for acceptable prints. In this way, with a little work and only a few rolls of film, you can learn how to control and use the process to obtain perfect negatives with density intervals that reproduce the subject as you would like.

The Quality of the Negative

One of the most common difficulties the amateur photographer encounters in the early stages is evaluating the quality of the negative.

A negative has three basic characteristics:

1. *Fog or minimum density* (the level of transparency of the negative in unexposed areas). It is usually easier to check the minimum density of the negative in the areas outside the frame (for example, between the perforations on 35mm film). If the fog is readily apparent, the development process has been too long or the film is beginning to deteriorate.

2. *Maximum density* (the maximum opacity obtainable in exposed

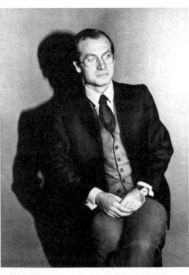

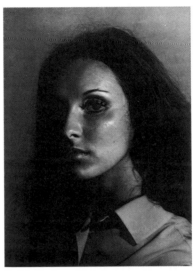

The first negative on the left is overexposed; if the shade of the jacket is taken as the central tone in printing, the tone of the face is at the top limit of the tonal scale. The example on the right shows the opposite case; part of the negative is underexposed, so only the illuminated part of the face forms the image. The effect is quite dramatic.

areas). It is not always easy to trace the zone of maximum density on a negative, but one good way is to refer to the density of the manufacturer's number printed on the edge of the film or, better still, to the exposed leader of the film. In this way you can get a rough idea of any underexposure; the higher the maximum density of the film, the wider the density interval used in forming the image.

3. *The contrast* (the number of tones needed to reproduce the entire tonal scale of the subject from white to absolute black). This depends on the characteristics of the film and the developing methods used. The graph on the following page shows how contrast can be varied to bring it more in line with the brightness interval of the subject.

A good exposure meter can be used to take a rough measurement of the density characteristics of a negative, provided that it has a sufficiently narrow measurement angle or special accessories to cut down the field being measured. The procedure is as follows: Expose a roll of film to produce a scale of eleven values, five of them progressively underexposed and five progressively overexposed, by photographing a standard gray card covering the whole frame. The roll of film will have eleven frames of increasing density (uniform density in each frame), from a completely transparent negative to one with the highest possible density. Place the exposure meter in a stable position opposite a light source, and take a reading of the light source alone; write it with and without a negative in between, will give an approximate estimate of the density of each negative. Draw a graph of the meter readings. When you know the exposure used to produce each negative, you can reconstruct the sensitometric curve of the film.

This type of homemade density scale can also be used to evaluate the effect of a variation of development time on the contrast of the image and to compare different types of film. It also familiarizes you with the concept of sensitometry.

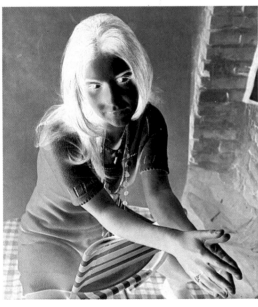

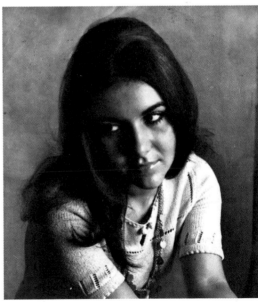

The three key tones are shown in the first three negatives of the top sequence, taken with ASA 400 film—black and white in the squares and middle gray in the background. The first frame was exposed at ASA 25 (with 4 EV overexposure), the second at ASA 400 (reference frame), and the third at ASA 3200 (underexposed by 4 EV). The fourth frame shows the gray scale at the proper exposure.

A correctly exposed negative such as the one above includes the widest possible tonal scale and a maximum amount of information. It is also much easier to print.

down. Then place the darkest frame of film between the meter and the light source. The exposure-meter reading will now be influenced by the negative's density. Take subsequent density readings from all the other negatives (in order) in the same way. The difference between the two values,

Keep in mind that an EV light value corresponds to 0.3 unit on the logarithmic scale of exposures and thus each frame on your homemade gray scale will have a variation of 0.3 log E (E = exposure).

Once you have mastered the procedure for exposing and developing

THE GRAY SCALE IN BLACK-AND-WHITE PRINTING

ZONE

Zone		Description
0		Absolute black, maximum density of paper
I		Almost completely black, with a hint of variation
II		Tone between black and dark gray, showing detail
III		Dark gray, corresponding to the shade of black clothes or dark materials
IV		Dark gray, corresponding to the shade of black skin, dark vegetation, and dark shadows in full sunlight
V		Standard middle gray, which reflects 18 percent of the light, corresponding to the shade of suntanned skin and middle-tone vegetation
VI		Light gray, reflecting 36 percent, corresponding to white skin in general
VII		Light gray, corresponding to very pale skin in diffused light; tonal reproduction of white cloth with well-defined three-dimensional details
VIII		White with slight detail; the tone of snow in sunlight, zones in light
IX		Absolute white, corresponding to unexposed areas of paper

ASA 200

ASA 800

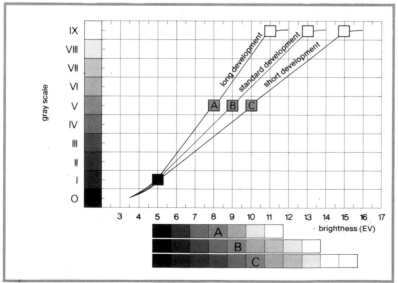

Left: The gray scale. Center: Two negatives obtained from the same film and exposed in the same light conditions but at different speed ratings. Bottom: Tonal reproduction of grays with the zone system. The graph shows the relationship between the brightness scale reflected by the subject and the scale of grays that can be obtained on the print. The brightness scale of the subject is shown on the abscissa, measured with a reflected-light meter. Each step corresponds to 1 EV. Using the measurement obtained by reading the light reflected off the subject with an exposure meter, you can obtain the average tone of the subject in zone 5—middle gray on the print. When you have taken this first measurement of the average value, you must measure the light reflected from the lightest and darkest areas in the frame. The difference between these two values is the contrast range to be reproduced. A common value is 9 EV, but it is possible to get shorter or longer scales.

The red line on the graph indicates the ideal curve of a scale corresponding to nine shades; note that the whole tonal scale of the paper is used in the reproduction. It would not be possible to use the full gray tonal scale in other cases with the same exposure and development. By varying the exposure and / or the development, however, as indicated by the other two lines, you can make the most of the tonal range of the paper to include the whole contrast range.

film accurately, the printing and enlargement stage takes a minimum amount of time, space, and effort.

Printing

A good photograph is the product of a series of operations—from taking the shot to printing it on paper. Each operation affects the final quality. Anyone who takes the time and trouble to develop a negative well should be interested in converting it into a high-quality photograph by doing the printing, which gives the photographer control over both the contrast and the composition of the final printed image.

The black-and-white process provides great scope for creativity because of the many variations that can be produced from a negative by dodging it or printing it on high-contrast paper. The aim of the printing process, however, is to produce a photograph with the widest tonal range possible from a given negative. The better the exposure and development of the negative, the easier it is to obtain the image on paper with the right tonal balance. The ideal black-and-white print is one in which the gray scale is reproduced so that there are points of pure black and perfect white, but with detail in even the darkest shadows and the brightest highlights. It makes full use of the entire range of tones.

Organizing the Printing Process

In order to apply the same rational criteria to the printing stage as to the production of the perfect negative, it is advisable to start with a system that allows you to familiarize yourself with the

operational parameters of the printing paper. Once you understand the limits of your printing paper, you will be able to produce correct reproduction of middle gray through the use of specially prepared negatives. With practice, and with a suitable combination of different contrast papers, you should be able to reproduce the same quality gray scale as you could on film.

The Gray Scale

The zone system establishes the tones of gray that are usually available in printing. The ten shades of gray corre-

spond to ten different exposure levels, and each differs from the next by one full exposure value. Neutral (or middle) gray corresponds to zone 5; the first zone, 0, is absolute black and the last, 9, is absolute white. Zone 6 normally corresponds to the tone of white skin.

The main variables in the printing process are:
1. *The type of paper.* There are three to six different grades (depending on manufacturer and surface) of fixed-contrast grade paper on the market. In addition, there is "polycontrast" paper, which allows you to vary

A famous and splendid photograph by Henri Cartier-Bresson which can be taken as a symbol of his unsurpassed ability to capture the "magic moment." Any scene you come across in the street can become an opportunity to take extraordinary images full of human and aesthetic meaning. Cartier-Bresson uses the language of black-and-white photography cleanly and without any artificial devices to capture moments in which reality becomes symbolic.

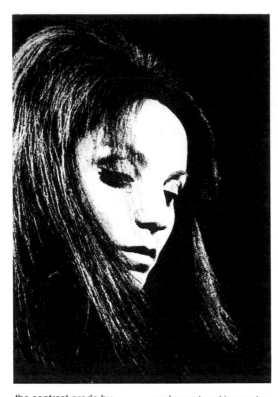

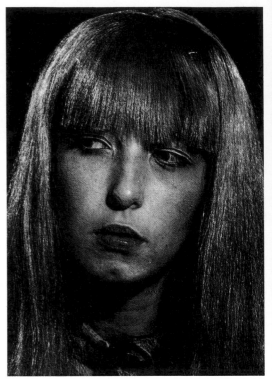

the contrast grade by using colored filters. The contrast grade of paper should be chosen to counterbalance the contrast range of the negative. In other words, the more contrast range in the negative, the less the paper should have.

2. *The type of developer and dilution.* Both factors have a decisive influence on the image contrast, which can be determined by precise tests with the gray scale.

3. *The type of enlarger: condenser or diffusion.* A diffusion enlarger produces an image that is softer, with less contrast than that produced by a condenser enlarger.

Although it is possible to control the contrast of a negative by varying the processing time, in printing the correct processing time of the paper is a constant and cannot be reduced without sacrificing the deep blacks and producing a flat print with

unpleasant and imprecise low contrast.

Above: Two portraits by Valentino Torello. The first is a high-contrast image in which the grays have been removed to produce a graphic effect. The second is an example of darkroom work: the negative was printed in contact with a positive to give more relief to hair. Opposite: A successful

portrait by Raffaele Murari in which a special process was used to enhance the grain of the negative. Note the difference between the grain in this photograph and the unpleasant graininess of the one below, caused by enlargement of a small detail of the negative.

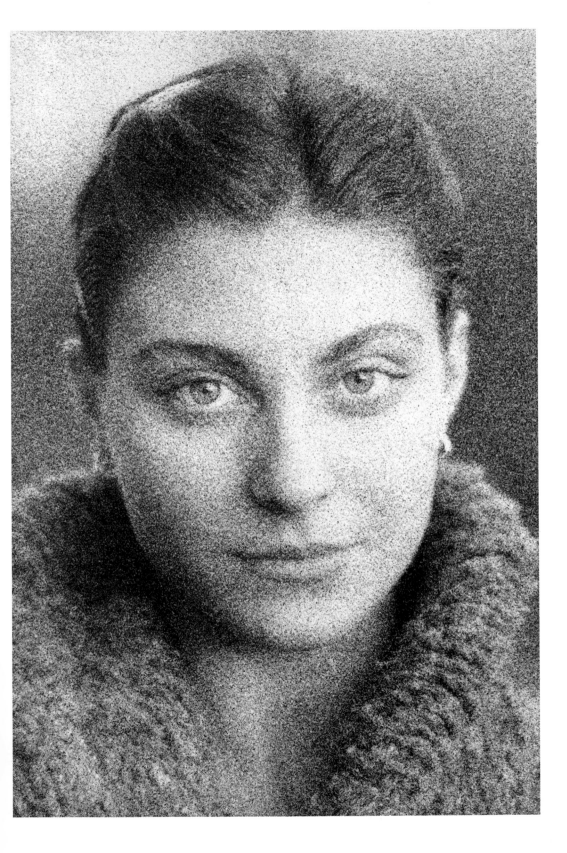

THE COLOR-PRINT SYSTEM

The most popular photographic system is the color-print system. Its intrinsic versatility makes it suitable for use in the most varied exposure conditions. Its sensitometric characteristics and the controls in the intermediate printing process make it possible to correct any exposure error within quite a wide range. In addition, the negative makes it simpler to produce copies, enlargements, and reproductions on various types of material. The quality level of prints produced from negative color film in laboratories with automatic equipment is quite satisfactory for run-of-the-mill photographs.

The main disadvantage of this material is that the results cannot be guaranteed. The quality of the image depends mainly on the printing lab, and fully automatic processing is designed to level out the features of the image. Normal 9-×-13-cm or 10-×-15-cm (3½-×-5-inch or 4-×-6-inch) prints are also quite inexpensive, but greater enlargements must be produced with a non-automatic process and are more expensive.

You can do your own color-negative printing; the process is relatively simple and produces good results. But when you add up all the costs, it is not much cheaper to do the enlarging at home than to pay a good lab. You also must take into account the fact that you have to do some amount of printing regularly if you want to get consistent results and make the most efficient use of your chemicals. However, making your own prints is certainly the best way to create your own fully personalized photographs.

Characteristics of the Film

There are two types of color-negative film: medium sensitivity and high sensitivity. Both have a very wide exposure latitude and respond well to even two stops under- or overexposure. The tolerance with overexposure is particularly good, and because it is, the negative can be overexposed for improved color saturation. Compared to black-and-white film, however, all color film is less elastic under strong lighting conditions, and this disadvantage is aggravated by reduced flexibility in processing. In other words, color film works better with soft lighting (with lighting of a smaller brightness range, not above a brightness ratio of 4:1). Also, bright light and deep shadow have a definite effect on the color tone.

Color-negative film (with the exception of Vericolor L Professional) is balanced for daylight. If it is exposed under artificial light, color balance can be restored in one of two ways. You can use the proper color of conversion filter when shooting, or you can use filters during printing. Generally, using a conversion filter results in a better-quality photograph and simplifies printing. When you use a conversion filter, however, the sensitivity of the film drops by two full values; that is, it is reduced by a quarter.

Organization of a Color-Print System

Color film has the additional variable of color balance, which is especially important in the correct reproduction of skin tones. With color film it is even more important than with black-and-white film to organize your system and be in full control of the process.

There are two ways to test your color system and develop a reference point for the exposure of color negatives. The more basic of the two is used when all the printing is done in an automatic laboratory. In this case, it is called the *neutral gray card method,* which allows you to check both the exposure and the color neutrality of the film. It is done by photographing an 18 percent gray card (mentioned earlier) under the same light to be used for the remainder of the film and so that it fills the frame. The second method is the *diffusion method,* which involves exposing one or two frames with an opaline diffuser fitted onto the camera lens (or directly onto the body of the camera). This diffuser can be a neutral translucent plastic disk or a translucent or white sheet of paper. By exposing normally according to the readings on the exposure meter, you should get neutral gray. Both methods give a reference frame for testing the color balance at the beginning of the film. This reference is very useful during printing, and it also provides a check on the whole process. It allows you to control the quality of lab work quite easily.

If you do your own developing and printing, a reference point becomes even more important, and it is a good idea to use a more complete method. By photographing a color scale, a gray scale, and a middle-gray card, you can produce a reference frame to help you control the exposure latitude and the consistency of the color balance. The different negatives exposed in this way should be contact printed for comparison under the same exposure and filtration.

Shooting Color Film

The philosophy behind using color film is vastly different from that of black and white. Because of its complexity, color film presents much less flexibility in processing. Any alteration to the composition, even cutting the image differently, involves custom work and is consequently more expensive. As a result, color photography has to be much more accurate and careful, and the final image should really be created when you take the shot. That is the time to determine the composition and contrast, and to add any special effects such as diffusion or vignetting.

Processing Color Film

Processing color negatives is rapid and does not require many baths. The most critical problem is maintaining a constant temperature of 100° F. (38° C.). The advantage of doing your own processing is that you can vary the developing time with a view to modifying the sensitivity of the film. The advantage of using a laboratory is that it is more convenient, and you have a greater guarantee of more controlled and regular processing. Add to this the fact that you can keep your processing standardized only if you do it frequently, and the fact that the photographs often cannot be repeated, and you will see that there are certain advantages to professional processing

The color-print system permits great exposure latitude, particularly with overexposure. Bear in mind that printing tends to neutralize the effects of exposures not based on the average density of the scene (whether accidental or intentional), so when you rely on a processing laboratory you may find that a variation of 1 or 2 EV is lost.

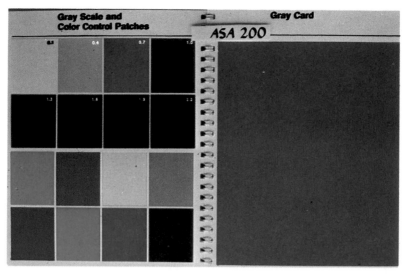

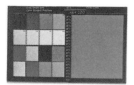

In these three examples of the gray scale and color-control patches photographed with ASA 100 film and developed normally, you can see (top) that underexposing to a value of 1 EV (by setting the film-speed rating at ASA 200) results in a negative that is slightly lighter than normal, the gray tone slightly denser.

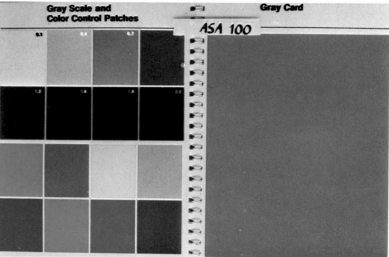

In the case of overexposure (right), you can go up to 2 EV more— expose at ASA 25—without losing much in quality in the gray scale and color saturation. Compare these with the center example, where the negative was exposed normally.

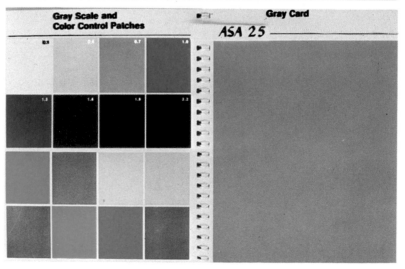

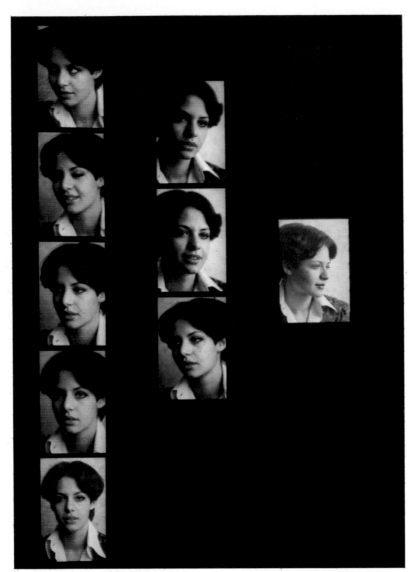

Printing Color Negatives

Color printing is also within easy reach of any amateur photographer. Automatic equipment is readily available, and the simplicity of the chemicals and processes makes it a real possibility for anyone seriously interested in photography. However, it still requires considerable time and money to obtain quality pictures and consistently good results, and many photographers who know how to use color film properly do not find that it is worth the effort.

As with black-and-white prints, the quality of a color enlargement depends a great deal on the size of the original negative. Anyone who regularly makes large prints should consider using a 120-format camera. Color prints are less stable than black-and-white prints, and they fade if they are exposed to sunlight for a long time.

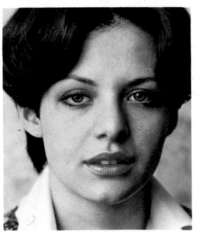
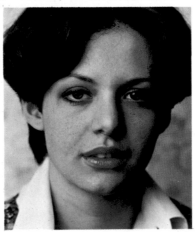

With contact sheets you can easily select the desired expression of the subject and at the same time decide if filtration is necessary during enlargement. Notice that the frame on the right has a colder color balance than the others, indicating that it needs to be filtered differently. At the left you can see the effect of filtration, used to correct a magenta dominant in a photograph (far left).

THE COLOR-SLIDE SYSTEM

Color-slide (or reversal) film produces one single original, which needs either a projector or a viewer to be seen properly. The positive color image is formed directly on the film and has, as a result, only the same dimensions as the format of film used. This is a great limitation, but despite it this type of film is popular with skilled amateur photographers.

The main advantages of color-slide film are its brilliance and rich color saturation, combined with a low unit cost (particularly 35mm slides). In addition, slides can be filed and catalogued logically, and they take up very little space. It is also the most suitable color film for reproduction in books and printed matter, and thus it is widely used by professional photographers.

Reversal film has even less latitude for exposure error and color balance than color negative-positive film. Consequently, it is manufactured in different types, each of which is designed for a different range in the color temperatures of light.

Daylight film covers the interval between 5500 and 6000K, or the light commonly found outdoors in full sun.

Tungsten Type A film is designed for artificial light at 3400K, that produced by the boosted tungsten lamps commonly found in photographic studios, so it is of particular interest to professionals. With a number 85 filter, it can also be used in daylight.

Tungsten Type B film is made to be used in artificial light at 3200K and is suitable for normal tungsten (bulb) lamps, provided that they are more than 200 watts, or prefer-

ably with quartz-iodine lamps. This film can also be used in daylight with a number 85B filter.

Slide film is the only film that *must* be used with conversion filters in light that is of a different temperature from that for which the film was manufactured. This is because the positive image cannot be corrected after it has been developed, as you can do when printing color negatives.

A transparency presents a tonal scale which, unlike that of color negatives, depends entirely upon the choices the photographer made while taking the shot. Development does not alter the color reproduction and obviously no printing is done by operators or machines, so the desired tonal scale must be obtained solely on the basis of the exposure.

When overexposing (as in the first frame below) or underexposing (third frame) by 1 EV with color-slide film, you get a variation in the general density of the image and the color saturation, so you can choose image density on the basis of the tonal scale of the subject during exposure. Remember that you can push the film-speed rating by increasing the development time; a useful fact when you find yourself having to shoot in very low light, as in the photograph below right.

thus requiring highly accurate exposure. It is important, however, to know that reversal film reacts better to underexposure than to overexposure (unlike negative film) and gives a decided lack of information and detail in areas where the light is too bright. The highlights can almost seem to be holes in the slide.

On the other hand, in a slightly underexposed slide the image is com-

Processing Color Slides

Reversal film is noted for its inflexibility, so for good color balance and sensitivity, the processing again should be standardized as much as possible. The only possible variation is increasing development time to "push" the film speed two to four times above the normal sensitivity set by the manufacturer. When you do this, however, you should let the

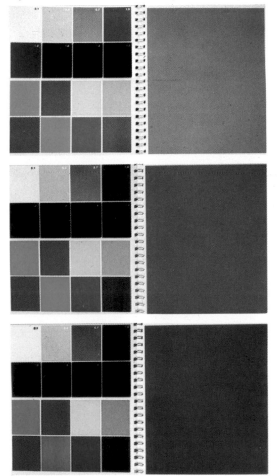

Organization of the Color-Slide System

Because the color-slide process is so critical, it is particularly important to organize specific film-camera-processing systems for regular use. The tests made in this case are done for a different reason than with the films discussed earlier. The important point here is to establish the exposure range in which you can rely on the film, with re-

gard to both the density and the color quality of the light. Of course, the tests will also give you an opportunity to test the quality of the lab that processes your film. The test is very simple. Check the quality of the color by photographing a neutral gray card at the beginning of each roll of film.

Exposure Latitude

Slide film has a very limited exposure latitude,

plete and detailed, though occasionally too dense or with too much color saturation. However, an underexposed slide does produce an image that can be very evocative when projected. This factor resulted in a tradition of underexposing slides slightly to produce better saturation whenever there is any doubt about the proper exposure.

lab know the effective speed at which the film was exposed. Though it is not possible to "push" all types of color-slide film, it is nevertheless becoming more popular to do so. It is convenient to have two or three different speed ratings available from the same type of film, particularly when unforeseen circumstances arise. The quality of the image suffers as a result.

Prints from Transparencies

If done properly, very high-quality prints can be produced on reversal paper, so that a transparency can be used like a normal negative. Unlike a negative, however, a positive transparency can be directly viewed or projected in order to determine the cropping of the print.

Prints from slides are produced in one of three ways: through an internegative for printing on ordinary negative paper, by printing directly on Kodak reversal papers, and by printing directly on Cibachrome reversal paper.

Color-slide film is particularly suitable for obtaining perfect color reproduction with great richness of tone, as you can see in this example. You also get very expressive deep blacks, unlike those of color-negative film, which are usually somewhat smoky, as they are lightened by automatic printers.

THE INSTANT-PICTURE SYSTEM

Instant-picture cameras use two different systems. The first type of system uses peel-apart film such as Polacolor 2, lenses do not have to be of particularly high quality since the image is not usually enlarged). The instant-picture camera is tive, but a few types use a film-based black-and-white negative which allows enlargements and duplicate prints.

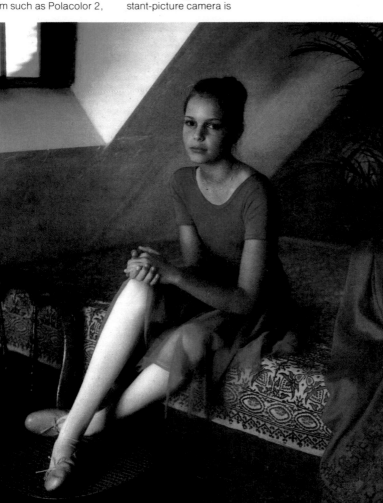

in which the photographer manually stops the developing process; the second uses automatic integral-processing film, which is extremely simple to use and gives very high-quality results. In both systems the image is formed in its final size at the time of exposure, which explains why the cameras are so large and why they have lenses of a focal length around 120mm (though the

very popular with amateur photographers, but it also has professional applications, such as to check preliminary results in the studio.

Instant-picture photography does have its limitations, though. The system is inflexible, and each film type is compatible only with its corresponding camera type. It is also more expensive. Most of the film produces a nonreclaimable nega-

Instant-Picture Film

There are basically three types of instant-picture film: (1) the traditional Polaroid peel-apart film in which the processing time is controlled manually, available in both color and black and white and in different formats for use with different cameras and professional adapter backs; (2) Polaroid SX color film for use

with the SX70 camera; and (3) Kodak PR10 film for Kodak Instant cameras.

Polaroid produces all black-and-white instant-picture film in different formats suitable for the recent EE-series cameras and the two adapter backs that can be fitted onto 2¼-square or larger-format cameras. The developing process takes only a few seconds; the photographer peels apart the two sections of the package, one of which contains the negative and the other the positive, to halt the process. Some of these films have a film-based reclaimable negative that has to be rinsed in a 12 percent solution of sodium sulfite (if this is not available, ordinary household salt does a reasonable job). This film is particularly suitable for use with the special backs that can be fitted onto studio cameras. T107 film has a reasonably high-speed rating which facilitates photography in ambient light.

Polaroid 2 (ASA 75) color film works on a similar principle and is suitable for the same kind of equipment. It is available in various formats up to quite large sizes.

Polaroid SX integral-processing film requires no manual operation on the part of the photographer. The image is ejected by an electric motor immediately after exposure, and the color picture slowly appears in full light. Its speed of ASA 150 is adequate for interior shots, and the chromatic equilibrium is balanced to reproduce skin tones correctly in daylight.

Time Zero is a new type of Polaroid film. It needs even less development time and has greatly improved color quality, particularly in the green

Below: Emily, *a well-known and splendid example of the very personal style of Maria Cosindas.*
Opposite: A romantic image by Ed Judas. The two photographs were taken on Polacolor 8-×-10 film. range. The colors are bright and saturated, and the pictures obtained with it are highly stable, much more so than with other traditional amateur films.

Kodak PR10 color film, the first instant-picture film not produced by Polaroid, works on the same lines as the SX system.

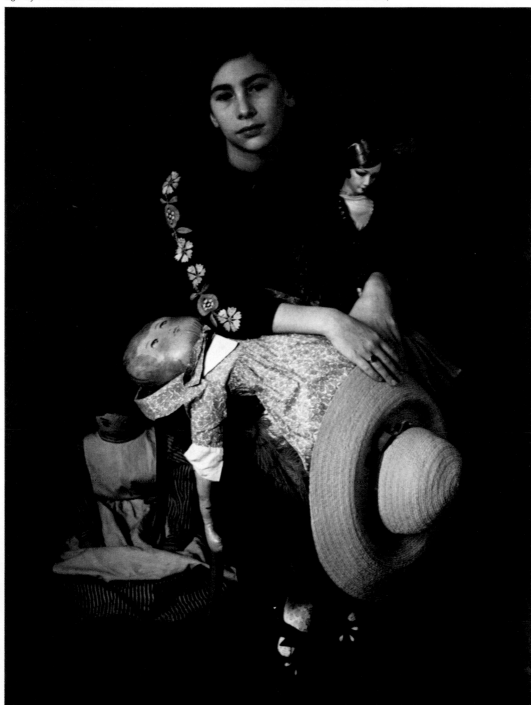

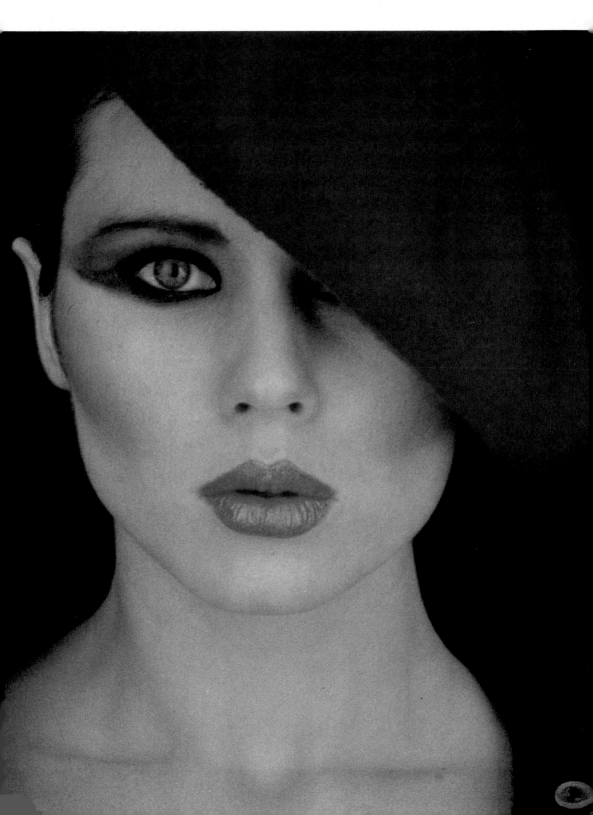

THE MECHANICS OF SIGHT

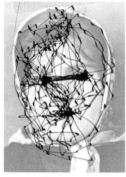

Sight is a much more complex phenomenon than the mere perception of the image as projected onto the retina of the eye. Seeing is not a passive, automatic, and regular phenomenon but is, in fact, an intense and tiring activity. The human eye explores, recognizes, and examines the outer reality by means of automatic and unconscious movements directed and controlled by the brain. Contrary to what may seem, the eye never takes in an entire scene, or even a full face, at once. When you look at something, only a small part of the retina is used for observation—the fovea, which has a reading angle of only a few degrees. In order to take in a whole scene, the eye moves continuously, clicking away rapidly through the foveal angle to scan and register the thousands of details making up the image. Thus

the eye automatically and continually scans the subject, selects details, and collects the essential elements (such as the eyes and mouth, which, being the important features of the face, attract the attention of the eye and are therefore examined repeatedly). All this information is then relayed to the brain. This process has been proved experimentally by registering the movement of the eyes to formulate a scientific explanation of the phenomenon of sight. Research has confirmed what students of aesthetics have always known intuitively—that seeing means grasping the predominant features of a subject.

The secret of this prodigious ability lies in the mind's capacity for memorizing a vast number of faces and facial features which are then compared with the image relayed by the eye. In reality, the eye minimizes the effort involved in reading an image by rapidly scanning the shape and texture of the image in order to recognize it and then make the comparison with its memory bank. Getting used to looking at something thus means accumulating visual experience and increasing the store of images retained in the memory to enable us to see forms, structures, faces, and people with ease. The result is that when you look at a face that is well known to you, a fleeting glance is enough for you to recognize it, whereas you have to make a greater effort to analyze, classify, and memorize an unknown face.

The Principles of Visual Perception

At the beginning of this century, psychologists of the *Gestalt* school in Germany worked out the principles of visual perception. These principles have since provided a stimulating interpretation of the mechanics of vision and thrown new light onto the way we read images. The basic principles of the theory, which are of greatest interest to the photographer and give an interesting and authoritative starting point for a rational analysis of the technique of visual communication, are the following.

Above: An image containing many details and strong contrast makes the eyes scan more intensely; the brain "reconstructs" the parts of the figure in shadow.
Above left: The physiolo-

gist A. L. Yarbus traced the track of eyes scanning an image; the path is shown in the bottom photograph.
Opposite, top: The dome in the background seems to sit on the head of the man in the foreground because of the principle of proximity. Lionello Fabbri deliberately created the effect in this case to "crown" the great sculptor Alexander Calder. Bottom: Two ways of controlling the difficult balance between figure and background. The background of the photograph on the right is rich in graphic elements and is used to frame the subject with related objects. In the photograph on the left, on the other hand, the open and suggestive background suggests space and a human landscape in which the figure belongs, but from which he stands out because of his dynamic pose.

The principle inspiring the theory known as *Gestalt* (which is German for "grouping," "structure," and "composition") is that a composition of visual elements is different from and much wider than the simple sum of its parts. In other words, in a photographic portrait the elements of the image can give rise to different interpretations of the same figure, depending on the way they are

three dimensions of reality are reduced to two; elements on different planes are compressed into just one plane, and so are easily seen as part of the subject if they are close to it.

The Principle of Similarity

Visual elements that are similar in shape, color, and size tend to be related to each other. This phenomenon is related to

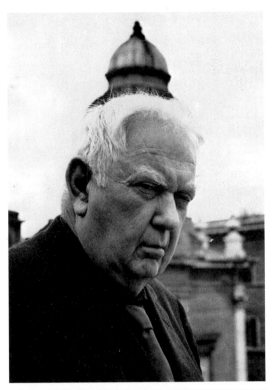

grouped and organized.

The following four principles explain the mechanics of vision and show how certain elements of the image are instinctively related to each other, while others are not.

The Principle of Proximity

The closer the visual elements of an image, the greater the probability that they will be seen as a unit. This fact is of the utmost importance in photography, where the

symmetry and repetition, both of which can give an image rhythm and unity.

The Principle of Continuity

Elements in line with a minimum number of interruptions are seen as one continuous line and strongly attract the eye.

The Principle of the Closed Form

Lines and shapes are perceived more easily if they are closed, or uninterrupted, as in a circle or polygon. There are many

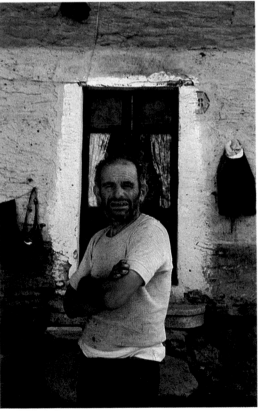

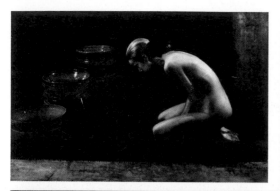

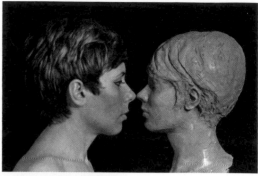

examples of this principle in the figurative arts; for example, triangular or elliptical shapes are immediately recognized in a composition and supply great balance.

Left: The closed form of the arms is the dominant element that significantly increases the effectiveness of the photograph.
Top left: An isolated figure can be seen more clearly if its tone is different from that of the background, even if the latter is complex.
Top right: The comparison between the subject and the sculpture adds interest to the image, which is reinforced by the symmetry of the shot.
Opposite: Because the soldiers are all alike, there is both continuity of line and rhythm in this image.

COMPOSITION

Composition can be defined as the way elements of an image are organized within the frame of the photograph, in accordance with rules common to the arts in general. To understand this concept more clearly, it is useful to refer to the mechanics of visual perception discussed previously. Just as sight follows a sequential order, so the photograph must have a certain internal order.

Composition: The Elements of Choice

The ability to build effective and pleasing images

In photographs of people, the rectangular format is usually preferable for reasons of composition. The vertical format is often used, as in the photograph on the facing page. The horizontal format is obviously better for a reclining figure.

is acquired gradually by learning to recognize the compositional elements of images encountered in daily life and then using the same criteria to create your own pictures.

One explanation of pictorial techniques that has proved useful and productive is the concept that a composition is made up of three basic and independent elements: (1) the *format of the area of the composition,* in other words the frame, or the lines delimiting the image; (2) the *negative space,* which is the area of the composition that does not include the subject; and (3) the *positive form,* which is composed of the subjects in the photograph, whether people or objects.

Format
The format determines the way in which the elements of the composition are arranged. A vertical rectangular format obviously lends itself better

than others to depicting the standing human figure.

The edges of the photograph are boundary lines with expressive importance. If the outline of the subject touches the edges of the frame, the effect is often very different from when just a few millimeters of space are left inside it. When the figure touches the edges, the edges limit the positive forms, whereas in the second instance they become the limits of the negative area.

Negative Space
The concept of negative space is extremely useful in the analysis and construction of an image. It interprets rationally what can often be sensed but cannot easily be explained. In essence, it says that an image is made by filling an empty (or negative) area with a subject, and that the form of this empty space itself has a great capacity for communication and ex-

pression. We do not usually think in terms of negative space, so you have to try to learn to visualize this consciously in order to use it effectively in the construction of images.

Negative space offers two particularly interesting possibilities, mentioned before but discussed in more detail here. When the outline of the subject remains entirely within the limits of the composition, the negative space has the structure of a frame bordered on its outer edge by the format. Thus it acts like a ring surrounding the subject and giving it a sense of space and isolation. But when the subject's outline touches the edges of the area of the composition at more than one point, there is no longer one whole negative area, but independent and detached shapes that provide the image with different expressive connotations. In this case the edges of the

Left: The ovals here represent the face schematically. Changing the position of the oval changes the meaning of the composition. When the rectangle cuts off the sides of the oval, the negative area is interrupted and carries less compositional weight because of its reduced area.

The photograph below illustrates what is meant by the positive form of a composition. The figure, which has a definite shape, geometry, and distribution of gray tones, emerges from the uniform background, assuming the precise meaning of the female body.

The negative area can be seen clearly in the image on the opposite page. Moving the figure in the frame would create different shapes and thus different expressive meanings.

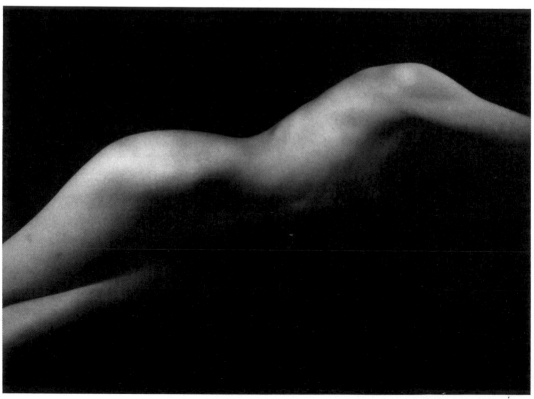

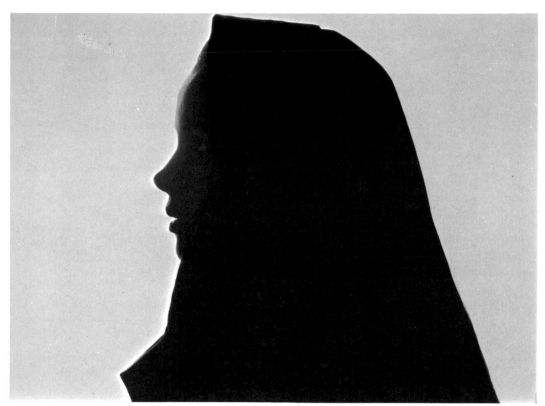

frame become the border of the subject itself, and the subject seems to be projected out of the composition.

Evaluation of negative space becomes particularly useful when a subject is framed under controlled conditions, because this is the parameter that is most easily altered, simply by changing the position of the figure within the frame. Varying its position in this way correspondingly alters the negative space and thus substantially alters the symbolic meaning of the image. See the examples of this on the facing page, produced by drawing ovals on different-colored backgrounds. A change in the position of the ovals creates vastly different symmetrical, or asymmetrical, negative space, which suggests different figurative designs. If the oval shape intersects one

edge of the frame, it loses its original shape on the side where it is cut by the border of the composition, and the negative space loses the closed form which conveyed balance and stability.

Positive Form

The third element of the composition, the positive form, is made up of the subject, the person or object in the photograph. The subject is defined by its outline and areas of shadow and highlight.

What are the visual elements to be considered in creating a correctly composed image? There is no simple answer to this question, but the following practical rules of composition represent the best compromise and serve as a guide to the construction of an image.

1. *Unity of the image.* Every image should be considered as a whole, and its elements cannot

be altered without affecting the balance of the whole. Even the smallest detail on a photograph makes a positive or negative contribution to the composition.

2. *Balance.* The elements of any photograph (lines, shapes, and colors) should be balanced physically and figuratively in order to blend effectively. An unbalanced composition can be compared to musical disharmony, which creates a sensation of uncertainty and confusion.

3. *Simplicity.* The simpler and more regular the structure of an image, the more immediate, pleasing, and easy it is to understand. It often happens that by simplifying the composition you can make a photograph more effective and expressive. In effect, any element that does not make a positive contribution to the picture should be removed so

that it does not detract from the balance of the image.

The basic elements making up the positive form of an image are the following:

Dominant lines are created by the outlines of the figures, objects, and surfaces of different tones. The eye explores the form and outline of the objects in a photograph, and the form and direction of the lines determine the dynamism and rhythm of the composition.

Dominant shapes make up the subject of the image. A face or a human figure is not normally perceived as a geometric form, but as a person with his or her own physical and psychological identity. You must develop a capacity for observing the form to be able to obtain a balanced composition. The tone and size of the dominant

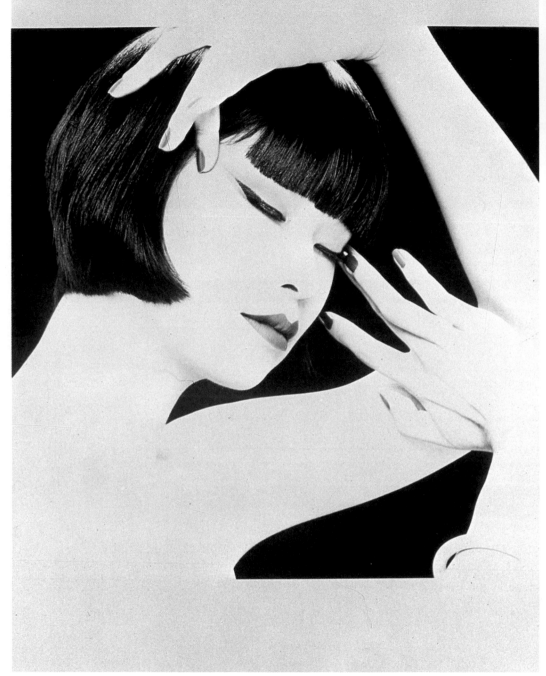

forms, together with the two other variables—the negative space and the format—determine the composition.

Color can become the most important element in the balance of a composition. Patches of intense color, even small · patches, have an extraordinary capacity for attracting the eye and changing the rhythm of the image. Harmonious juxtaposition of color can in itself be sufficient justification for a photograph. Color also influences the psychological impression of a photograph. Pictures with predominant yellow-orange tones are seen as warm, happy, and cor-

Above: Hideki Fujii presents the figure of a woman with refined taste through the harmony of the composition, which favors lines and a graphic effect, without depth.

dial, whereas those with more blue are seen as cold and uncommunicative.

Practical Rules of Composition

The following rules of composition should be a starting point for building up powerful images. Once you have mastered the use of these traditional techniques, you should no longer adhere to them blindly, but develop your own style.

The Rule of Thirds

This rule says that an image is more harmonious when the centers of interest lie close to the intersection points of imaginary vertical and horizontal lines which divide the frame into thirds. (In fact, the golden rule of ancient Greek culture recommended a ratio of 5:8, but 2:3 is close enough.) As can be seen in the drawing on page 48, the imaginary lines have four intersection points (A, B, C, D), which are the ideal positions for the centers of interest. Also, in practice the horizontal and vertical lines are effective places for dominant lines existing in the scene. Consequently, it is not a good idea to place a dominant vertical or horizontal line in the center of a photograph, because it will divide the image in half and create a static and monotonous structure. This rule does not apply, however, when you are trying to create symmetry between the two halves of the image.

An image in which color reinforces the triangular composition.

Predominance of the Subject

When there is only one dominant subject in an image, the other ele-

Linear Perspective and Viewpoint

In accordance with the rules of linear perspective, size appears in-

versely proportional to distance. In photography this is the most important means of creating a sense of space, distance,

mal viewpoint is the one of the subject in the photograph—at his or her eye level, not the photographer's—and is called the

and three-dimensionality. The effect of perspective in photography depends on two factors: the viewpoint (the position from which you observe the subject) and the distance. These are two powerful variables for altering the structure of the image and its capacity to communicate. The nor-

neutral viewpoint. From this position the viewpoint of the camera becomes that of the person looking at the image.

Another important point is the orientation of the photograph. In order for the image to be seen as horizontal or vertical, the dominant structural lines have to be parallel

ments should be arranged so that they lead the eye toward it and avoid competing with it or distracting the viewer from it. To do this, first choose the subject and then eliminate any distracting elements; then choose a background that will not disturb the positive form and the negative space of the image.

Above: In the·field of composition, the key points (A, B, C, D) lie at the intersections of lines dividing the rectangle into thirds horizontally and vertically. The photograph above, by David Hamilton, shows the classic position of the figure in a horizontal frame.
Right: The figures of the. two women are instinctively seen to be similar, even though one is twice the size of the other.

to the edges of the frame. A slanting horizon, for example, can throw the whole image out of balance. Remember also

The Rules of Dynamic Composition

A sense of dynamism and movement can be conveyed in an image by

that parallel lines converging toward infinity, such as the classic railway tracks, are accepted as a natural fact, but this is not true of converging verticals. In the traditional representation of perspective, vertical lines are always seen as such and are unconsciously compared to the sides of the image.

Above: The position of the man's arms and the controlled blur create a sense of movement. Left: An example of converging lines that are easily accepted as natural. In the photograph below, however, the perspective seems unnatural, but emphasizes the importance of the person.

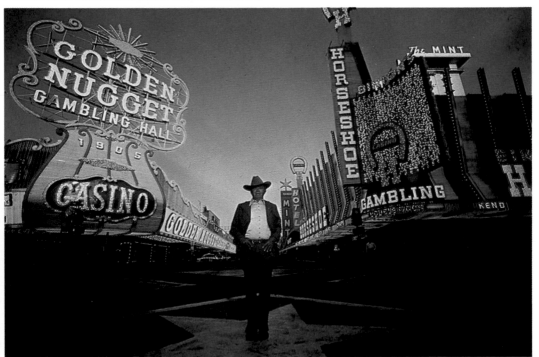

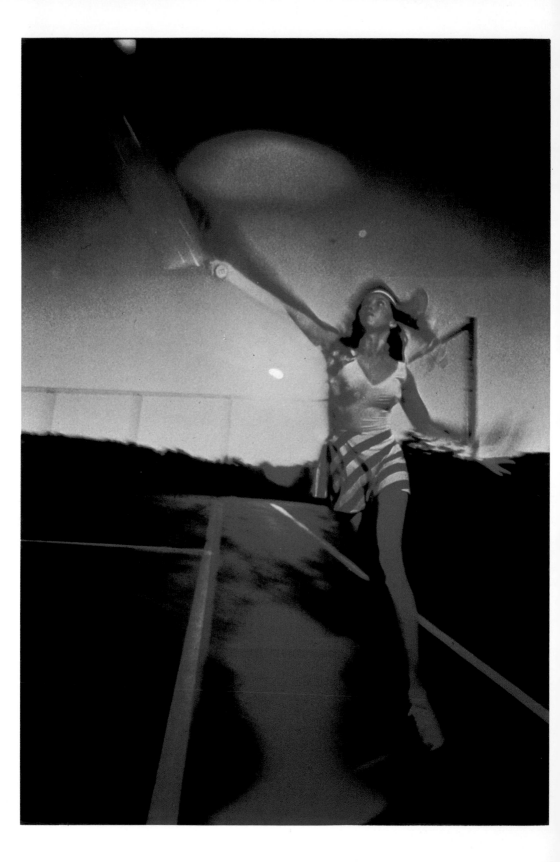

using dominant lines that run diagonally across the frame. This technique is frequently used in photographs of faces, where the image is often suitably counterbalanced by having the line of the shoulders run in the opposite direction.

Another way of conveying motion is related to the subject and its complementary negative area: when the subject is photographed in its position of maximum potential energy, the maximum dynamic effect is achieved in the photograph. Maximizing potential energy to create tension in a photograph also applies to the position of the subject in the frame. For example, the dynamic effect is often lost when the subject is too close to the edge of the frame because the subject seems drawn to the edge. Applying this rule of potential energy in a wide variety of photographic situations can add dynamism to your photographs.

Color

Color adds a further dimension to the language of photography. The main factors governing the choice of color as an element of composition are the basic concepts of *primary and complementary colors.* These are shown in the accompanying triangular diagram. At the vertices of this triangle

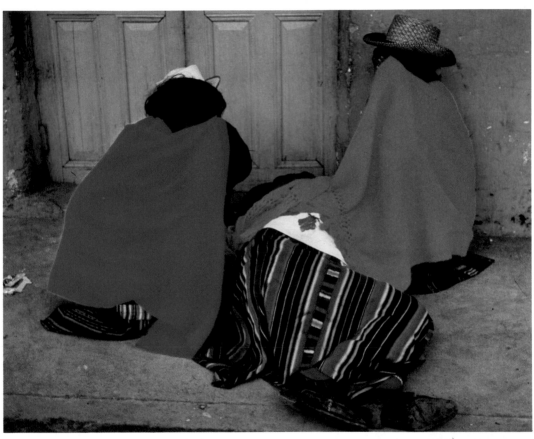

Above: Color can become the motive and justification for a photo. Right: Triangles of primary colors and color saturation.
The photograph on the facing page condenses various elements expressive of movement: the dynamic position of the arm, the controlled blur, the diagonal composition, and the accentuated perspective of the lines.

are the primary colors of blue, green, and red. The complementary colors of yellow, cyan, and magenta are opposite their corresponding primary colors and between the two primaries that combine to produce each of them. Each of the three pairs of primary and complementary colors makes up a negative-positive color system.

Another fundamental concept is that of *color*

saturation. The tonal triangle of a color represents all its shades from maximum purity, or saturation, at the top, through the lighter and darker shades to the two bottom edges, finishing with absolute black and white. It is important to understand how the shade changes by varying the saturation, for the photographer can achieve the same effect by altering the exposure. A good way to learn this is to photograph the color table and see exactly how the shades change with both under- and overexposure.

The third factor is what is known as the *psychological color temperature.* Shades from yellow to red are seen as warm colors and are associated with fire, the sun, and tanned skin. On the other hand, blue shades communicate cold, isolation, and silence; they are the colors of ice, cloudy skies, and night.

Color can be used as

an element of composition in two fundamentally different ways. Using one *dominant color* gives the photograph its color temperature. (In this case, warm colors normally prevail over cold colors next to them in the same picture.) Second, *color patches,* even small patches, contrasting with the colors of the rest of the picture can change

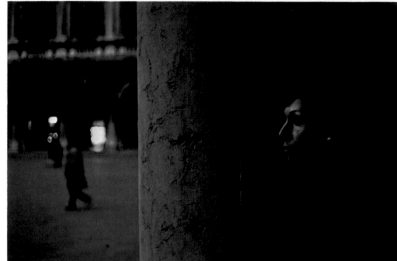

the balance of the composition.

The next important concept is that of *color contrast.* The more colors are pure and saturated and of complementary shades, the more contrast there is in their juxtaposition. In fact, pairs of colors adjacent in the color triangle are considered to be harmonious, whereas pairs of

Above: The cold tones intensify the mystery and suspense suggested by this image of silent waiting.
Below: A photograph taken by Fulvio Roiter, in which the warm orange tones of sunset predominate, presents a completely different atmosphere.

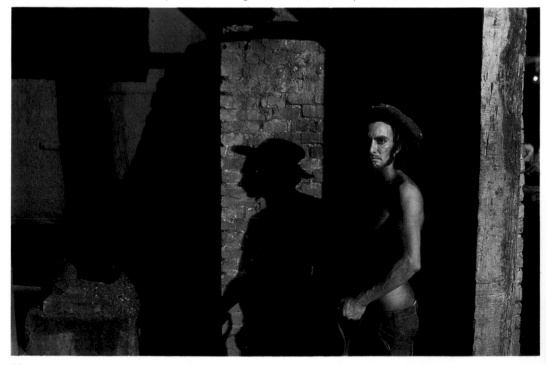

the primary colors, or complementary ones, are of high contrast.

Finally, mixed and desaturated color alters the psychological connotations of a photograph. Because of the infinite number of possible shades, color blends are as varied and numerous as musical combinations.

Left, top and bottom: Two significant examples of the expressive use of color, which is the principal feature of both photographs.
Above and below: These two photographs present similar subjects, both taken frontally. The presence of harmonizing colors certainly makes the top one more satisfying than the other.

PHOTOGRAPHY AND LANGUAGE

A photograph is an efficient means of interpersonal communication. As a visual language, every picture has a symbolic message which takes on different associations, depending on the visual culture of the viewer.

Anyone who uses photography as a means of expression is in a way competing with the other forms of communication, from the printed word to movies and television. It is therefore important to consider the language currently used in those other media, for that language is continuously evolving and is a reference to which every image is compared. You should be aware of the forms of expression associated with precise connotations which represent well-tried methods of adding color and emphasis to what you want to say. In order to be able to read the language of photography intelligently and use it effectively, you must be aware of its complexity.

Composition, seen from this point of view, is a tool for accentuating an idea that you want to express and for making it more immediate and understandable.

Confrontation consists of using two opposing concepts in the same image to underscore what is really the aim of the image itself. For example, you can find the ugly with the beautiful, order with disorder, large with small.

Comparison is the opposite of confrontation; it is the introduction of a second element to clarify the proposed concept.

Hyperbole is the intensification of the expression, the extension of the meaning by exaggeration. For example, you

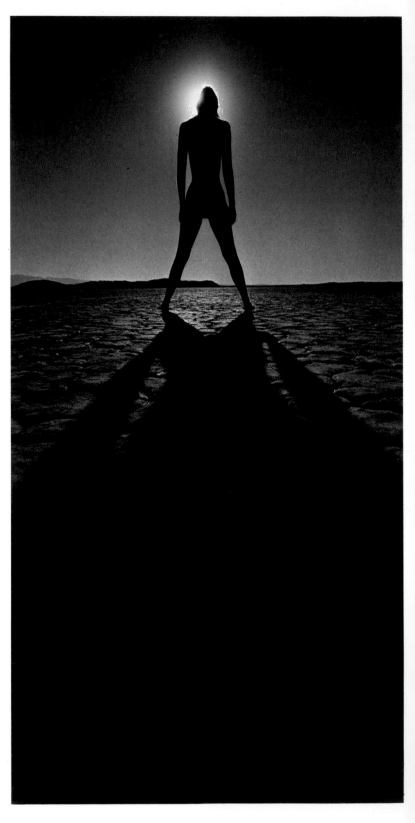

can exaggerate the human face almost to the point of caricature by using powerful wide-angle lenses, or "monumentalize" a person's stature by using a low camera angle.

Common ground includes images representing well-known ideas which have become banal and obvious but for that very reason are eas-ily accepted and understood. Typical common areas include the images used frequently in advertising, such as happy children at play or girls in stereotyped poses.

Humor is a form of observation of human reality that is generally optimistic, often has bite, and can provoke a smile. But it is not easy to capture highly expressive images that surpass the expected limits of observation when you use the special, precise, and difficult mechanism of humor.

Left: An example of contrast between the adult and the child.
Above: The humor in this photograph arises from the strident contrast of the men carrying a coffin while eating a pizza.
Below: A classic example of simile in a photograph by Franco Fontana, who creates "female landscapes."
Opposite: A simple composition based on symmetry. The very low angle of the shot exaggerates the shadow.

PHOTOGRAPHIC STYLE

Each time you decide to confront a certain theme and develop it through photography, you must ask yourself what is the purpose of the pictures you want to produce and what public you are aiming at. The answers to these two questions involve establishing a certain style of photographic narrative. Images of the same subject can be completely different, depending on the photographer's personality, the purpose of the picture, and its intended audience. The choice of background is made on cultural and ideological grounds, for each individual uses the camera to express his or her own ideas which are based on personal feelings and culture. The creative photographer should approach the subject with the intention of saying something specific in an appropriate style for predetermined aims.

Descriptive Style

The aim of the photographer using the descriptive style is to document reality objectively, impartially, and scientifically through the art of photography. The descriptive photograph is aimed at an anonymous and impersonal public that is looking for scientific or technical information. An example is the classic identity photograph, which is more than just a portrait because its only value lies in its being an exact likeness. It is a document that enables recognition of a person as others normally see him or her. The documentary style eliminates unnecessary techniques and uses normal perspective. It lists but does not interpret, refers but does not recount. The image looks

as though the camera has captured it automatically with no help from the photographer, who, in fact, may not even be involved if the subject triggers an automatic machine that records everything in front of it.

This category also includes scientific and medical photography, which is technically and expressively very difficult because the clarity and objectivity of the document can be obtained only through thorough knowledge of the subject matter and efficient use of suitable photographic techniques.

When the subject is the human form, it is always difficult to remain neutral, but you must not react to the behavior of the subject under observation or try to influence him or her in any way. It is never easy to document human reality with any degree of objectivity, however, so the best technique is to take the photograph without the subject's knowledge—but often this is not possible. Learn to make yourself as invisible as you can and comply with the subject without arousing any emotion or reaction that might falsify the meaning of the image.

Narrative Style

The aim of the narrative photograph is to tell a story, to make an observation, or to recount an episode in a human life that is considered to be worth recording. Identifying the public to whom it is directed determines the exact approach. If, for example, you are documenting the life of your own family, you can presume a family audience who know all the people and background facts.

In photographic report-

A famous portrait of Chou En-lai, taken with masterly skill by Giorgio Lotti in 1973. The prestige and power visible in his confident bearing are effectively echoed in the position of the arms and eyes, which look toward the light.

Opposite, top: A woman quietly and affectionately relives memories through photographs, now scattered on her lap, that she has kept lovingly. A very poetic image by G. P. Cavallero.
Bottom: A dramatic image by Carla Cerati which distills the solitude and despair of the life of inmates in a psychiatric hospital. This image shows a body without a face, without any hope of sharing its sorrow, in a figure that is closed in grief upon itself.

ing, you must eliminate any details from the frame that are not part of the reality you want to document. A typical example of this is a series of travel photographs in which the presence of strangers totally destroys the atmosphere. Furthermore, in photographs of this nature, you should never direct the subjects; you are recording reality to produce an authentic document. This, of course, does not deny the faculty of choice and the full application of your technical abilities.

Dramatic Style

The dramatic style differs from the narrative style more in the content of the images than in their form. Anyone confronted with a situation loaded with human drama, who overcomes emotional involvement to decide to record the events on film, bears

witness to the whole human race. As a result, no tricks or unnecessary technicalities should appear in the images. They are so full of emotive content in themselves that they have no need of emphatic composition and should be kept simple, immediate, and in a documentary style. What is more, in situations of human suffering you must show due respect for the feelings of others and respect their right to privacy.

Epic-Legendary Style

In this case the image is intended to communicate a positive, optimistic idea of the ideal person. Such images are generally destined for a wide public or even whole communities. This style is typical of portraits in which the subject is to personify some human quality such as

beauty, goodness, wisdom, intelligence, or power. The photograph becomes an instrument of propaganda and assumes symbolic connotations. Because of this, all public personalities, whether politicians or movie stars, have to be careful about the pictures they allow to be published, because those are the ones the public will remember. For decades, official portraits have served to convey images of powerful or famous celebrities to the public. Film stars in particular have been able to keep up the legendary images built up about them in the movies and carry them into their private lives by careful choice of publicity photographs. Public image is a very important factor in the success of well-known personalities, of course, but each of us also has an ideal image

on which we base our social relationships.

The photograph that creates a legend has to be clean in composition and immediately understandable even at a distance. Like a symbol, it must also inspire some emotion and convey a message to the public at which it is directed. Creating this kind of photograph is far from easy.

Lyrical-Aesthetic Style

The aim of the lyrical-aesthetic photograph is not to tell a story or create a legend about a person, but to satisfy taste and aesthetic sensitivity. If we use the comparison between narrative images and prose, this style corresponds to poetry. The photographer needs to have acquired technique and a figurative sensitivity leading to a search for form as the expression of harmony and beauty. Usually, photographs taken by skilled amateurs are in this style.

An impeccable technique in both shooting and developing combined with accurate composition are elements typical of these "salon" photographs which are skillfully created for a public of discerning colleagues and competition judges.

Any photograph in which the search for harmonious form is the principal motive can be considered to fall in this category. This type of picture is often used in advertising because its "musicality" and harmony capture attention.

Left and below: Dreamy atmospheres and diffused pastel shades characterize the images of David Hamilton, who is a master of lyrical, or more often lyrical-erotic, photographs.
Opposite: Fujii captured the grace of a Japanese woman in a dry poetic style with a clean image of abstract beauty.

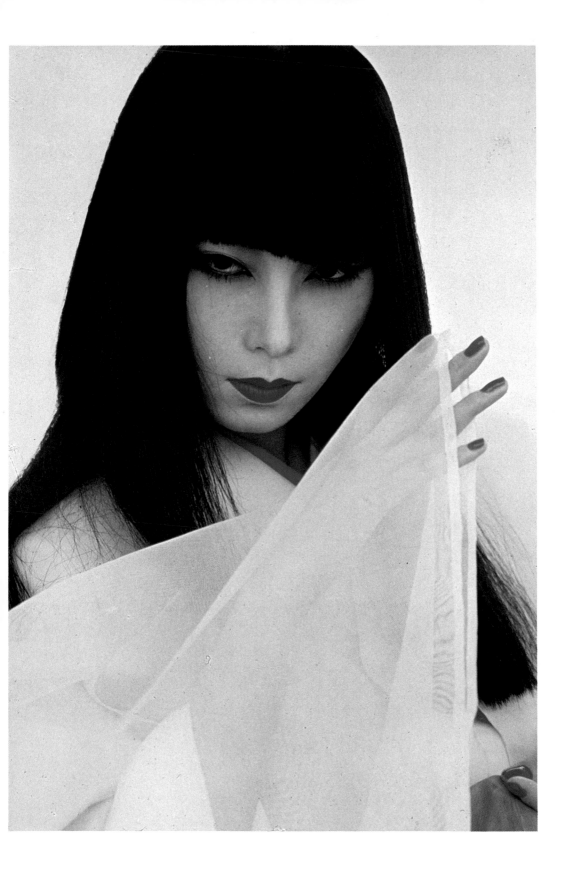

PREVISUALIZATION

Your skill as a photographer reveals itself at two points: at the creative and imaginative moment when, even for just a fraction of a second, you can imagine the photograph that you want to create, and at the technically creative moment when you use all your experience to turn an idea into reality.

Most modern cameras have simplified the technical problems of taking a photograph, but creativity is still closely linked to the photographer's skill and imagination. The ability to visualize a photograph, figures, and composition can be acquired like any other mental ability. Developing a photographer's eye means being able to visualize effectively the result of the photograph. You can increase your figurative sensitivity by carefully examining all the photographs you come across in magazines, books, on television, in exhibitions, and at the movies. Ask yourself, "Why is this picture effective? What is it that captured my attention? How was it done?" These questions make you analyze and compare different photographs, and so the exercise is an extremely useful tool for increasing your capacity to see reality. Observe your fellow humans, noting expressions and facial similarities that may have previously escaped

you altogether.

Previsualization of a photographic image must be accompanied, as already discussed, by a conscious assessment and solution of possible technical problems. Sooner or later everyone gets disappointing photographs that are nothing like the previsualized images, but this should not discourage you. The important thing is to learn from your mistakes and refine your figurative sensitivity and photographic techniques each time. The difference between a beginner and an expert often lies in the fact that the first takes photographs while trusting mainly to luck, whereas the latter tries to create an idea that already exists mentally by using the techniques that maximize the possibility of success. It is therefore easy to understand how important previsualization is.

The Frame Card

It is never very easy to see a photograph in its entirety in the mind's eye and evaluate its composition, but it can be helpful to use simple pieces of equipment that enable you to study the composition directly and evaluate its effectiveness. The simplest and most practical of these is a frame card made of two L-shaped pieces of cardboard, white on one side and black on the other.

Tape the two pieces together so that you can get any intermediate format just by adjusting their relative positions. The inner opening should not be less than 20 × 25 cm (8 × 10 inches) and the pieces should be at least 5 cm (2 inches) wide. The white side is used to frame subjects of middle to high density, and the dark side is useful for light subjects. To simulate the shooting angle of an ordinary lens, hold the card at a distance from the eye roughly equal to the diagonal of the inner opening. Bringing it a third closer gives the ef-

fect of a medium-wide-angle lens, and doubling the distance simulates the shooting area of a moderate telephoto lens. This card is also useful for examining the composition of prints or transparencies projected onto a screen. Special accessories used by movie directors are also available for studying an image. They are made up of a lens system similar to a zoom, look like a telescope, and allow you to vary the angle of the field. Another obvious alternative is to use the camera itself, though this gives less immediate results.

Above: The frame card helps you previsualize the frame in a studio.
The two photographs on the left show two different ways of framing the same subject. The search for the best frame is essential in photography.
Opposite: The expressiveness of the face and the gestures can dominate all other formal and aesthetic elements of a photograph.

HOW TO ANALYZE THE COMPOSITION OF A PORTRAIT

A good way to analyze the structure of a portrait is to examine it carefully upside down. This makes it easier to grasp the purely compositional aspects of the image, because dominant forms and lines, the structure of the negative area, and shadows and shapes show up more clearly. When the eye is forced to observe an image in a way to which it is not accustomed, it must analyze it as if it were an abstract figure made up of grays, highlights, shadows, and masses. Because of this, looking at a portrait upside down reveals any asymmetrical, doubtful, or imbalanced areas that might otherwise go unnoticed.

You can apply this kind of analysis effectively to portraits of figures in settings, but particularly to the nude as a formal study, for in this kind of image, composition and forms are of primary importance.

PHOTOGRAPHS OF THE HUMAN FORM

The portrait, once a privilege reserved for officially depicting the famous and powerful, has now been popularized through photography. Paintings used to be idealized representations, more symbolic than realistic, and the only way images could be passed down to posterity. Nowadays, though, photography is a simple, fast, and versatile way of capturing various kinds of pictures in all types of lighting conditions, requiring only a minimum amount of effort to master the essential techniques.

The Portrait

The term *portrait* is used here to mean any kind of representation of the human form; the subject is not limited to photographs of faces, but includes the figure in a much wider sense in varied surroundings. These photographs describe the traditions and environment of the subject from which he or she cannot be isolated without losing elements essential to an understanding of personality and culture. Photographs of people are different from all other types of photography by virtue of the unique and never-to-be-repeated quality of the moment. They capture the person's life in a particular place at a given time. No other picture will ever be the same, so the photograph will remain a unique creation, testifying to a moment that has been preserved for eternity. Photographing other people implies human interaction, and an attempt to capture the emotions and impressions of the people with a view to giving them an eternal quality. In this way, photography becomes an opportunity for an en-

counter between two people, the photographer and the subject.

People Watching

The infinite variety of customs and traditions of different peoples provides an endless source of photographs documenting human communities and the products of their cultures. Another vast field of exploration is the individual whose coded and interpreted expressions and gestures illuminate our self-knowledge and the meaning of the thousands of actions we

do unconsciously every day.

It is essential for the photographer to develop a capacity for observing and analyzing body language and understanding its implicit signals, for these hidden and silent signals are the first to come across in photographs. As a result, you must become an observer of people. Study their expressions, habits, and the most basic gestures that would not normally attract attention.

We are all human observers to a certain ex-

tent, as we all use body language unconsciously to pick up the moods of those we live with. This is the natural sensitivity we need to develop, so a positive attitude with genuine interest in others can make anyone into an attentive observer of human behavior. All people have their own stories, their own personalities; you can try to work out what they are from a distance while waiting for a bus or walking through a crowd.

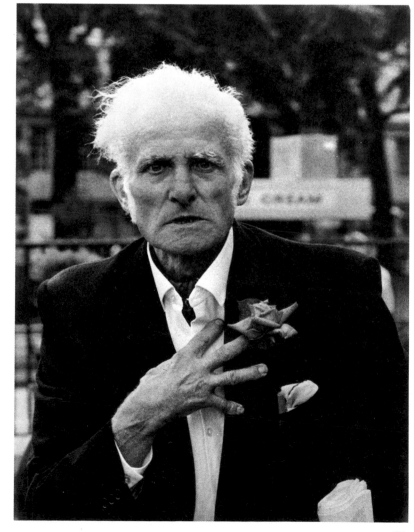

BODY LANGUAGE

In creating a photographic portrait, you encounter three different types of problem. There are the technical problems of taking the shot, which are constantly becoming simpler with the proliferation of improved automatic mechanisms; the aesthetic problems of composition, which can be mastered quite easily; and the problems of interpreting body language, which is first shown in the expressions of the face and is thus the decisive • factor in the final analysis. A technically faultless photograph with elegant composition but a completely false expression distorts the message of the image.

Knowing how to see is the key to knowing how to take a photograph, from both the formal and the psychological point of view. Because the elements of nonverbal body language communicate specific information about the subject, independent of photographic and aesthetic considerations, intuition is a great gift to any photographer who wants to focus on the human form and interpret someone's personality. The photographer needs to be like a fisherman, knowing where to cast the line, understanding the prey, and being able to wait for the right moment, prepared for all eventualities. Moving just a fraction of a second too soon or too late can mean a lost opportunity. Everything around us speaks volumes about ourselves—

The Full Figure

Certain details of the whole body are usually immediately noticeable. *Clothing* is a vast and complex area of nonverbal communication in its own right (you need only remember how accurately an expert can date a photograph purely on the basis of the clothes). *Physical features* such as stature and body structure have precise associations. *Motor features*—a way of walking, moving, and the rhythm and elasticity of the

not only our faces, but also the way we talk and dress, and above all our complex gestures and expressions. A good actor can change his personality just by altering a few gestures and expressions; let us point out some of the essential features of body language which are clues to the personalities of those around us.

Above and left: The hands have an extraordinarily expressive capacity. Attitudes, gestures, and positions usually communicate the state of mind and human situation in a precise and unequivocal way.

Opposite: This famous photograph is by Christa Peters.

step—can convey lightness or heaviness, elegance or clumsiness. The *attitudes of the body* in relation to other people, such as a stiff or relaxed stance, leaning toward one person rather than another, can convey shyness or confidence, like or dislike, and other attitudes. From these features you can often guess the character, social status, and culture of a person, even without exchanging a word. Despite habits ingrained in us by our education and culture, our public image reveals a lot about us: there are always unconscious attitudes that enable others to sense our temperament and mood.

The Hands

The hands have a dual importance for the photographer. They constitute an effective element of the composition, providing it with a more balanced structure. But they are also an element of expression; their appearance and position can contribute to the description of the subject's personality. The hand, a symbol of action and work, reveals a lot about character. It also has great potential for expression through the "codified" gestures which we understand immediately, and so they have an extraordinary capacity for communication, though the meanings of their gestures may differ from culture to culture. Remember that gestures and facial expressions in a photograph have a much stronger meaning than when seen live, for precise psychological reasons. The gesture is a dynamic signal made up of a series of successive movements that take place with such speed that the whole effect is tempered.

The Face

The face is an extraordinary means of continuous and complex communication expressed in two ways: first, through the physical features, the facial lines that make up the fixed characteristics of the subject; and second, through its expressive potential, which lies in its mobility and capacity for sending out nonverbal signals. Capturing the right expression is the key to the success of a portrait, so it is useful to analyze the essential elements that compose expressions and their more interesting meanings. The generalizations and mechanisms described on the following pages are obviously only a guide, to point out the importance of body signals and describe the more meaningful; they provide useful points of reference in the interpretation of modern techniques of portraiture.

In addition, there is no movement in a photograph, though in many expressions it is the movement itself that is the key to understanding. You must visualize the image carefully and freeze it mentally to decide both the instant in which to take the shot and its formal aspect. Because of this, a motor-driven camera can be an advantage in studies of facial gestures and expressions.

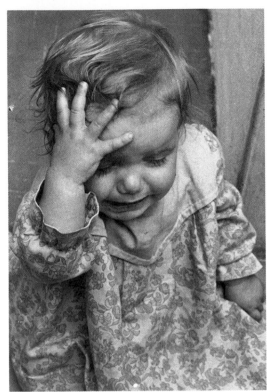

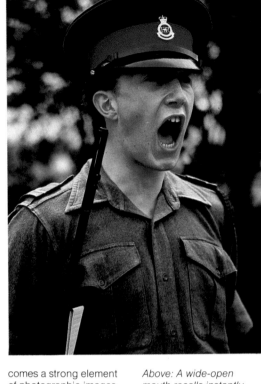

Facial Expressions

The complexity of facial expressions and the speed with which a face can change is quite astonishing. The most common expressions can be classified as sad or negative, serious or neutral, and smiling or positive. Other expressions, which are usually less interesting photographically, are represented by unusual states of excitement such as a smile, tears, or anger, which can alter or even distort the face to a certain extent, giving it the appearance of a mask because of the violence of the gesture captured.

The only subjects who can be photographed at any time with any kind of expression are children, for whom tears and laughter are spontaneous ways of expressing vitality and reacting to the world, unconditioned by social convention.

Eye Contact

Eye contact conveys attention centered on the person you are talking to, and an invasion of private "territory." In everyday social relationships, eye contact is limited to intermittent exchanges of looks that are often intended to express reciprocal friendship and show that you are paying attention and intend to reply. A look that is too intense, however, becomes an intrusion, motivated by either attraction or repulsion. We accept eye contact in a photograph the same way we do in reality: a person with a direct and intense look seems to be wanting to say something to us, whereas if the eyes are lowered, we accept it as a sign of shyness and an attempt to avoid contact. Because of its great psychological importance, the direction in which the eyes are looking be-

comes a strong element of photographic images.

The Pupils

Various researchers have discovered that whenever you look at something that is particularly attractive or interesting, your pupils dilate spontaneously. A portrait showing dilated pupils conveys greater human warmth and a subconscious availability, probably related to the greater ease of making eye contact.

Above: A wide-open mouth recalls instantly the bark of a military command. Above left: Children are marvelous subjects to photograph. Below: The eyes are a very important personal element, even in photographs, so their "absence" cuts off all communication. Opposite: The direct look and the wide, serious eyes of this little Nepalese girl strike you immediately.

A serious face is also often richer in psychological undertones and has the advantage that an observer does not tire of it as quickly because it has the neutral, almost statuesque attitude of a classical portrait. The eyes become the exclusive fulcrum of the expression, and the look on the subject's face is the dominant element, and so should be carefully examined. In general, a serious portrait suggests the social status of a subject—authority, confidence, and intelligence. Depending on the different tradition and culture involved, however, a serious expression can be considered normal; or, if the open and positive smile is more common, it may communicate detachment, firmness, and thoughtfulness.

The Social Mask
The face that an individual presents to neighbors during social contact becomes his or her public image and as such follows certain rules designed to improve or simplify social relationships. Self-control and imperturbability, courtesy and mutual respect, are the principles that govern social attitudes toward those who do not enter the private circle of friends but are inevitable social contacts. Under these circumstances, the face assumes certain characteristic expressions which, whether

Left: The poet Ezra Pound, photographed by Lionello Fabbri.
Below: An intense look, skillfully caught, contrasts with the poster image.
Opposite: The sad expression on the face of an adolescent caught up in the drama of the refugees from the Spanish Civil War, taken by Robert Capa.

Eyebrows
The eyebrows make a significant contribution to many facial expressions, because they make movements that are sometimes deliberate and at other times automatically connected to the position of the eyes and mouth. One characteristic signal is a quick raising of the eyebrows as a sign of greeting or recognition. Arching the eyebrows and opening the eyes wide denote surprise, whereas drawing the eyebrows in, or furrowing the brow, reveals intense activity of the mind or mental preoccupation.

Serious Faces
A serious face expresses neutrality, calm, and reflection. The face becomes the dominant feature; there is no obvious expression of the state of mind, so other elements become more important and are unconsciously scrutinized to decipher the personality of the individual. A face that is basically serious is associated with mental activity, because when you concentrate on a particularly demanding problem all expressions, whether smiles or tears, are automatically erased from the face. It is almost as if the brain, being employed on much more serious matters, ceases any other conscious occupation to focus its energy on one single subject. At the same time, however, other automatic and often completely unconscious gestures are no longer under control and manifest themselves involuntarily, like frowning, playing with the hair, or sticking out the tongue.

smiling or serious, constitute a true mask that slips only very rarely to reveal the real state of mind—enthusiasm, happiness, discomfort, or sadness, whatever may be the case. The smile is most commonly used to defend privacy; it is also the oil that lubricates the social machine and makes the enforced co-existence typical of large urban areas more fluid and bearable. It has also become a discreet and welcome signal of greeting and recognition which can take on an infinite variety of meanings, depending on circumstances and tradition.

Sad Faces

Being depressed, irritated, or worried is not uncommon, but photographs showing these expressions are. Either subjects are careful not to be photographed under these conditions, or no one like images that record the more unhappy moments of life. The typical features of a sad face are half-closed eyes, furrowed brows, lack of eye contact, and a turned-down mouth, forming the classic ''long face.'' Usually people in these circumstances publicly assume a neutral mask to prevent involving strangers in their personal sadness. A sad expression can even become comic by psychological contrast when it is obviously unjustified, as, for example, on an identity photograph, or if the effect is out of proportion to the gravity of the irritation.

The Smile

The smile is perhaps the most common expression in relationships; it is certainly common in photographs of the human face. The habit of smiling

is acquired from the environment, so its meaning differs in different cultures. Interpreting the meaning of a smile correctly is not always easy; it can express an infinite variety of feelings and signals—amusement or physical pleasure, friendliness or scorn, confidence or doubt, anxiety or surprise. Remember also that the intensity of the signal in a photograph is due to the fact that a fleeting expression has been captured; in reality other parameters such as the length and dynamism of the smile are just as important.

The simple smile. The corners of the mouth are lifted to give the mouth its characteristic crescent shape, perhaps revealing the top teeth. This cordial and spontaneous smile is the most common type and reveals a state of calm and well-being. It accompanies every form of sincere greeting or moderate amusement.

The open smile. The lips open to reveal part of both sets of teeth, creating an intense and spontaneous expression of great pleasure or amusement which can even border on true laughter. The eyes open and the eyebrows raised, suggesting pleasant surprise, typical of funny situations such as when you are involved in games or jovial company. Because this is a brief and spontaneous reaction, it is very difficult to falsify. It is not very successful in photographs, however, because it tends to look like a mask of optimism more than the representation of a person. It is found, however, in press or news photographs taken with a flash.

The half smile. The lips turn upward, showing the upper but never the lower teeth. This is the typical convenience smile, the cool, automatic signal of greeting that does not involve the person in any way and so is the most easily affected. It is well known to photographers because it is usually the subject's first awkward attempt to satisfy the traditional request to "smile." It is often seen in identity photographs where any sort of smile will do. A sure way of telling whether a smile is sincere or not is to look for the small swelling under the eyes that can only be produced involuntarily by the muscles contracting under the stimulus of genuine amusement or satisfaction.

The challenging smile. The lower teeth are re-vealed more than the upper teeth and the eyes look tense. This spontaneous reaction has two sides to it: one is the aggression revealed by "baring the teeth," and the other is the acceptance of a challenge indicated by the tense look and smile. It can be seen on the faces of youngsters in competitive

games and on adults tensed for sports.

The smile of wonder. This is similar to the half smile but is a spontaneous variation reinforced by the curling of the lower lip onto the teeth and a raising of the eyebrows. It reveals surprise or doubt.

The suppressed smile. The lips are pressed against each other to form a thin line, indicating a state of complicity and shared amusement deliberately hidden from others. It is commonly found on the faces of children playing games, when they turn their heads and try to hide their faces from the others.

*Above and right: You can capture countless fascinating and spontaneous expressions rich in freshness and vitality on the faces of children.
Opposite: Gisele Freund photographed a bright smile on the face of the writer and educator Ivan Illich with great human intuition.*

MOTIVATION AND PHOTOGRAPHIC STYLE

Whenever you point your camera at someone, you always have some precise reason for doing so, whether conscious or not. You must understand why you are about to take the shot if you are to decide on the most logical technique and the surest approach to achieving the desired image. If the reason is not clear, the style and the composition of the photograph will probably be confused and ineffective.

The key to lively, effective photographs lies in having clear ideas of what you want to say. What is it about the person that strikes you? Facial beauty? A pleasant expression? In fact there is always some personal observation or feeling behind every photograph; you want to bring out an amusing expression, a statuesque posture, a tender look. It is impossible to tell several different stories in one single photograph and capture the full personality of the subject. You must choose and decide precisely what to capture and what to save for another picture. Once you have decided on the aim of the photograph, stick to it in order to produce the most effective image.

The meaning of a photograph does not depend on just the sensitivity of the photographer; both the message and the style of the image depend largely on the destination of the photograph itself. For example, two photographs of the same girl will have completely different styles if one is destined for a beauty competition and the other is meant to be a souvenir for her parents. In many cases the functional aspect of the photograph

takes the upper hand, and this is a fundamental concept in portraiture.

Let us have a brief look at three different categories of portrait. First, consider a portrait taken by the amateur for personal pleasure. Its function is purely expressive of the photographer's figurative sensitivity; he or she decides the content and the style of the image and is free to experiment with new techniques without external restrictions. This is the most purely creative sphere of photography, even for professionals.

The second category includes portraits taken at the request of the subject, which is the reason for professional portraiture. What does the subject really expect from

the portrait? Almost without exception, the picture is supposed to reveal the person's positive side to confirm and enhance his or her self-esteem and

public image. The photographer's task in this case is quite demanding, because the standards of each subject can be radically different. In fact, their image of themselves is often not very ''photographic,'' but more, shall we say, their self-impression reflected in the reactions and judgments of others. Anyone who undertakes to take a photograph of a friend or client has the job of creating a satisfying image, removing facial imperfections, and capturing the person's most photogenic side. The power and skill of the photographer therefore lie virtually in the ability to depict any subject as interesting or unpleasant, elegant or gauche. Even the most famous models

can be made to look ungainly if the right moment is frozen in the right light. A photographer can strike fear into the heart of a subject, for he or she can destroy a person's self-image through a photograph that reveals an unpleasant side. Even if the photographer is convinced of having done a good job, the ultimate judge of a photograph is the subject, so it is always advisable not to be too sure of the results until you have seen the test shots. Often subjects coldly and politely lay the blame in these cases not so much on the photographer as on themselves for not having been in good form when the shots were taken.

The third category is photographs taken at the request of someone other than the subject. Examples are press, publicity, and scientific photographs that are functional and designed to convey information, arouse emotion, or record faces. A photographer who tackles this difficult area of communication must know how to express himself or herself and use the proper techniques. It is the recipients of these photographs who determine their messages, though the photographer does have a certain degree of freedom in choosing the approach and the style. The success of a picture is determined on a purely functional basis, but in the constant search for more effective modes of expression the professional photographer can often surpass the original commercial requirements to produce authentic artistic expression.

Above: A formal portrait of the writer Alcide Paolini, by Marzia Malli. Opposite: A suggestive, theatrical portrait by Hideki Fujii.

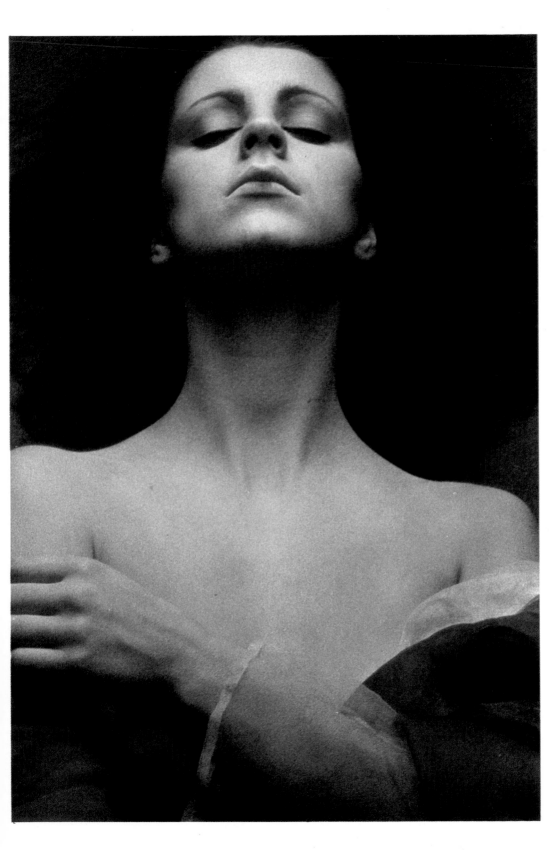

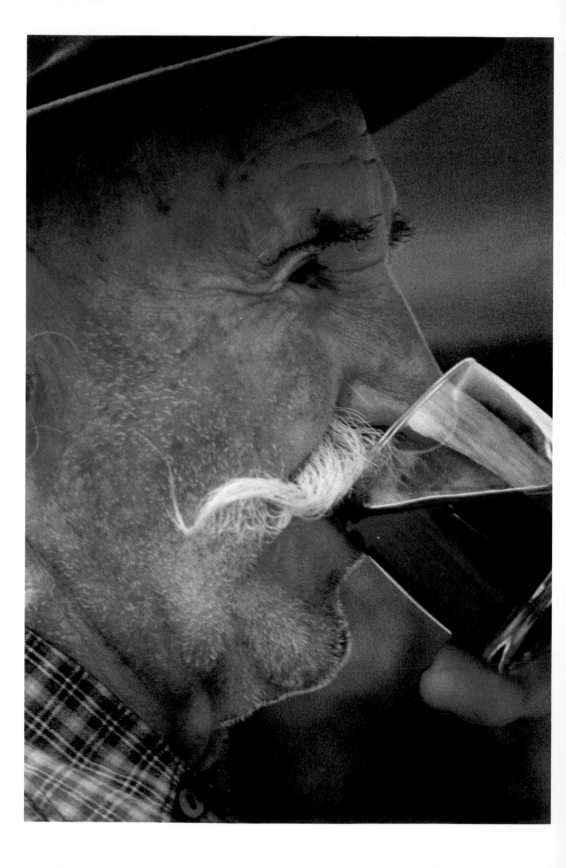

THE MEANING OF THE FRAME IN A PORTRAIT

The portrait assumes different meaning and requires different techniques according to how much of the human figure appears in the frame, so it is useful to understand the significance of these fundamental choices in composition.

The Extreme Close-up

When the face fills the whole frame, vertical composition is essential. This kind of framing is not commonly used, because it really puts a face to the test, emphasizing both the features and the expression. You must minimize skin imperfections if they are not specifically required for the shot. A face in extreme close-up loses all sense of location, for it receives no information from background or clothing. This kind of framing is useful when you want to isolate the face from its surroundings and remove it from the context in which it is photographed.

The shooting distance for the extreme close-up should never be less than 1.5 meters (5 feet) to avoid distorting perspective. As a result, a 135mm or even longer telephoto lens becomes necessary.

The Close-up

The close-up is the most common type of portrait, corresponding to the classic head and shoulders of the identity-photograph format. In this type of shot, the

When only the face of a subject appears in the frame (opposite), it is an extreme close-up. A close-up (below) includes the shoulders.

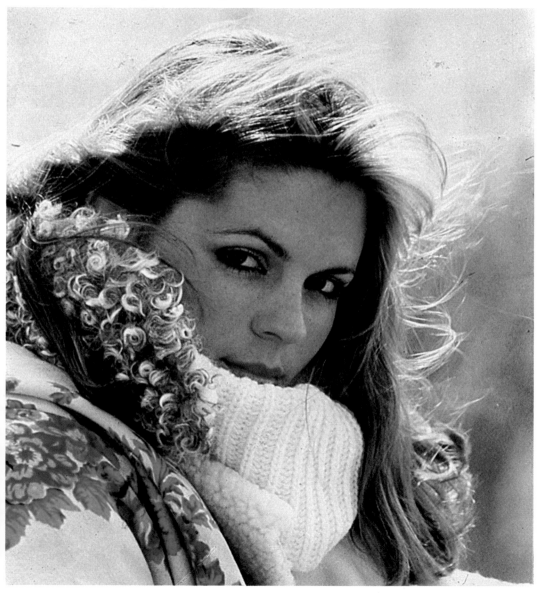

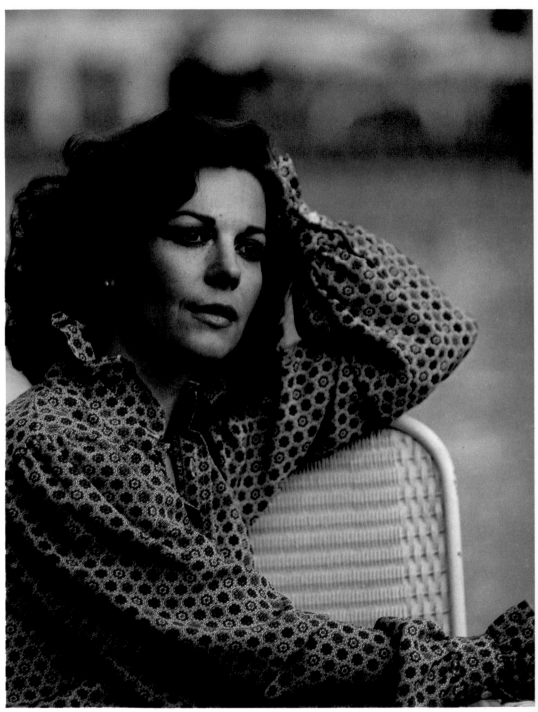

composition can be either vertical or horizontal, because the geometric arrangement of the head, neck, and shoulders has both vertical and horizontal elements. The shoulders have an important expressive function, because they reveal the position of the body and its attitude relative to the camera. The position of the head determines the balance of the composition: if it is high in the frame, the figure acquires importance and stability. Other important elements in the image are the clothing, which identifies *A medium shot, where the figure is cut off at the waist. The photograph opposite is an example of the American shot—the medium long shot—with the figure cut off at knees.*

The Medium Shot

The subject in a medium shot is photographed from about the waist upward in a frame corresponding to the highly classical structure of the portrait in a background setting, as in the style of paintings. Vertical composition, centering on the chest, is preferable. This type of portrait, compared to the close-up, includes the traditional expressive elements of the arms and particularly the hands, whose position is decisive for the expression of the portrait, given the great variety of meanings that can be expressed through gestures. The position of the whole body can also be deduced from that of the trunk and arms. In all, powerful body language comes into play, revealing either the spontaneity or the artificiality of the pose.

The compositional structure communicates even more through the background and, by extension, the setting, which together with the clothing assume much greater significance. Triangular composition is often found; the hands find their own natural position to create a closed structure and give the portrait stability and harmony.

The shooting distance in this type of picture should be about the same as for a close-up—1.3 meters (4¼ feet)—but shorter-focal-length lenses can be used with angles of view of 45 to 30 degrees.

The American Shot (Medium Long Shot)

This composition, a frame of the body taken from above knee level, is so called because it is widely used in American movies. In films only a horizontal

the subject's social standing; and the background, which places the subject in an environment and plays an important compositional role. The negative area in the

close-up is broken up and open, so the subject is dominant.

The minimum shooting distance for this type of frame should never be less than about 1.3

meters (4¼ feet). The most common focal lengths for the 35mm camera range from 80mm to 135mm, corresponding to shot angles from 20 to 30 degrees.

format can be used, so the full figure would be too distant to create an intense presence or permit a clear understanding of the actor's expression. The medium long shot proves to be a good compromise, allowing sufficient contact with the spectator while setting the actor fully in the scene.

The Long Shot

In the long shot the full figure appears in the frame and becomes part of the whole scene while remaining the center of interest. The elements that began to come into play in the close-up—the background and clothing—have much more importance in the long shot, so there are many more sources of information and signals to help identify the subject's attitude, culture, and environment. The negative area becomes a closed form, complementing the figure. By the principles of association of mean-

ing, the elements in the setting become connected with the subject, so the background should be chosen very carefully and a lot of thought given to what would create a unified meaning. Anything that does not belong in the picture should be removed.

Full-length portraits

cover two situations. In the first of these, the subject is photographed in the environment where he or she lives, so the surroundings are naturally connected and descriptive and indicate the person's social standing. In the second, the person is photographed in a vague setting against a neutral background,

The portraits on this page, set in detailed backgrounds, demonstrate that the environment has a precise expressive function. It completes the description of the subjects and their social status. The plain background of the photograph opposite, however, contributes no information.

which can be either a neutral-colored screen or a studio backcloth. The background may even be out of focus in order to isolate the subject.

The full human form in an environmental setting also has different connotations from those of a close-up. The aspect of individuality is reduced, and the collective aspect of social and human status with which the subject is associated or the activity in which he or she is engaged becomes much stronger. That is to say, the symbol outweighs the individual. Photographs describing a person's life, work, traditions, and skills are examples.

Both telephoto and wide-angle lenses can be used to photograph the full human form, but they produce different results. The most commonly used wide-angle lenses are 35mm and 28mm, which provide good perspective in all kinds of shooting conditions and relate the subject and environment in a balanced way to convey a sense of closeness and participation. Using a telephoto lens, on the other hand, results in a colder and more detached view, more suitable for underlining action rather than a subject's personality and for concentrating more on the subject than the environment through selective focusing.

Groups

When more than one person is framed in a shot, the interaction between them is more important than the expression of each individual if there is any justification for their having been grouped together. As a result, the problems increase geometrically if the subjects are given equal importance. In fact, two different situations arise: in the

first, there is only one effective protagonist in the picture, set against a background of others who have secondary importance (extras, to use the film term); in the other, all the subjects are equally important, so the group itself becomes the sole subject of the shot.

Photographs in the first category can be defined as "figure in a group"; they have one center of interest, so all the points discussed for individuals apply; the other people in the picture, although they are important elements in conveying the whole group photograph. In both cases you need to determine how many protagonists there are, who they are, and what the message of the photograph is. You will find, in

message, form part of the background as a human setting.

When more than one person is the protagonist of an image, however, it is correctly termed a

The photographs on this page demonstrate a main protagonist with extras. Opposite: The common element of the group becomes the subject of the image.

fact, that as in films, there cannot be too many protagonists in the same picture; it seems that when there are more than three people in a group, the group itself becomes

stadium, surgeons in an operating theater, farmers sowing seed, or soldiers in battle, the attitude of the group as a whole determines the message.

the subject and the people lose some of their individual identity, becoming more symbolic and therefore general. For example, in photographs of sports fans in a

Large Groups

The rules of composition exploit geometrical forms to unify large groups. The closeness of the individuals to each other and the continuity of the

structure determine the structure. Straight or curved lines, closed and open shapes, can all convey the idea of a group, though with different graphic impact, and can create an overall impression of rigidity or mobility.

The viewpoint for such photographs is usually higher than normal, making it easier to compose the picture by photographing the group panoramically and thus reducing the problems of depth of field. This type of shot also benefits from the use of wide-angle lenses, which allow

Above: An example of a large group taken in spontaneous positions with no forced poses.
Left: A simple but famous image by M. Giacomelli, who has skillfully translated a carefree, dynamic moment shared by these young seminarians into the language of photography.
Opposite: A closed composition formed by a group of four people around a table.

close-distance shots. From a distance, on the other hand, a telephoto lens compresses the perspective and emphasizes the geometric arrangement of the group. Typical examples of this type are shots of soldiers on parade in lines.

Groups of Two

The combination of two people in the same photograph always has to be justified both graphically and psychologically; the very fact of associating two people in one picture suggests a discussion or correlation between them. The eyes are the line of force that unites or separates the two; they are the means of creating unity and making the image warmer and more vibrant. Two figures in a rectangle constitute a difficult compositional structure that does not use the available space harmoniously, so it is generally wise to avoid a picture with two subjects in line vertically or horizontally. In practice you can decide whether to play up the symmetry of a mirror-image type or emphasize one subject more than the other, or even whether to introduce a third element to create a triangular structure.

Groups of Three

A group of three people creates a structure that is quite common, valid, and stable: the triangle. It is therefore quite easy to compose the image, if you bear in mind that you can add vitality by varying the importance of the three subjects to create a preferential order of observation. The classic mother-father-child triangle, for example, has a strong compositional element in the bond between the two parents and that with the child, who carries a different

weight in the image, either more or less, depending on the circumstances.

The group of three seems to be the largest unit that preserves a sense of individuality while conveying discourse and unity between the persons depicted. The result of this type of grouping, however, is that problems are tripled: each of the three people has to cooperate to make the image a success, and it is certainly not easy to keep your eye on three people at the same time to capture that common magic moment.

Groups of Four or More

When there are four people in the group, the composition tends to be identified with the stable, closed form of the square, whereas larger groups are seen as units. A linear arrangement creates the sensation of monotony and military order, whereas closed arrangements convey a sense of collaboration and discourse among the individuals.

One way of handling this type of composition is to break it up into smaller groups. For example, you can separate one of a group of four from the rest and give

that person priority, thus simplifying the composition. Photographing a group without settling for stereotyped images is never easy. You need luck and intuition to produce valid, meaningful images.

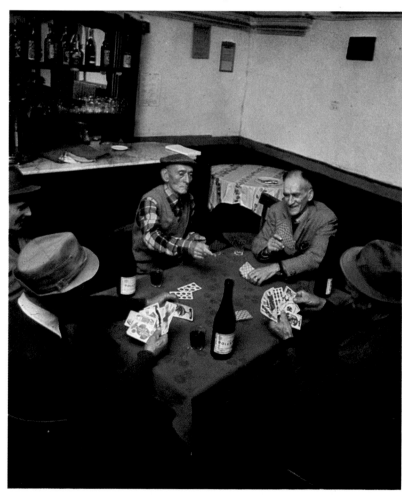

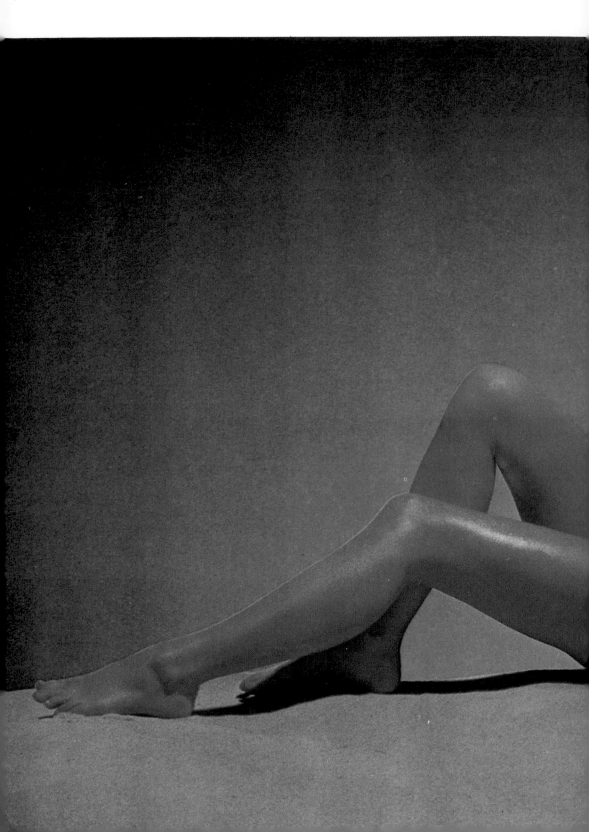

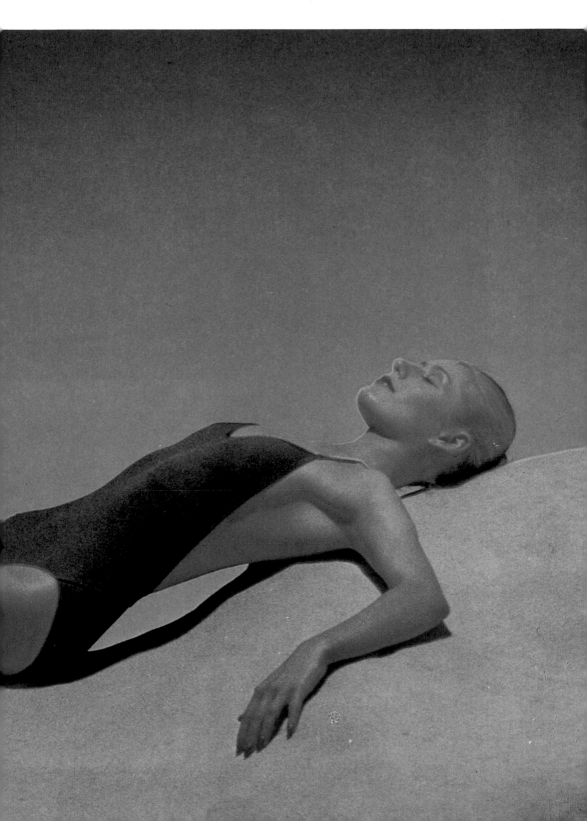

THE SUBJECT AND LIGHT

Shooting techniques used in portraiture are very different from others and are essentially based on two variables: the availability of the subject and the lighting conditions. The first is in effect the strictly limiting factor. The accompanying diagram shows the two categories of shooting techniques; the first uses methods similar to those employed in nature and wildlife photography. Working in this way, the photographer must adapt to the lighting conditions around the subject; available lighting cannot be controlled. These are the characteristic conditions of photojournalism in existing or ambient light (light available at the location), whether natural or artificial.

If the subject is aware of the photographer and more or less consents to the photograph, it is possible to control the lighting a bit, if necessary, by using simple portable systems such as electronic flash or small reflector screens. Nevertheless, both cases fall into the category of "on location" photography with limited time and means. Classic examples of this are outdoor or indoor shots taken with light and portable equipment on travels.

The second category is studio portraiture, in which the photograph can be taken under fully controlled conditions, with the possibility of

Below: A man alone in the cold, alienating architecture of the city. The juxtaposition of harmonizing colors creates a sudden, unexpected consonance, similar to that of distant music, where the human figure is absolutely essential. The photographer, Al Satterwhite, has skillfully and shrewdly made the most of the existing light.
Bottom: A logical arrangement of portrait techniques.

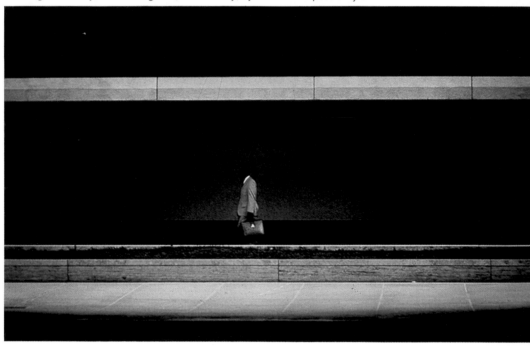

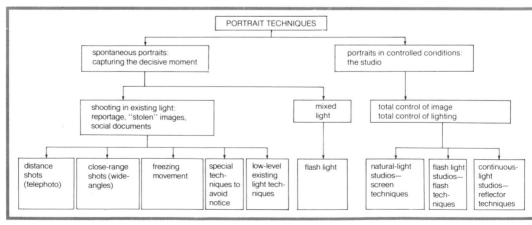

PORTRAIT TECHNIQUES								
spontaneous portraits: capturing the decisive moment						portraits in controlled conditions: the studio		
shooting in existing light: reportage, "stolen" images, social documents					mixed light	total control of image total control of lighting		
distance shots (telephoto)	close-range shots (wide-angles)	freezing movement	special techniques to avoid notice	low-level existing light techniques	flash light	natural-light studios— screen techniques	flash light studios— flash techniques	continuous-light studios— reflector techniques

building up the image by manipulating lighting and the tonal scale.

The Advantages and Limitations of Ambient Light

To use ambient light effectively, you must know how to evaluate lighting conditions. Intuition and timing are the essential qualities of the action photographer, who often chooses black-and-white film in order to have more control over the image after exposure.

Ambient light offers some quite important advantages. You can often re-create natural and suggestive atmospheres that are difficult to obtain in artificial light. It is also good for portraits in many cases because its direction and quality often favor this style. There is only one fundamentally negative aspect to daylight: the contrast in most conditions tends to be too high for faithful reproduction on film, particularly color film.

Equipment for outdoor photography must be versatile and manageable to enable you to take portraits quickly and unobtrusively. Fast or medium-speed films and relatively fast lenses allow you to work to the limit of the technical possibilities.

The Shot

The three aspects that determine the success of a portrait are psychological, aesthetic, and technical. The diagram below clearly shows the logical process behind a shot, from the moment when, having observed the subject, you decide to take a picture (which already implies a rough mental previsualization of the desired image) right up to the moment of exposure.

Depending on the available equipment and the viewpoint, it is possible to frame the subject physically in different ways with different methods. For example, if your camera is a fixed-lens automatic, your choice is limited to framing and viewpoint; all the other variables shown in the blue box are fixed or automatically set. If you are using a reflex camera, however, you have more flexibility and can change the lens to achieve a more effective frame. Furthermore, you set the photographic parameters of exposure and focus.

The blue box contains the basic technical choices: exposure is connected to depth of field by the common feature of the aperture, and exposure time is a function of the subject's movement.

The photograph produced will be more successful the closer it gets to the desired image (the previsualized image), and although it is possible for it to be even better, the opposite is usually true.

Focus and Depth of Field

The choice of focusing plane is very important; the sharp area of the image is what attracts the observer's attention, so it must coincide with what the photographer consid-

The quality of light varies considerably throughout the day as well as with weather conditions. The photograph below was taken immediately after sunset with medium-fast film.

The diagram at the bottom of the page represents the logical process behind a photographic shot.

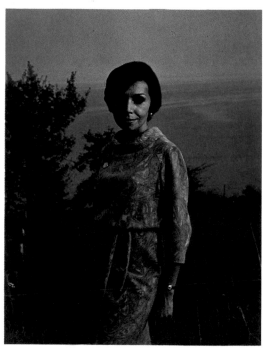

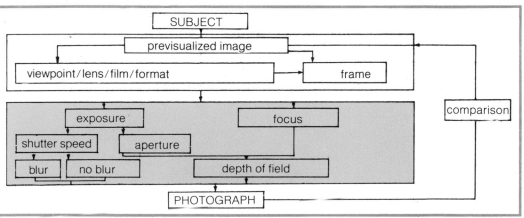

ers to be the main subject. This clearly shows how selective focusing can be a powerful creative and compositional tool, characteristic of the language of photography. Because the subject of the photograph is usually three-dimensional, the very idea of focusing implies the concept of depth of field—the extension of the area in sharp focus on the image both behind and in front of the focusing plane. Knowing how to determine correct depth of field distinguishes the expert photographer from the beginner.

Depth of field depends on four factors, all of which affect each other: focusing distance, aperture, the focal length of the lens, and finally the maximum acceptable circle of confusion, which can be defined as the diameter of the points making up a sharp image which are indistinguishable to the eye and considered here to be 1/20 mm.

There are two ways of checking depth of field: using the special depth-of-field scale, usually set on the focusing ring of the camera and calibrated against the distance index; and using the special depth-of-field button available on many SLR cameras, which stops the aperture at the effective preselected value to enable you to view the image exactly as it will appear in the photograph. This can be a disadvantage in bad light conditions with small apertures because the viewfinder becomes dark.

The graph shows the depth-of-field mechanism more clearly (at least from the point of view of quality). The relatively simple reasoning of geometric optics combined with a convenient

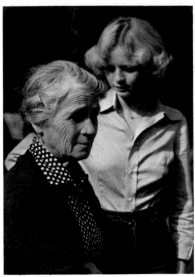

simplification demonstrates that depth of field depends on two variables: the distance of the subject and the effective diameter of the lens aperture. Another variable that is often considered to be important is the focal length, but this has practically no effect in itself at the same aperture diameter.

Consider this example.

The effective diameter of the aperture on a 100mm telephoto lens at f/8 is 100 (focal length in millimeters) ÷ 8 (aperture) = 12.5 mm; a 24mm wide-angle lens at the same setting, f/8, has an effective aperture of 3 mm (24 ÷ 8). To get the same-size aperture and consequently the same depth of field, the 100mm lens should be stopped at

32. The three curves, obtained on a computer, describe the depth of field at three typical focusing distances—1 meter (3.3 feet), 3 meters (9.8 feet), and 10 meters (32.8 feet)—as a function of the effective diameter of the aperture in millimeters from 0.5 to 100 mm. The area bounded by the hyperbola of the same color on the right indicates the area in sharp focus. In conclusion, the depth of field increases the more the lens is stopped down and the greater the focusing distance.

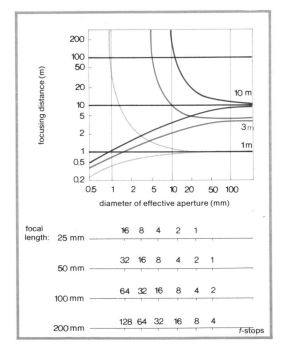

The two photographs above show how changing the focus plane also changes the point of interest in the two figures. Left: A graph showing the progression of depth of field at three typical focusing distances as a function of the effective aperture of the diaphragm. Below that are the corresponding f-stops for different focal lengths. The area limited on the right by the two hyperbolic curves of the same color corresponds to the area in focus.

The graph at right shows the progression of the hyperfocal distance (solid line). When the effective aperture (in millimeters) of the diaphragm is varied, the circle of confusion is equal to 1/1000 the focal distance of the lens. The dotted line indicates the minimum extension of the depth of field; the blue area is the zone in focus. Below: Selective focusing enables you to tone down background elements.

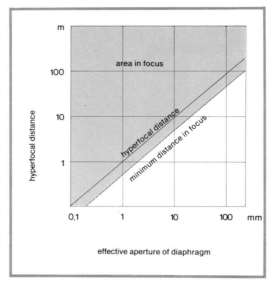

effective aperture of diaphragm

Hyperfocal Point

When the lens is focused at a given aperture on what is known as the *hyperfocal point,* the depth of field extends from halfway between this point and the camera to infinity. Knowing the hyperfocal point is useful when you want both the subject and the background to be in focus. It can be calculated in one of two ways, either by estimating it in practice by a special device found on SLR cameras, or by calculating it with the formula

$$i = \frac{F^2}{f \times C}$$

in which *i* is the hyperfocal point, *F* is the focal length in millimeters, *f* is the aperture, and *C* is the maximum acceptable diameter of the circle of confusion which, as we have already seen, is usually considered to be equal to 1/20 mm.

If, for example, you are using a 100mm lens set at *f*/16, the hyperfocal point will be

$$i = \frac{100 \times 100}{16 \times 1/20} = 12{,}500 \text{ mm}$$

equal to 12.5 meters (40 feet). Setting this distance on the focusing ring will give an area in sharp focus extending from about 6 meters (20 feet) to infinity.

You may find it more practical and sufficiently accurate to use a simpler formula, valid for short and medium focal lengths, that gives the correct aperture setting to use to get infinity in focus by regulating the metric scale of the lens against the distance of the subject. The formula is

$$f = \frac{F(m) \times 1000}{\text{distance of subject (m)}}$$

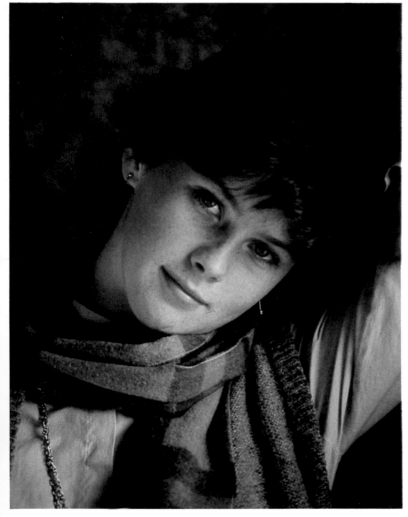

For example, using a 50mm lens for a subject 2.5 meters (8 feet) away:

$$f = \frac{0.05 \times 1000}{2.5} =$$
$$\frac{50}{2.5} = 20$$

As you can see, in practice you can divide the focal length by the distance. Of course, if the resulting stop does not exist on the scale, use the closest one.

Depth of Field in Portraits

The rule to follow almost without exception is this: the subject's eyes must be in focus, and the depth of field must include the part of the face closest to the camera (usually the tip of the nose). A minumum amount of depth of field is usually needed as a safety measure to leave room for any unexpected movement of the subject's head. In fact it is best to focus on the eye that is nearer the camera and select a suitable aperture to cover the required area of the body.

Focusing Instruments

Various methods have been introduced to facilitate focusing. SLR cameras permit the greatest control over the image projected from the lens onto the focusing screen, so you can also check the depth of field. Focusing screens normally incorporate a microprism or a split-image focusing device, but these can be less effective at lower light levels because they become difficult to see clearly. In such cases it is useful to have interchangeable screens.

Wide-angle lenses combine good depth of field with a sense of considerable spaciousness.

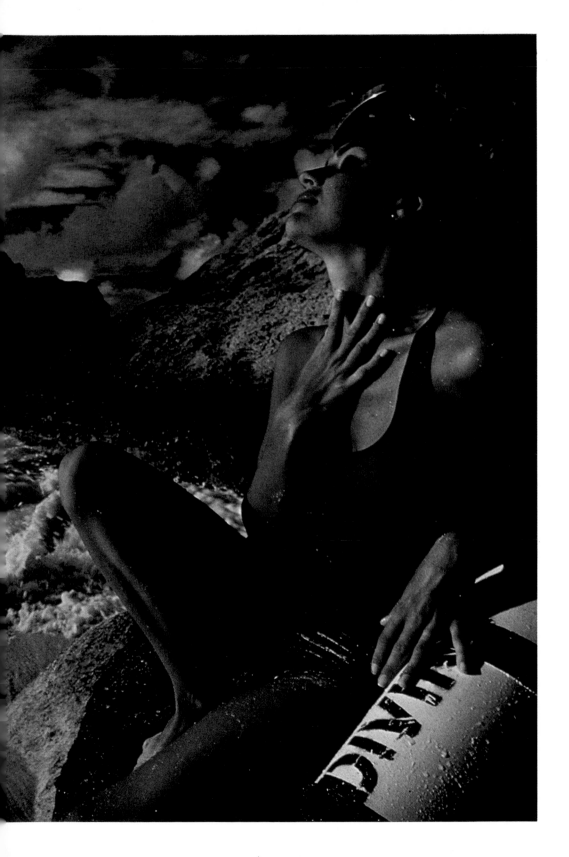

EXPOSURE

Determining the correct exposure really entails two choices: determining the amount of light necessary for correct exposure, and choosing the best of the many possible equivalent combinations of shutter speed and lens aperture. As you can see in the diagram on page 85, the choice of aperture is connected to the focus to determine the depth of field, so these three fundamental parameters of the photographic process are closely related. The parameters of the shot determine the type of image produced and therefore constitute an expressive choice.

Exposure Graph

The graph below shows a condensed version of all the possible combinations of shutter speed and lens aperture that are normally used. Each diagonal corresponds to an exposure value (EV), and every speed-aperture combination marked by the junction of the vertical and horizontal lines along the same diagonal indicates an equivalent exposure in the sense that the amount of light reaching the film is constant. For example, 1/30 sec. at f/11 is equivalent to 1/250 sec. at f/4. The different exposure values indicated by the diagonals correspond to the various conditions of ambient-light intensity.

Consequently, correct exposure means, first of all, establishing the light level with an exposure meter—finding the right exposure value on the basis of the film speed—and then choosing the combination of shutter speed and lens aperture from those available for that exposure value. This is actually quite a fast and simple operation with modern exposure-metering systems, some of which are more automated than others. Nevertheless, it is useful to know that the exposure area most commonly used is, in fact, quite limited: the area between 10 and 20 EV, for example, covers all normal shooting conditions in daylight. The rectangular area from 1/2000 sec. to 1/30 sec. is the range in which it is possible to photograph moving subjects, followed by the area up to 1/2 sec. in which it is possible to take only stationary subjects, with special care to avoid camera movement. Speeds over 1 sec. compose the exposure area for typically static exposures with tripod-mounted cameras; they are generally unsuitable for photographs of people.

Bracketing

When you are photographing an important subject, how do you get the perfect exposure? There is one sure method that is widely used by professionals who cannot risk losing an opportunity. It is known as "bracketing," or shooting two extra frames, one with slightly less exposure and the other with slightly more than the metered value. The intervals between these exposures depend on the film and the conditions, but can be half to a full exposure value more or less than the assessed amount.

With this system you also have the advantage of being able to choose the most favorable density as well as having extra copies of the same picture, which can be particularly useful, especially if one of the frames gets damaged. At least two of the three frames are usually successful.

How to Measure Light

All modern cameras incorporate an exposure meter which measures the light level and indicates the correct exposure under normal conditions of shooting. In portrait photography, however, you often encounter problems that can be resolved only if you fully understand the exposure mechanism and the techniques of controlling contrast on the image. You must understand that the information given by the exposure meter on the basis of the amount of light that strikes it and the speed rating of the film is designed to produce midrange tones; the meter is calibrated on the supposition that the subjects are middle tones, comparable to the standard gray, which has already

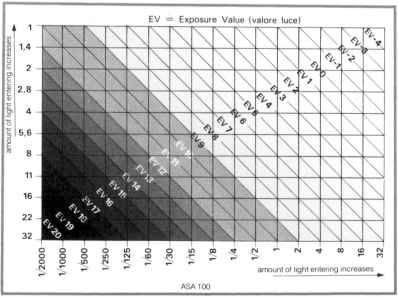

EV = Exposure Value (valore luce)

amount of light entering increases

amount of light entering increases

ASA 100

The graph at left summarizes all the possible conditions of shooting as a function of shutter speed and lens aperture. The diagonal lines connect all the points of equivalent exposure—those with the same exposure value. Starting with a value of 20 EV at the bottom left corner and proceeding to 4 EV at the top right, the amount of light entering the camera gradually increases; each step indicates double the amount of light.

Opposite: A diagram illustrating the measurement of exposure and the logic behind the process.

been discussed at length. For most shots this causes no problems; but imagine wanting to photograph a white wall—trusting completely to the exposure meter will result in underexposure, making the wall look gray. Conversely, a dark subject will be overexposed, resulting in a smoky-gray version of black.

Obviously you should bear all this in mind when taking portraits because it is the tonal and chromatic reproduction of skin that matters. Remember that even if you take the meter readings at close range, you may have to correct the information to avoid lightening dark skin and vice versa. To reproduce skin correctly, you also must check that nothing around the face (background, lights, or even clothing) can adversely affect the accuracy of the exposure.

Measuring Reflected Light

This is the more common method of light measurement used by all manufacturers of cameras with built-in exposure meters. The light cell measures the amount of light reflected by the subject and determines the average shade over a given area. The acceptance angle of the exposure meter is very important; a wide angle from 30 to 50 degrees is useful for normal subjects with a wide range of tones because it avoids readings taken mistakenly from small areas of shadow or highlight. Meters with a narrow acceptance angle, from 7 degrees down to 1 degree, allow you to select the important area of the subject for exposure and enable you to measure the tonal interval—the contrast on the image.

Examine the diagram at the bottom of the page.

When you use a meter that gives an overall reading, whether built-in on the camera or hand-held, you come across three different possibilities. If the overall shade of the image can be compared to standard middle gray, the reading will be correct, but if the subject is particularly dark or light, following the meter reading will result in incorrect exposure. In such a case you have two alternatives. Either you can use an approximate fixed correction, or, to be more accurate, you can take a substitute reading from a surface of a known shade in the same lighting conditions as the subject.

Depending on convenience and availability, you can use a large number of substitute surfaces. The most important of these is definitely the standard gray card which reflects 18 percent of the light. Because it is so useful in all types of light measurement, you

should always keep it at hand in your photographer's kit. By measuring the light reflected off the card in the same lighting conditions as the subject, you will always get an accurate exposure reading. Comparing this reading with one taken from the subject will give the difference in exposure values. In low-light conditions, it is better to read the light reflected off a white card and multiply the indicated exposure time by a factor of five, an increase of about 2.5 EV, which makes it possible to measure exposures that would fall below the sensitivity of the light cell if you were to use the gray card. On the other hand, if you are shooting a subject that is basically dark in strong light, you can measure a black surface and reduce the exposure time by a factor of 5 (a reduction of about 2.5 EV). In portrait photography the most common and practical substitute

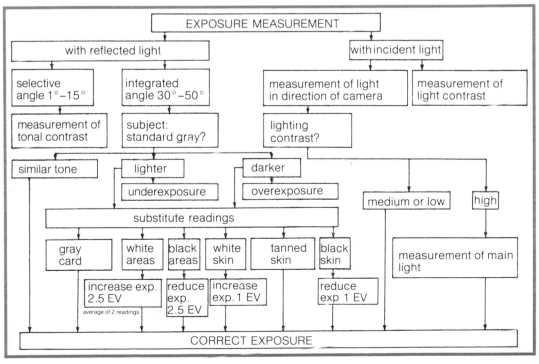

reading is done by measuring the light reflected off the back of the hand. In this case, however, you have to double the exposure, because skin tone is usually lighter than standard gray, and although suntanned skin will give a correct reading, you must halve the exposure when photographing black skin. Finally, you can also use other surfaces such as green grass, red bricks, or certain tones of wood as substitutes. They are of a tone comparable to standard gray and are easily found both indoors and outdoors.

Measuring Incident Light

This is a different concept from measuring reflected light and is less common because of the ease of exposure-metering systems built into cameras for measuring reflected light. It does, however, offer certain advantages and is used for specific purposes which have led to its being widely adopted in film and television photography.

The incident-light method measures the light that illuminates the

subject, not the light it reflects, so the tones of the subject itself have no effect on the reading. The exposure is calculated on the assumption that the

subject is standard middle gray, so it corresponds exactly to the reading of light reflected from the standard gray card in the same lighting

conditions. To get the reading, point the meter, covering the cell with a special dome diffuser, toward the camera from the position of the sub-

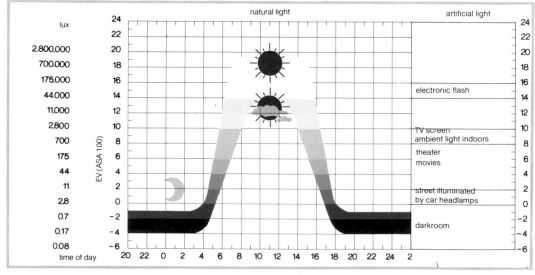

Right: A jazz group in the French Quarter of New Orleans at night. Light measurement is always critical at such low intensities, both because of the light contrast and because "reciprocity failure" must be taken into account—exposure must be increased at least 1 EV. Below: Incident light can be measured by fixing a plastic cup on the lens with adhesive tape.

Opposite, top: Methods of measuring reflected light. Point the exposure meter built into the camera toward the subject or the standard gray card in the same lighting conditions as the subject. With a traditional hand-held meter that has a reading angle of more than 30 degrees, take the measurement close to the subject, but with a meter that has a narrow reading angle, you can take the measurement accurately even from a distance. You can take both readings from a standard gray card in the same lighting conditions as the subject. Light meters with a narrow reading angle can also be used to determine the contrast range of the scene.

The second drawing shows methods for measuring incident light, the light that falls on the subject. There are basically two ways of doing this: by covering the cell with a suitable diffuser and pointing it toward the camera, or by turning it directly toward the light source. The average value of these two measurements is often more accurate.

Opposite, below: A graph showing the curve that describes the variations in light on the earth in the Temperate Zones.

ject, so that the meter receives the same illumination. A camera with a built-in exposure meter can also be used to take this kind of reading as long as you fix a white dome diffuser on the lens with adhesive tape. Even an ordinary plastic cup can do the job. The most obvious advantage of this system is that skin is always correctly exposed, even when background or clothing conditions change. When you measure a scene with the reflected-light system, a black background tends to increase the exposure, making the skin tone of the subject too light, whereas a white background would have the opposite effect.

The only time an incident-light reading gives a somewhat unreliable result is in high-contrast light. The exposure will be calculated on the average between the shadow and highlight values, and only the brighter lights register, so the areas in shadow reproduce completely black. Consequently, in high-contrast lighting it is better to measure the light intensity in the direction of the camera as well as in the direction of the

light source and to use an exposure midway between the two readings. Remember too that in conditions of high contrast the film cannot register detail in both shadow and highlight areas, so you must decide which part of the image is really important.

How to Estimate Exposure Without a Meter

A useful reference for calculating an approximate exposure in daylight when you have no exposure meter is the so-called f/16 aperture rule: in average sunlight conditions with the aperture set at f/16, the shutter speed required for correct exposure corresponds to the ASA speed rating; for example, with ASA 100 film, the exposure time would be 1/100 sec.

MOVEMENT

Photographing the human form always involves freezing movement, for human subjects make continual, irregular, and sometimes imperceptible movements with their whole body, even when they are trying to stand still. Ordinarily, a shutter speed of 1/30 sec. is considered the longest acceptable time that allows you to photograph the stationary human form with a good probability of success. The blink is a good example of movement that can irreparably damage the outcome of a shot; you must pay close attention to the regular rhythm of this involuntary movement.

Movement is of two types: that of the camera and that of the subject.

Movement of the Camera

Camera movement can be involuntary, a movement or shake that always harms the quality of the image; or deliberate, which requires a certain degree of skill if it is to be done properly.

Let us see first of all how to reduce or eliminate camera shake. Vibration of the camera when the shutter is released can be caused either by the photographer, if he or she cannot hold the camera still enough, or by the shutter mechanism, which sets off a rapid sequence of movements in the SLR camera that cannot easily be absorbed. Direct-vision rangefinder cameras are much smoother and more stable during shutter release, and this is reflected in the shot.

To be completely still when you release the shutter, learn to stand in the positions that most stabilize the body, using

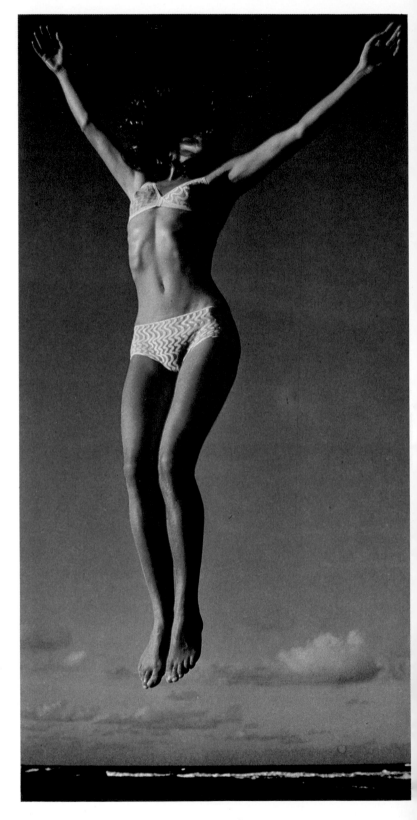

techniques from sporting activities such as archery and shooting. Try taking photographs at slow shutter speeds up to 1 sec. and then work out statistically the limit beyond which the probability of success in the same conditions is too low to be acceptable.

The photograph on the opposite page is a perfect example of movement frozen at the culminating moment. The photograph below, on the other hand, shows that a blurred effect caused by moving the camera can also be interesting at times. It is often useful to have masses of color in this type of photograph; they acquire a dreamlike haziness which almost dematerializes the reality.

Experience tells you when the exposure was made with particularly effective stability. Knowing how to take advantage of all the available makeshift supports around you is the key to success with even relatively long exposures without accessories, which are often not around when you need them anyway. For example, you can rest your head against a nearby wall and absorb the vibrations of the camera by pressing it against your forehead, or you can rest the camera on your knees if you are sitting on the ground. Another effective trick is to press the shutter release with your index finger while counterbalancing the thrust with your thumb against the opposite side of the camera. To consolidate these moments of quiet, learn to hold your breath and press the shutter release slowly.

Tripods and various other accessories that make it easier to shoot at slow shutter speeds are available. They can be used in all kinds of shooting conditions. The *monopod* is a telescopic support on which the camera can be fitted to help eliminate vibration. It is practical because it is compact and easily portable, but a strong belt can serve exactly the same purpose. Attach it to the screw fitting on the camera and stand on the other end, holding the belt under tension. Any light and easily portable accessory like this can often prove particularly useful.

Supports with a shoulder stock are typical accessories for wildlife photography. They are particularly useful for shots with telephoto lenses, because they increase the stability of the camera by making it an extension of the photographer's body.

Tripods

The tripod is the classic accessory for the studio portrait photographer, but it is also an important tool in many other conditions where you may want to check framing and illumination. There are small, lightweight, portable tripods that can serve as emergency equipment. They are suitable for both outdoor shots in ambient light and in artificial light, where they can also double as a flash support.

The tripod is a basic piece of equipment for the studio photographer. It facilitates checking the image and the lighting exactly, as well as eliminating camera shake. A good tripod should be solid but not heavy and should have catches to lock the extension tubes in place so that you can

see whether they are closed and thus avoid the possibility of the camera's falling unexpectedly and ruining the shot. The central column should be adjustable in height and operated by a handle that can be locked in position; some models can also be placed at an angle to make angle shots easier. The weight and solidity of the tripod should be proportional to the weight of the camera.

The tripod head, whether ball-and-socket or pan-and-tilt, not only must be the right size to hold the camera firmly in all positions, but it should also have the capability of holding the camera in a vertical position, particularly with a 35mm SLR, which is often the most suitable frame for the vertical shape of the human form. Some models have two separate handles for independently positioning and locking the vertical and horizontal movements of the head.

Shutter-Release Cables

The shutter-release cable is an accessory with a double advantage: it does not transmit any vibrations to the camera, thus making it easier to shoot at slow shutter speeds; and it prevents any inadvertent change in the frame when you shoot from a tripod. It also gives you the possibility of releasing the shutter from a distance if the cable is long enough. This is useful when the camera is set up and ready but the subject is too tense to assume the expression you want; by pretending to forget about the camera and involving the subject in a conversation, you can often relax the subject so that it becomes possible for you to capture some interesting photographs.

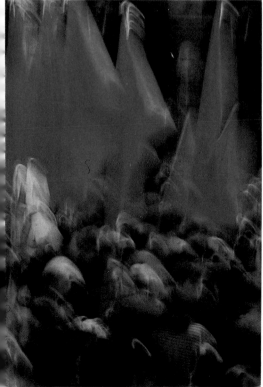

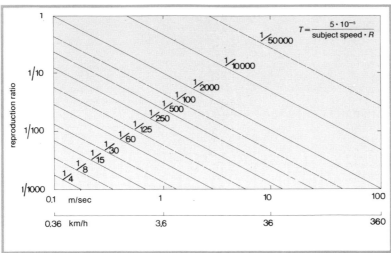

$$T = \frac{5 \cdot 10^{-5}}{\text{subject speed} \cdot R}$$

Frontal movement, heading either toward or away from the camera, is much slower than the other two types, because the image does not, in fact, change position on the film, but gets progressively larger or smaller. With this type of movement, it is the reproduction ratio that varies during exposure. Consequently, the movement will be negligible when R = 50, but it will become critical when the approaching subject has the value of R = 10.

Above: Freezing movement. The lines on the graph indicate the shutter speed necessary to arrest movement as a function of two fundamental variables—the real speed and the reproduction ratio—on the assumption that the subject is moving parallel to the film plane, which is the most critical condition. If we want to take a photograph of a person running at an estimated speed of 1 meter (3.3 feet) per second, in such a way that he or she fills the frame, the reproduction ratio will be 1:50 (as explained on page 109); on the graph you read the required shutter speed, 1/500 sec.

The following are a few estimated average speeds of moving human subjects: a person walking slowly moves at 1–2 km/h (½–1 mph); at a steady pace, 3–5 km/h (2–3 mph); running, 5–20 km/h (3–12 mph); the movement of the hands and feet in slow dances, children's games, and bicycle riding, 5–20 km/h (3–12 mph); competitive sports, 20–50 km/h (12–30 mph); blinking, violent movement, and modern dancing, more than 50 km/h (30 mph).

Movement of the Subject

Blur is caused by movement of the image on the film while the shutter is open. Knowing how to control this effect means being able to capture the movement of the subject on film. The parameters determining how to transfer real subject movement to the image depend on simple projective geometry ratios. When you analyze the problem, you find that the determining factor is once again the reproduction ratio (R). The other factor is the angle of the movement relative to the axis of the lens, which determines the amount of movement projected onto the image.

Parallel movement to the film plane is the most critical and is the only type taken into consideration in the graph above, which shows the least favorable conditions.

Diagonal movement, on the other hand, is partially slowed down in its projection onto the film by the effect of angulation. Movement in this direction is often the best for creating dynamic compositions.

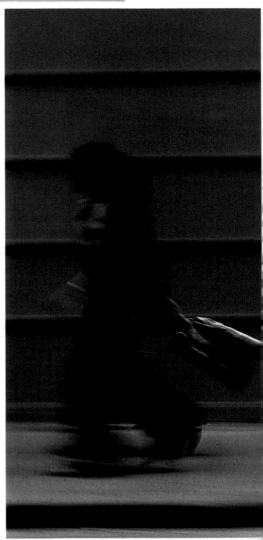

The shutter speed used to take the photograph below was so fast that it froze the movement of both the subjects and the water spray. The vivacious rhythm and the dynamic positions of the bodies make this an effective image. In this case, and in the example on the facing page, the movement photographed was parallel to the film plane, but in the second example, the shutter speed was slow enough to achieve a blurred effect but fast enough to register the background sharply.

How to Control Blur

The best shutter speed to use with a moving subject is the one that freezes the movement. Faster speeds have only two advantages: they increase the probability of success, and they allow the use of wider apertures. Those who have yet mastered shutter speeds tend to be too cautious and use faster and faster times, but in this way the range of apertures that can be used to control the depth of field is limited significantly.

The graph on the facing page explains why and how to freeze the movement of the subject on a photograph. It gives the shutter speeds necessary to freeze subjects moving at speeds of 0.1 to 100 meters (4 inches to 328 feet) a second, with the reproduction ratio in order from 1/1000 to 1. The reproduction ratio indicates how much smaller the image is than the real subject, and it gives proportionately the relative reduction in speed (that is, the movement of the image on the film).

The reproduction ratio is easily calculated by dividing the distance of the subject by the focal length of the lens, so it is not difficult to get a close estimate of the speed on the basis of the type of movement under observation and the data in the table. These two parameters enable you to calculate the necessary shutter speeds accurately through the formula given in the table.

Effective Blurring

Any movement can be frozen with sufficiently fast shutter speeds, but if you deliberately leave part of the figure blurred, the image has greater expressive value and makes the subject's attitude more immediately understandable. For example, a hand gesture can be interpreted in different ways if it is frozen at a particular phase of movement, but the whole movement itself often determines its real meaning. A hand that is raised, immobile, and open can be a gesture to get someone's attention, whereas a waving hand may be a friendly sign of greeting. Partly blurred, the movement registers more clearly and the meaning is more easily deduced.

The technique of blurring effectively in a portrait can introduce an element of intense vitality and great dynamism, as long as it does not in any way prevent the observer from fully understanding the expression and interpreting the personality of the subject. The face usually should be clear enough to reveal the expression, so when you are deciding on shutter speeds you should consider the two types of movement: that of the person as a whole and that of his or her extremities which can move

even faster, such as with subjects who are dancing or engaged in some sport. This rapid movement should deliberately be left blurred, whereas the rest of the body should be frozen. The choice of shutter speed becomes easier the greater the difference between the two relative speeds.

To get the right blurred effect, do tests to learn to estimate the effects of different shutter speeds. The best way is often to take a series of frames at increasing shutter speeds to increase your chances of hitting the right one. An automatic winder is very useful for shooting sequences of this type. The desired blurred effect is difficult to achieve, however; it is almost always obtained by doing repeated tests and having a certain amount of luck.

Panning

Panning is a rather special technique, often used in films, in which the camera is moved during exposure to follow a moving subject. The camera must be constantly trained on the subject, moving in a horizontal arc and following the hips and legs to avoid jolting the camera and ruining the results. The operation is neither easy nor instinctive at first, and you

A good panning effect: the drawing below shows how the camera followed the movement of the child and captured the joy in his run (bottom). Opposite: Controlled blur can be very expressive.

ates a graphically dynamic effect even though the subject is completely frozen and in focus. For this kind of photograph you should use shutter speeds that freeze the secondary movements of the face and body of the subject, leaving the pri-

The "Decisive Moment"

You might say that all photographs of people capture a decisive moment: both in the studio and in travel reports, it is the choice of when to fire the shutter that often determines the meaning of a shot. To capture the decisive moment of the action, you must know what is going to happen and what to expect, so that you can use the proper technique. Consequently, you must be able to rely 100 percent on your own reflexes and equipment.

In fact, you should fire the shutter an instant or two before the decisive

An electronic flash can be very useful and removes the problem of blurring, but it should really be used to supply reflected light, because direct flash nearly always results in flat images with hard shadows and no atmosphere.

If you do not use a flash, you need fast speeds even when freezing movements that seem relatively slow. For example, natural head and face movements need speeds of at least 1/250 sec. for close-up portraits, but you cannot be sure of capturing the exact moment if you take only one frame. Normally the perfect picture has to be selected from a series,

need a certain amount of skill to coordinate your movements. With a subject who is walking, for example, panning actually stops the movement of the person while the background seems to move in the opposite direction at the same speed. This deliberately blurred movement cre-

mary movement against the background completely blurred.

Don't forget that the focusing screen of a twin-lens reflex is useless in this case because the image moves in the opposite direction to the camera.

moment to compensate for any delay in both your own reactions and the shutter mechanism. In many situations the action goes through slower phases, or is even held for brief pauses of maximum expression in the body or the face, coinciding with a state of sudden equilibrium.

preferably taken with a motor-driven camera.

Motor Drive

Automatic winders were considered to be costly luxuries on professional cameras a few years ago, but they are now quite common. There are still some SLR cameras that do not have this feature,

but they are usually the least expensive or older models. Some new models have the motor incorporated into the camera body, the first of these being the Konica FS, which no longer has the traditional lever winder. This innovative solution has undeniable advantages over the separate motor in that the size, weight, and even price are lower thanks to the simplification in construction.

Most reflex cameras have the motor as an accessory, usually using the following types:

Single-shot motors purely for winding the film, known as winders, are now not common; they are being replaced with more complete models.

Single-shot and *continuous-exposure motors* that take up to two or three frames per second are currently the most popular; they are not too expensive, and their performance is more than

adequate for normal requirements.

Single-shot continuous-exposure models that take up to five frames per second with automatic rewind are the most sophisticated and expensive versions, designed for top-of-the-line cameras. Some can also be used with special backs for 250-frame reel film.

Certain features of these cameras are especially useful in specific cases. For example, they offer the possibility of programming the sequence for a predetermined number of frames, as well as remote-controlled shutter release via an electric cable.

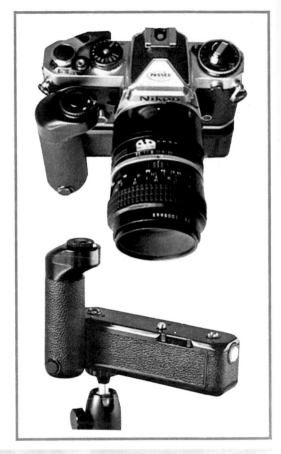

Opposite: A motor drive (the Nikon FE is shown at the top of the page) enables you to take series of photographs in rapid sequence, so it is much easier to capture the culminating moment of an action (bottom).

These sequences taken with the help of a motor drive present a wide range of facial expressions; it was easy to choose the best (center).

LENSES

Technological progress has resulted in the production of an incredible range of above-average-quality lenses at competitive prices. It is still true, though, that definition, high contrast, and uniform resolution over different areas of an image, even at the widest apertures, are features that can significantly differentiate one lens from another and make it a reliable workhorse or an outstanding solo instrument.

Single-lens-reflex cameras and a few others allow you to change lenses easily, thus giving you the opportunity of choosing the best focal length for the type of picture you want to create, not only technically, but also according to personal taste.

When you try a new lens, you realize that it not only widens the possibilities of shooting, but also opens up new creative horizons. It is probably every photographer's dream to own a vast set of lenses, but just a few will cover most shooting conditions. The choice depends partly on your needs and partly on your personal preferences, but you should know beforehand the essential features of the various lenses as well as what they are suitable for. Do not forget that on the whole, the more powerful a long or short focal length is, the more expensive, heavy, and difficult to use it will be. Bear in mind that the focal length determines the angle of view for a specific format and as a result (with the size of the subject in the frame remaining constant), also the perspective. Each lens, therefore, has its own "personality" and its own way of resolving a given photographic problem.

Lens Speed

The so-called speed of the lens—the maximum possible aperture—is an important feature. It is, in fact, a distinct advantage in certain circumstances to have a lens that transmits a lot of light; it can even be essential at times to enable you to take a particular shot. But it is completely superfluous in most cases. For example, buy a 50mm f/1.2, which has a great facility for letting in a great deal of light, only if you frequently work in interiors in bad ambient light, or with fast-moving subjects in similarly unfavorable lighting conditions, such as sports competitions in bad weather or indoors. The same argument applies to some fast and

Below left: The focal length of a lens determines its field of view. For the 35mm format, standard lenses have fields of view ranging generally from 40 to 50 degrees. Telephoto lenses have longer focal lengths and narrower fields of view. Wide-angle lenses, on the other hand, have shorter focal lengths and wider fields of view, as shown in the diagram below right.

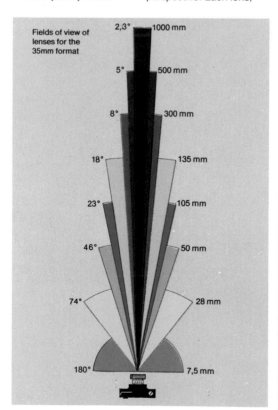

Fields of view of lenses for the 35mm format

FIELD OF VIEW	LENS FOCAL LENGTH FOR 35mm FORMAT	LENS FOCAL LENGTH FOR 2¼-SQUARE FORMAT
180°	7,5	—
110°	15	28
94°	20	38
84°	24	46
74°	28	50
62°	35	—
46°	50	80
28,3°	85	150
23,20°	105	200
18°	135	250
12,20°	200	400
8,2°	300	
6,2°	400	
5,0°	500	
4,2°	600	
3,0°	800	
2,30°	1000	
1,2°	2000	

CORRELATION BETWEEN LENS FOCAL LENGTH AND FIELD OF VIEW

Below left: A shot taken at night that makes the most of the little existing light by means of a fast lens and very fast color-slide film (ASA 400) balanced for daylight. Tungsten street lighting produced the warm dominant.

Below right: The top two photographs of the pairs shown were taken with a standard lens and the bottom two with a wide-angle lens. Comparison clearly demonstrates the difference in perspective. With a wide-angle lens you must be much closer to the subject to make it fill the same amount of the frame.

expensive telephoto lenses like the 180mm f/2.8, or the 400mm f/3.5, which enable you to take shots that would otherwise be impossible.

The high price of very fast lenses is explained by the fact that for each stop above maximum aperture, the surface area of the front lens, with all the constructional problems involved, roughly doubles, which also increases the size and weight of the lens. The optical quality of a lens has nothing to do with how fast it is, as you may be led to believe by the price. In fact, you usually get better resolution from lenses that are not too fast, precisely because their construction is simpler.

Ultra-Wide-Angle Lenses

These lenses have a focal length ranging from 24mm to 15mm, taking, for reference, the usual 35mm format. They are easy to get enthusiastic about, but also easy to tire of, and to use them properly to produce good and not just strange pictures, you have to serve a kind of apprenticeship.

The unusual perspective this kind of lens produces can stimulate the photographer's creativity, but it can also lead to results of little value—superficially eye-catching and effective, but monotonous after a while. Very short focal lengths, in fact, need a heightened sense of perspective and balance, yet there is nothing better when you are in a difficult situation with narrow settings and a profusion of detail that you want to capture in one image. Outdoors, they create a sensation of space and dynamic perspective that strongly

involves the onlooker.

Conventional Wide-Angle Lenses

Focal lengths from 28mm to 35mm for the 35mm format are the most versatile and practical for photographing interiors because they are small, not too expensive, and quite fast. Furthermore, the wide angle of view is perfect for the human environment, involving human subjects and objects in a close, vital perspective that creates a sensation of being in the middle of an event without a forced and unnatural perspective. These lenses are now commonly used for photographs of interiors and figures set against them. They can capture as much as you need of an average-size interior to re-create it effectively. If used more than the normal lens,

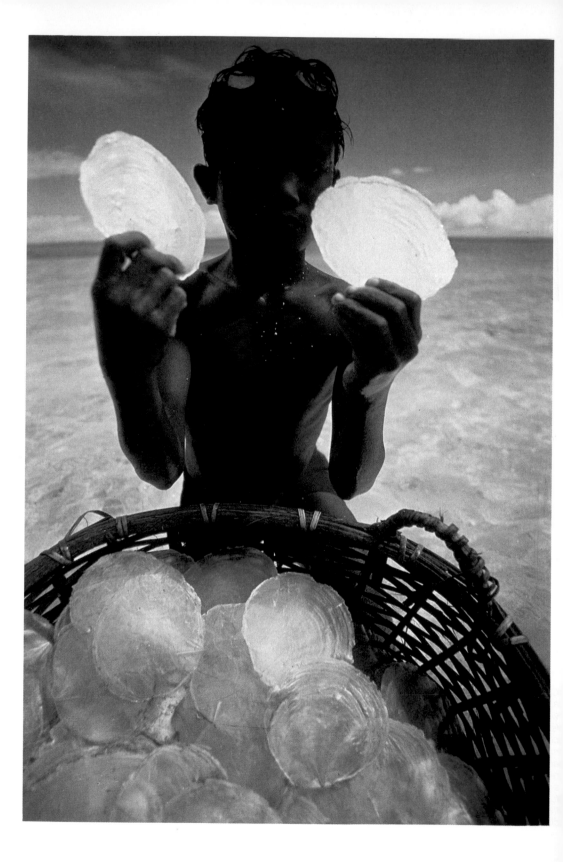

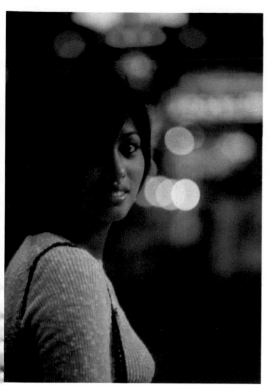

Above: A pleasant portrait taken in the light of signs on the city street. The strong blurring in the background indicates that a fast lens was used at full aperture.
Above right: Medium telephoto lenses are recommended for portraits, particularly those with a focal length of about 100mm.

Opposite: A splendid image by Juergen Schmitt, who used a wide-angle lens to create a sense of closeness and involvement between the subject and his environment. The result is an immediate and concise photograph full of life and color but at the same time simple, clear, and easy to read.

they should be quite fast, at least $f/2.8$

The Normal Lens
This type of lens has a focal length of between 45mm and 55mm and is the one usually sold with the camera, although many manufacturers have adopted the excellent practice of letting the customer choose the first lens. In my opinion, you should buy the normal lens, also known as the standard lens, only if it will really be useful. In fact, if you were later to buy a conventional wide-angle lens like the 35mm, you would no longer use the normal lens much.

The "normal" lens does have the advantage of being very fast—$f/1.4$ or $f/1.2$—with excellent image quality at a reasonable price, so it could be useful in bad ambient light. Its angle of view is about 45 degrees, which is usually inadequate for interiors or landscapes

but at the same time is too great for close-up portraits. It has a neutral, flat, and conversational perspective that puts no emphasis on either the setting or the subject. For this reason it is a difficult lens to use and, in fact, can only be used to advantage when the content of the picture speaks for itself quite clearly, immediately, and provocatively, as in reportage and photojournalism.

Short Telephoto Lenses
The focal length of short telephoto lenses falls between 70mm and 150mm. They allow you to photograph a face in close-up from quite a distance with the right perspective. Short telephoto lenses have the same angle as that with which we naturally and instinctively see things. Consequently, they are the ideal compromise for photographs of the hu-

man form in isolation or in a moderate setting. They are light, usually quite fast, and relatively inexpensive, giving a silent and discreet view similar to that of a fleeting glance, combined with a natural and harmonious perspective.

Medium Telephoto Lenses
The focal length of these lenses lies between 200mm and 600mm. They isolate the subject and examine reality from a distance without any personal involvement, as if the photograph were taken from another planet. There is no possibility of contact between the photographer and the subject; the detachment is total. They take an abstract view of reality, as if seen from above.

New and unusual symmetry shows up on the focusing screen. Graphically, the images take on a fascinating new aspect:

a flat, geometric look without volume or depth. The different planes run into and overlap each other, and the rules of space seem turned upside down.

You must familiarize yourself with this unusual view of reality if you are to obtain interesting results with it; otherwise you could soon be disappointed. The most useful aspect of these lenses is the way they completely isolate subjects, bringing them into the foreground and removing any interference from the background. Their other main application is the possibility of creating synthetic images using the compressed perspective. Normally, these lenses are not very fast; they are also quite large, heavy, and expensive.

This range also includes the catadioptrics, or mirror lenses, which use mirrors to reduce the physical length of the lens. A typical example is the 500mm, which is very light and compact and so can be used freehand with the techniques of wildlife photography. Medium telephoto lenses are very useful for capturing spontaneous pictures of people unobtrusively from a distance, but remember that the larger focal lengths in particular are not easy to use, and there is a higher risk of blurred results if you do not have a support available or if you do not use fast speeds, which are often incompatible with the slow speed of the lens itself. The result is that you can really use them only in bright light or with ultra-fast film.

Supertelephoto Lenses

Supertelephotos are lenses with a focal length of over 600mm. Because of their cost and general

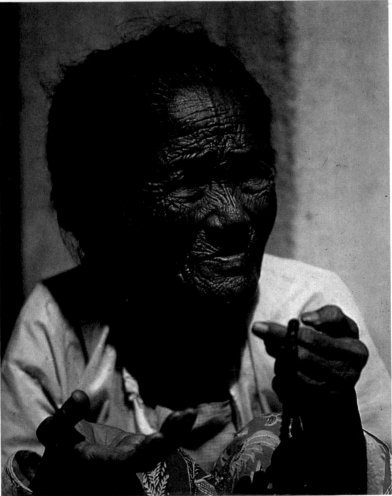

characteristics, they are really a specialist-class lens with limited use. The optic quality of the lens is vital for successful results, and the light transmission drops progressively. They are used mainly for nature and wildlife photography, because with them you can photograph very timid animals that would not let you near them.

Macro Lenses

These are normally very high-quality lenses that allow you to take photographs of subjects very close to the lens without additional lenses or extension tubes and bellows; all you need use is the focusing ring on the lens. Consequently, they are very good for photographs of small objects and minute details, but they are particularly good for nature photography, using the techniques of macrophotography. Because they can also be used for normal photography, they are advantageous whenever you want good resolution and contrast—for example, when you want to make very big enlargements from a negative. Their weak point is their high level of light transmission.

The zoom lens (right) enables you to make "made to measure" frames and to eliminate superfluous elements that could detract from the image (top sequence). Opposite, top: The use of a 35mm (left) and a 200mm (right) lens. Bottom: A very old Burmese woman photographed by Andrea Luppi with a macro lens. Note the sharpness of the face.

Zoom Lenses

Zoom or variable-focal-length lenses allow you to vary the focal length and consequently the angle of view within a given range. Their advantages are tremendous, because they are so practical. You do not even have to change your position or the lens to alter the frame within certain limits. The most interesting feature of a zoom lens is that it not only replaces at least two separate lenses at the extreme of its focal lengths, but it also provides all those in between without a break in continuity. As a result, it is easy to find the best image before firing the shutter simply by rotating the appropriate ring backward and forward. This way a zoom lens accustoms your eye to using different focal lengths to compose images effectively. It is particularly useful with reversal film, the frame of which cannot be altered during the developing process.

Two other characteristic advantages of zoom lenses are easier focusing, which can be done at the position of maximum focal length (that is, the least depth of field), and the possibility of obtaining the so-called zoom effect during exposure by using a slow shutter speed and moving the zoom control quickly through its range. The result is a special blurred effect that is more pronounced at the outer edges than at the center of the image.

The traditional disadvantages of this type of lens lie in the optic quality and the light transference, which are normally lower than with the corresponding fixed-focal-length lens, and they are usually heavier, bigger, and more expen-

sive. Modern technology has produced better-quality zoom lenses, however, and it is now more difficult to tell whether a photograph was taken with a zoom lens or a fixed-focal-length lens, even after careful examination on projection. The consistent quality of focusing at each focal length and the ease and manageability of the controls are very important. Zoom lenses that have a single ring to control focusing and changes in focal length are convenient, because they enable you to perform both operations with one hand, either by rotating the ring or pushing it backward and forward.

With a few exceptions, zoom lenses fall into three categories, depending on the variations in focal length offered:

Ultra-wide-angle to normal lenses (24–50mm) are suitable for photographing sets and interiors and are particularly useful because they allow you to frame correctly in accordance with the dimensions of the interior in which you are working.

Conventional wide-angle to short telephoto lenses (35–100mm) are ideal zooms that cover the range of focal lengths most commonly used. They are an excellent substitute for the normal lens when speed is not required. This type of zoom lens covers the angles of view that are by far the most common in general shots from the average interior to the close-up. It is highly manageable and is suitable for the various subjects typically found in documentary and travel shots.

Short to medium telephoto lenses (70–200mm) are currently the most popular zoom lenses and are generally

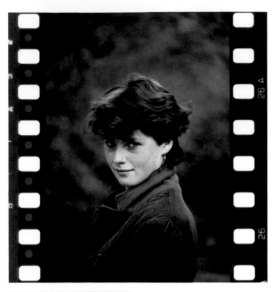

A doubler doubles the size of the subject in the frame. It is useful in portrait photography to convert a standard lens into a small telephoto lens and makes it possible to take close-ups with better perspective reproduction.

Medium to long telephoto lenses (200–600mm) are reserved for specialist use, not only because they are so expensive, but also because of their size. The angle of view is quite narrow and suitable for subjects at middle to long distances. They are particularly good for nature and wildlife photography in general, and the lenses are not very fast.

Range Extenders

Range extenders are additional optic systems that are placed between the lens and the camera body to multiply the focal length by a factor of 1.4, 2, or 3. Despite their indisputable advantages, there are also a few disadvantages that are more noticeable in the ×3 range extenders. Doublers, on the other hand, are the best compromise between quality and practicality. The advantages are that you can almost double the number of available focal lengths, especially if you buy your lenses with a view to eventually using them with a range extender. A set of three lenses such as the 28mm, 50mm, and 200mm combined with a doubler gives you two other lenses of 100mm and 400mm (you do not use a range extender with a 28mm lens). The resolution obtained with a doubler is good with normal lenses, but particularly so with telephoto lenses.

Range extenders are manufactured with different types of fixing so that they can be used with different cameras and allow all the built-in automatic systems to function normally. There are also special range extenders designed to function with a particular lens system, but they are quite expen-

of good quality. Some of them, such as the Nikkor 80–200mm, have an excellent reputation, and compared to fixed-focal-length lenses of around 150–200mm, they offer several advantages and few disadvantages: the weight, size, and quality are similar, and they do not cost much more. The focal-length range enables you to photograph subjects at short and middle distances quite effectively. They are ideal on travels for isolating people and other details.

sive. Range extenders are compact and keep the same minimum focusing distance as the lens to which they are coupled—an important advantage, particularly with medium and long telephoto lenses and macro lenses, because it allows you to work with a higher reproduction ratio without using additional lenses or extension rings.

In portraiture doublers are especially useful, particularly if you have a standard lens and no short telephoto. In fact, they can convert a normal 50mm lens into a short 100mm telephoto which is highly suited to this kind of photography. It is true that you typically lose a little definition and contrast with this kind of additional system, but this does not matter with portraits, where an increase in softness is usually an advantage.

The biggest disadvantage with range extenders is the reduction of transmitted light. In fact, the extender not only multiplies the focal length two or three times, but also the aperture that has been set on the lens, not by absorption of light through the extender, but because of the laws of geometric optics. For example, in a 50mm lens set at $f/8$, the effective aperture will have a diameter of 6.25 mm (¼ inch) because $50 \div 8 = 6.25$. Fitting a doubler makes the focal length 100mm, so the aperture on the lens at $f/8$ whose effective aperture is 6.25 mm in diameter is in reality $100 \div 6.25 = 16$, or $f/16$. In practice, you lose two stops because when the focal length is doubled, the same-size aperture allows a quarter of the light through.

FOCAL LENGTH AND SUBJECT DISTANCE

It is important to understand a fundamental concept in photography: the *reproduction ratio (R)*, which is the ratio between the size of the image *(I)* formed on the film during exposure and the real size *(S)* of the subject being photographed—$R = I : S$. A reproduction ratio of 1:10, for example, means that the size of the object on the frame is one-tenth of the real size; $R = 2:1$ means that the object is reproduced at twice its real size—obviously in the sphere of macrophotography. The reproduction ratio is easy to calculate if you know the data relative to the focal distance *(f)* and the distance of the subject from the lens *(D)*, using this formula:

$$R = \frac{f}{D-f}$$

(Remember that the focal distance is the distance between the lens and the film plane with the focus set on infinity.)

The graph alongside, obtained on a computer and referring to the 35mm format, uses curves to show how the reproduction ratio varies with the distance of the subject with certain focal lengths ranging from the 20mm wide-angle to the 1000mm telephoto lens. These curves are, in fact, hyperbolic; the curve relative to the 1000mm lens bends noticeably as it approaches 1:1, because at this ratio (because of the laws of optics which need not be discussed here) the subject-to-lens distance is equal to twice the focal length, in this case, 2 meters (6.6 feet).

In practice, unless you are working in natural or scientific macrophotography where reproduction-ratio data can be very

important, what should really interest you is knowing in advance which lens to choose to take a certain subject at a certain distance in such a way that the frame is filled to the required amount. There is a simple formula that is very useful in calculating the most suitable focal length as closely as necessary:

$$f = \frac{D \times I}{S}$$

in which f = focal length, D = the subject-lens distance, I = the size (length) of the subject as it appears in the frame, and S — its real size. For example, if we want to know the best focal length to get the image of a person 30 meters (100 feet) away to nearly fill the frame vertically on a 35mm format, with the result measuring about 30mm out of the 36 mm on the frame, and assuming an average human height of 1.70 meters (5 feet 6 inches), we need only do the following calculation (in millimeters:)

$$f = \frac{30,000 \times 30}{1700} = 529.4$$

Consequently, a 500mm telephoto lens would be

the best to use.

Now suppose that we have a 200mm telephoto lens and want to photograph a man just as he is coming through a doorway. We can find out how far to stand from the door to get the whole person in the frame without cutting off his head or feet, and at the same time get him nearly to fill the frame as in the previous example. The formula to use is based on the previous one:

$$D = \frac{S \times f}{I}$$

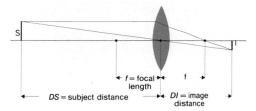

S — f = focal length f
DS = subject distance DI = image distance

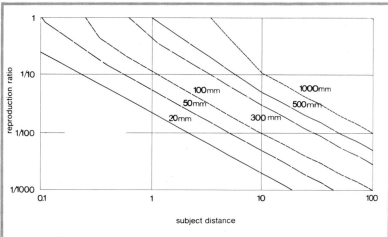

subject distance

Above: A graph summarizing the possible conditions of shooting with a subject at a distance of 1–100 meters (1–110 yards) and indicating the focal length necessary to obtain a given reproduction ratio. The abscissa shows the subject distance and the ordinate the reproduction ratio, expressed as a fraction ranging from 1/1000 to a maximum value of 1. When $R = 1$, the distance between the lens and the subject on the one hand and the lens and the focused image on the other corresponds to double the focal strength.

Let us now see how to use the graph. To reproduce a face in close-up, for example, with the 35mm format from a distance of 1 meter (3.3 feet) with $R = 0.1$, find the 1/10 position on the ordinate of the graph and 1 meter on the abscissa. The recommended lens is a 100mm, shown on the nearest curve.

Top: Diagram of a basic optic system. The reproduction ratio is defined as the ratio between the size of the subject and the size of its image on film.

By substituting the relevant data (in millimeters), we get:

$$D = \frac{1700 \times 200}{30} = 11.333$$

Consequently, we have to stand just over 11 meters (13 yards) away.

Relative Enlargement

It can be very useful to consider the enlargement of a lens you are not familiar with and compare it to another one that you know well in terms of framing possibilities. The calculation in this case is very simple: divide the focal length of the lens in question by the focal length of the lens you already know. With the 35mm format, for example, a 300mm telephoto lens, compared to a 50mm lens, has a relative enlargement of 6 (300 ÷ 50 = 6); this means that when the subject is the same distance away, the image is 6 times bigger.

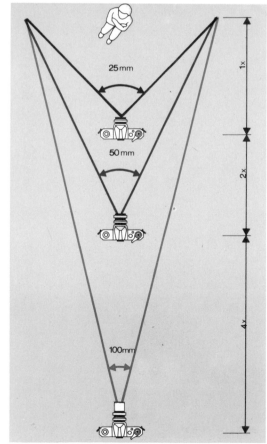

Left: Focal length, angle of view, and subject distance. The diagram shows how doubling the focal length requires twice the distance to get the same-size image. The principal changes occur in the perspective and the background. The photographic sequence above was taken with a constant reproduction ratio (the size of the image on the frame remained constant) but different focal lengths (200, 150, 50, 35, and 28mm) and distances. Note the change in the relationship between the foreground and the background.

Opposite: In this sequence, however, the position from which the shot was taken remained the same, but the focal lengths were changed (from 28mm to 200mm). The relationship between the foreground and the background is constant—in other words, you could get a frame similar to the last one by enlarging the detail from the first.

conception is that a wide-angle lens distorts perspective. Although you do see distinct and unpleasant distortions of a face viewed through a 24mm wide-angle lens, they are caused entirely by the closeness of the subject to the lens, which is necessary to get the face in close-up with a lens that covers a wide angle of view. The wide-angle lens enables you to photograph subjects at very close range with an unfamiliar geometric perspective.

Fish-eye lenses form a separate category; they produce circular images formed by an effective optical distortion.

The two series of frames on this page show, in effect, what it means to use the different variables just discussed. The sequence of shots was taken from a fixed position, but using different-focal-length lenses; you can see that the perspective remains the same. In the series on the facing page, however, the reproduction ratio was kept constant; not only has the focal length been changed, but also the shooting distance. In this case, the size of the subject is the same in all the frames, but the perspective has altered radically as a function of the distance.

Depending on your expressive needs, the effect you wish to achieve, and the type of setting, you can choose from among many creative possibilities. Whereas the wide-angle lens accentuates a figure in close-up, making the background seem much farther away, the telephoto lens brings the planes closer together, compressing them almost to the extent that it cancels the distance between them, reducing the three-dimensional effect.

PERSPECTIVE

A photographic image is made up of just a few simple parameters: lighting, subject distance, and the angle of view of the lens. Let us have a closer look at the last two factors, which constitute fundamental and independent variables of

shooting technique.

First, you must understand that the perspective obtained in a photograph depends entirely on the distance of the subject from the camera and is not influenced in any way by the type of lens used. In fact, it depends on the geometric projection of the space in front of the

subject, so when the subject is the same distance from the camera, the perspective remains unchanged no matter what focal length is used.

There are many misconceptions on this subject which arise out of terminology that mistakes the cause for the effect. The most common mis-

THE "STOLEN" IMAGE

It is not easy to photograph someone who is unaware of your intentions, not only technically, but also because of the moral and ethical choices involved. Taking a photograph of a person is obviously not insulting or negative in itself, but in many circumstances and in certain cultures it is considered offensive or at least unwelcome.

There is no question that if the person would be upset or merely irritated, you should not insist on taking the photograph. All people have the right to protect their own private images, particularly in their own homes. In addition, serious problems can arise from the subject's adverse reaction.

What It Means to Be Photographed

Being photographed presupposes that you have been carefully watched and scrutinized, so even without actually firing the shutter, the mere act of pointing a camera at someone can provoke a reaction in the person who feels that he or she is the center of unwanted attention. Even when the purpose is obviously positive—admiration of beauty or elegance, for example—you need a certain amount of impudence to overcome natural reserve.

Although a stare can be a welcome expression of admiration, the same cannot be said of a photograph, which can later be put to unwelcome use. If the subject suspects for some reason that the photograph might do some harm—that it might be used to ridicule or just show some negative aspect—the reaction against it can be strong.

The same people can show completely different reactions in different circumstances. For example, when people are sure of their image and want to display it in public, knowing that they will be showing their best side, the photograph is welcomed as a suitable opportunity of documenting social status. If, on the other hand, subjects do not think that they are in a favorable situation, the photograph will be taken as an affront or as an attempt to cut down prestige and public image. This is particularly true in the case of public personalities, especially the stars, whose public images are partly responsible for their success, but it is also true of private individuals.

The search for human subjects to photograph without their knowledge

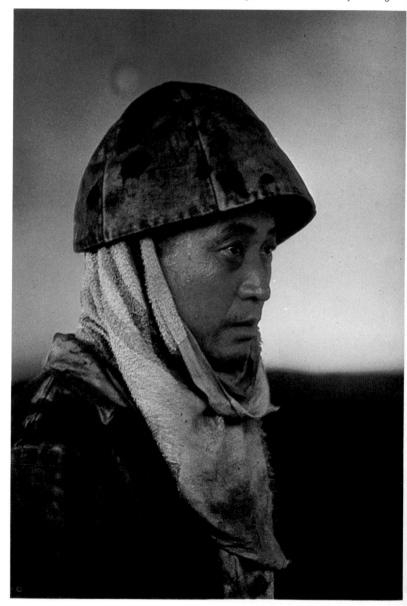

Below: An intense image by Marc Riboud. The woman, a Chinese worker, seems unaware of being photographed. Opposite, top: Even if people do not want to be photographed and turn their backs, at times you can still capture valid images, like this one by Eve Arnold. Bottom: You may get unwanted results in a shot of interesting subjects if you take the shot without actually framing.

s therefore quite a difficult task.

How do you approach this situation when photographing people? Your reasons for taking the photographs must govern how you act. If, for example, you want to photograph people in whom you are really interested, whom you sincerely respect, understand, and admire, it is natural to become friendly with them and thus break down any barriers. In this way you can have a lot more control over the shooting techniques because you are not restricted to using long-focal-length lenses. There are, however, many circumstances in which this is not possible, but the criteria guiding your behavior are still the same: you can take photographs without the subject's knowledge or consent if your motives are positive, but never to deceive or ridicule others.

Techniques to Use Without Being Noticed

The following are a few practical suggestions for taking photographs without being noticed:

1. Do not look directly at the subject, but follow him or her out of the corner of your eye. It is quite easy to become conscious of someone staring at you; eye contact would reveal your intentions and prejudice your chances of success. This ability to look as though nothing were on your mind should be combined with a capacity for acting out roles suitable for the place and time you are in.

2. Frame your picture without raising the camera to your eyes; doing so would reveal your intentions immediately. If you can avoid this, you are more likely to go unnoticed, even from quite close range. This technique of instinctive shoot-

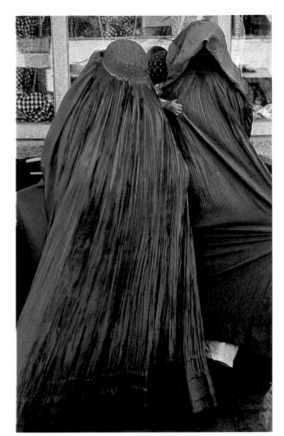

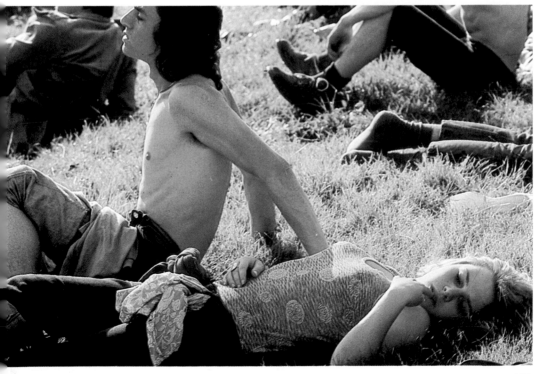

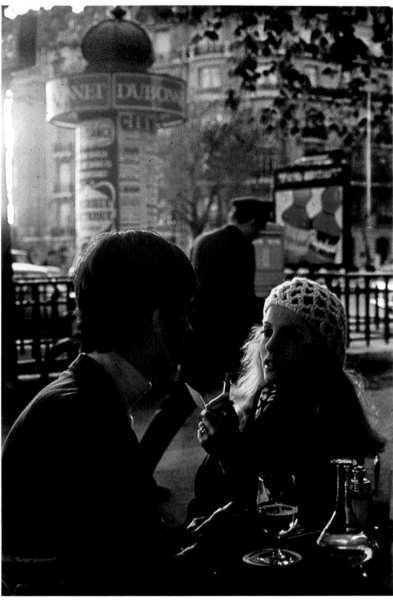

cameras have a few disadvantages in this respect. Cameras with a central shutter are a lot quieter because they are mechanically simpler, and so allow you to take photographs at slower shutter speeds with better results. The miniature Minox GL, for example, cannot be heard when there is the slightest background noise.

4. Set exposure parameters in advance so that you will not have to alter them later. Automatic cameras are very useful in this regard because they work so fast. It is often convenient to pre-set an average exposure manually and use a suitable hyperfocal point, which should be kept constant throughout the series of shots to avoid any possibility of error in estimating the distance.

Taking Photographs from a Distance: Techniques Using Telephoto Lenses

At what distance are you safe from trespassing on private territory and being seen? The answer depends on the presence of other people who could more or less justify your being there. For example, when you are in the middle of a crowd, just a few yards' distance from your subject should prevent you from being spotted, particularly in tourist areas where cameras are standard equipment.

In more normal circumstances when there are fewer people around, you should be at least 10 meters (11 yards) away from people to avoid intruding on their privacy, and under these conditions a medium or long telephoto lens is necessary. A zoom lens is a good alternative for mid-range shots; it allows you to frame correctly without

It is often possible to capture spontaneous poses and a particularly suggestive atmosphere only by working furtively without the subject's knowledge. Telephoto lenses can be useful; they allow you to work from a distance and to help you take photographs without being observed, as was the case with the photograph at the top and the facing page.

ing is quite easy with wide-angle lenses, and generally after a few test shots you can at least manage to center the subject. The best focal lengths for this are 28mm and 35mm, which leave enough room for error in framing without too wide an angle of view. You must, however, allow a margin of safety and leave space around the subject because you cannot be sure of the results.

Generally speaking, negative film is better for this kind of work; it gives more leeway in altering the composition during printing.

3. Avoid noisy cameras. The classic "click" of the shutter is a characteristic signal that cannot be attributed to other causes, so the old advice of taking advantage of some sudden noise to cover the sound of the shutter still stands. SLR

changing your position and also makes it very easy to follow a moving subject and select the most effective frame. Using a zoom lens also helps you to vary the viewing angle to eliminate distracting elements. The graph below can help you choose the necessary focal length for photographing a full figure at distances up to 80 meters (88 yards), the maximum practical limit for standard 35mm equipment; the operational radius is nearly half that with the 2¼-square format. The second graph is an enlargement of the first in the area from 1 to 10 meters (1 to 11 yards). Lenses of 150mm to 300mm are the most common for bringing in close a subject that is up to 25 meters (27 yards) away. For greater distances you need a longer lens, and more

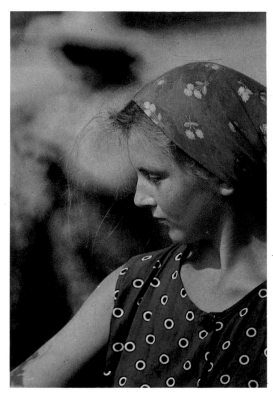

skilled shooting techniques.

Working from Close Range

The small, silent, compact camera does not arouse any suspicion, unlike the SLR which is difficult to hide. Wide-angle lenses also allow a certain margin for error, unlike telephoto lenses, which demand great accuracy, so with a minimum of experience you can frame quite accurately, even without checking first in the viewfinder. Focusing does not present the usual problems either, because of the increased depth of field, so in effect you need only decide on the basic position and choose a suitable hyperfocal point to cover the whole area of the shot.

When the subject is quite close, you should be able to adjust the focusing plane without looking at the aperture ring, so memorize the rotation of the ring so that you can set an approximate distance. Automatic compact cameras are particularly unobtrusive because of their discreet black plastic bodies and their size; they literally fit in the palm of your hand.

Whenever you are in bad light conditions, it is better to leave the diaphragm on full aperture and let the camera decide the shutter speed. The best way to vary the exposure is to set a higher or lower ASA rating. In fact, this is the only possible way on many automatic cameras and it works quite well.

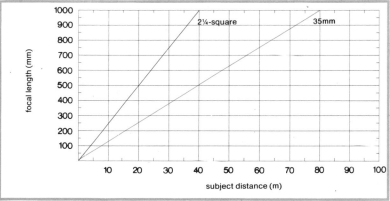

Above: This graph shows the telephoto lens to use when you want a subject approximately 2 meters (6½ feet) tall at a given distance to nearly fill the frame. For example, with the 35mm format and a subject 40 meters (44 yards) away, you need a 500mm lens.
Right: An enlargement of the area of the graph most useful for short- and middle-range portraits.

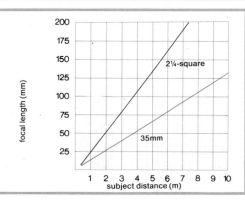

Using Mirrors

Working with a mirror changes the direction in which the camera is pointed, so it helps hide your true intentions. Mir-

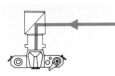

Above: A mirror attachment fitted onto the lens makes it possible to photograph at right angles to the direction of the shot. It is useful for hiding your real intentions from the subject but makes it difficult to frame a moving subject correctly. Below: Fast film and fast lenses enable you to work in all types of light: on the street by lamplight (left) or in dark interiors as in the photograph on the right by Ernst Haas.

rors can be found and used in many locations such as theaters and hotel lounges, and even outside rearview mirrors on cars can come in handy. Special mirror attachments that can be screwed onto the camera lens are available, but they are not so easy to use because of the difficulties in framing the subject. They do, however, certainly hide the real direction in which you are shooting. Traditional 2¼-square-format cameras with chamber viewfinders can be used in the same way and are in fact even easier because of the size of the focusing screen; the lens can actually be pointed at the subject while you hold the camera sideways. The disadvantage of larger-format cameras is that they are so big that they do not go unnoticed.

Low-Light-Level Shooting Techniques

Modern photographic technology has effectively made it possible to photograph any scene that can be seen with the naked eye, but when you photograph people in dark settings such as theaters, restaurants, and churches, the problem is arresting the subject's movement. Obviously you cannot freeze the movement of a dancer in a nightclub by candlelight; you must wait for a relatively quiet moment or a pause in the action. What is the best equipment for this? Everyone should find the best system on the basis of the preferred type of shot, but the following classic equipment is suggested as a guide: when telephoto lenses are necessary because you cannot get as close to the subject as you might like, you can use a normal SLR camera or a rangefinder camera with inter-changeable lenses, the prototype of which is the Leica. The advantage of the latter is that the shutter fires smoothly and quietly and allows you to take shots at slow shutter speeds without causing any vibrations.

Single-lens reflex cameras have a wide range of very fast lenses available which make it possible to take shots that were unthinkable up to a few years ago.

When you can get close to the subject, though, you can use normal or wide-angle lenses. They simplify shooting because at the same aperture you have increased depth of field, and the wider angle of view stabilizes the image, reducing the danger of blur. In addition, very fast lenses are much more common and less expensive in this category.

PRIVATE REPORTAGE

It is not uncommon for an amateur photographer who has acquired a certain degree of technical skill to have difficulty finding subjects worthy of being photographed. It almost seems as if the only interesting subjects are exotic ones such as Indian ascetics or fascinating ones like actresses and models. This is when the amateur photographer has to develop the ability to "see photographically," to examine the faces encountered in everyday life. There are countless opportunities for the photographer who is hunting human images, ranging from the unusual, intense, happy, and sad to the modest or flamboyant. Sports events, parades, festivals, and markets all present rich and varied human landscapes with vital, fascinating human situations to anyone who can make the most of them.

You may find yourself taking part in some totally unexpected event, so you should always have a small, lightweight camera with you whenever possible. Not everyone gets the opportunity to document a man fleeing a tornado (see photograph below), but the unexpected can present itself before our very eyes (and lenses). More commonly, though, you can get good images only by pursuing the lucky chance, trying out new techniques, and persevering in your efforts to obtain the images you desire. Get used to thinking of your camera as a notebook in which you record your experiences of life in an amusing and stimulating way. Doing so may not enrich your portfolio, but it does develop your aesthetic sensitivity and improves your ability to see into and behind appearances and therefore to understand others better.

Images of universal value should be easily understandable and enjoyable for all, even after time has passed. Therefore, document a given reality modestly and simply, capturing attitudes and events as a photojournalist without limiting yourself to family and friends. The photograph can bear witness to historical events, evoke faces from the past and preserve them from oblivion, document environments, human situations, and social conditions with amazing clarity.

With the passage of time, photographs also acquire historical value. They can be highly evocative of different eras and ways of life expressed through the infinite number of details in settings, clothes, and attitudes. It is with good reason that photographs that were originally "private" have later become famous.

The Objectivity of a Photograph

Can a photograph lie? How much of the photograph is the truth? To what extent can a photographer create hoaxes? Photography, like all other means of expression (painting, literature, film), is just an instrument in the hands of the artist and as such can recount all kinds of tales with a

A spectacular reportage photograph which effectively conveys the sense of panic created by the tornado visible in the background.

in the capacity to create a successful image that interprets a given human reality in an original and independent way and to direct the viewer to that particular message.

Tourist Photography

Subject to our own outlook and sensitivity, each of us can contribute to the efficient documentation and interpretation of the environments, human situations, and traditions we encounter during our travels and vacations. Taking photographs has become such a widespread, simple, and enjoyable hobby that it has almost become an inescapable duty. A journey is soon forgotten if there are no photographs, whereas the faces of the people you have met and characteristic settings are soon recalled with the help of a photograph, even after decades have passed. Every event that is photographed is preserved and can be quietly reexamined and relived.

Every one of us can bring back interesting images from our travels. Above: Inside a Tunisian restaurant. Below: A "dialogue" between man and horse in Finland. Opposite: Father and son with the same serious and composed expression in an excellent image of South America taken by Fulvio Roiter.

greater or lesser degree of invention. It is undeniable that a photograph presents an objective view of reality that seems difficult to bend to personal interpretation, yet the question is not exactly applicable, for what is objectivity? Is it not perhaps true that if the same event were presented, say, in a theater it would give rise to differing interpretations on the part of

each person watching? A photograph is the materialization of a selective, personal view of reality. Although it is reproduced with its immediacy almost intact, it is liable to contradictory interpretations. Individual observers see something different in every human figure, depending on their own culture and capacity for insight; the photographer's ability always lies

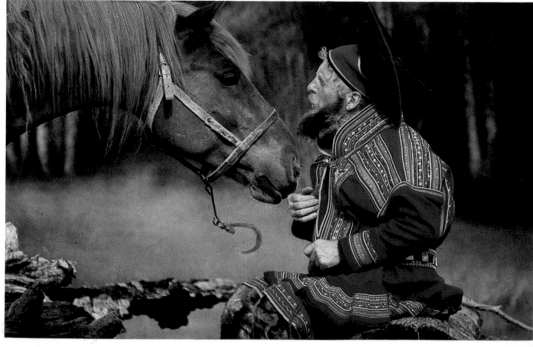

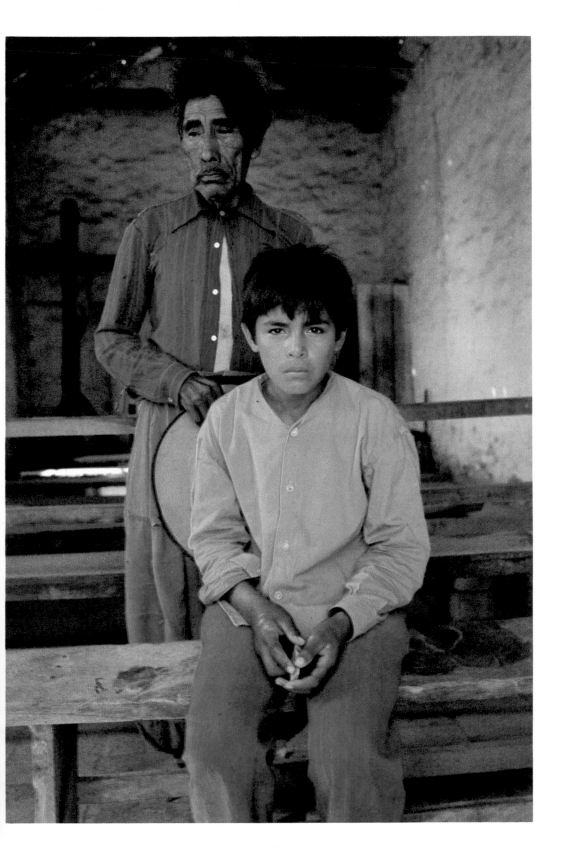

FLASH AND SHOOTING IN MIXED LIGHT

As we have already seen, taking photographs of people unawares presents many practical difficulties because you cannot alter the lighting or influence the subject's behavior. You have more control in shots where the subject does not object to being photographed and so can cooperate to help you create a successful image. This group of portraits also covers semi-posed photographs taken against an everyday background. This kind of portrait is preferable to one taken in secret because it is much easier to get good results at the right distance and with the right angle. In eliminating one problem, however, you encounter another—there is a high risk that the photograph may no longer look spontaneous. To reduce this danger, you must be able to make well-timed choices regarding the shooting conditions, the decisive moment of the expression, and the type of additional lighting that can be used to improve the image technically. As a rule, the only type of extra lighting available for this kind of photograph is flash, but in some cases it is also possible to add to the lighting with simple makeshift reflector screens, such as a sheet of white mounting board or any other white surface. The techniques of using reflector screens will be discussed in the section on studio lighting.

Flash Light
Flash is the most practical and versatile form of artificial lighting available to the photographer today. Its many advantages include the high speed of the light output, which eliminates blur; the smallness of the flash in relation to its power, which also means it is highly portable; and the color balance of the light, which allows it to be mixed with natural light. The only real disadvantage, one that cannot be ignored, is that you cannot see the effect on the subject immediately. Flash light comes from two sources: flash bulbs and electronic flash units.

Flash Bulbs
The light in flash bulbs is generated by combustion of the filament, so they can only be used once. Flash bulbs are now much less common than previously because of the increasing popularity of electronic flash units, which are much more practical and convenient. Bulbs are still used occasionally with inexpensive cameras, however, because they involve no investment in special equipment. The most common type of flash bulb is the blue-dot type, a flash bulb with the same color balance as daylight film.

Synchronization of the Flash
Because this type of light source is not important nowadays, we shall not go into detail on the synchronization techniques. Suffice it to say that an M contact is used to synchronize the shutter with the light emitted by the flash bulb, opening some 15 msec. after the flash is triggered, to allow the filament to begin combustion. You can, however,. use the normal X contact with a shutter speed under 1/30 sec.

Electronic Flash
This kind of flash is now the most common source of artificial light in photography, but before describing its use, let us have a look at the differences in the types of electronic flash units available.

Fixed-Output Flash Units
In fixed-output flash units the aperture is set in accordance with the guide number and the subject distance, but few of these models are around anymore. They are small, low-powered, pocket-size units that have been replaced by more practical automatic-output models.

Automatically Regulated Output Flash Units
Automatic-output models are now the most popular type of electronic flash, though the characteristics vary greatly between professional units and pocket versions. All you have to do with this kind of unit is set the aperture indicated on the flash selector, depending on the ASA rating of the film; the flash then regulates the light output within a given distance range by means of an external sensor. On the most basic models the sensor is fitted beneath the flash itself, but on the more complete and practical models, the light-sensitive cell is independent of the flash, as on the classic Vivitar 283. The great advantage of these units is that you can illuminate the subject as you like with the flash in any position, while the sensor on the camera accurately reads the amount of light reflected off the subject.

Automatic Flash Units Integrated with the Reflex Camera
This is a new generation of automatic flash units that work strictly in conjunction with the camera.

Direct flash in this image by Miguel Martin has cast hard, sharp shadows onto the red background, creating a kind of specular reflection that makes the image more dramatic, deliberately theatrical, and artificial.

The flash is connected by supplementary electric contacts through which the ASA rating set on the camera is relayed to the flash. The camera automatically selects the correct exposure time.

The most sophisticated automatic SLR cameras such as the Olympus OM-2, the Contax 137, and the Nikon F3 allow direct measurement of the light reflected by the film. The cells on the camera, which read the light reflected off the film during exposure, automatically regulate the light output. Because every different camera model has a different type of electric contact for the corresponding flash unit, only specially built units can be used with all their facilities.

This system of measuring the direct light on the focal plane offers such advantages that it constitutes a technological revolution in the use of flash. Compare the two drawings at the top of page 122, and you can see how the system works. Silicon light cells placed under the mirror of the reflex camera are turned toward the film surface and control the exposure, interrupting the duration of the flash at the required moment. In this way the camera operation is fully automatic even with flash. The measurement actually takes into account any accessory that could vary the effective quantity of light striking the film. A flashing light on the flash itself indicates that exposure has been sufficient. You can also use the indicator to check whether the operating conditions are right simply by doing a test flash. The superiority of this system is particularly in evidence

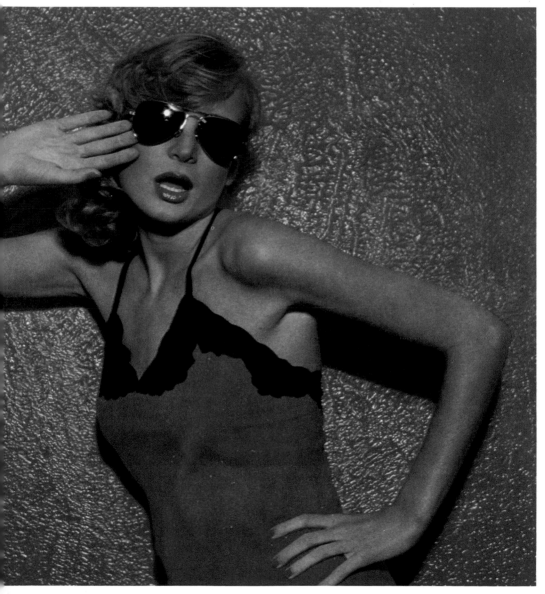

Right: The technique of bouncing flash off a ceiling when using a flash with a separate light cell fitted onto the camera. The light cell reads the light reflected off the subject. The flash can be put in any position, whatever is most suitable. The light cell on the camera unit measures the reflected light and stops the flash unit accordingly.
Center: The technique of bouncing flash off a ceiling when using a camera with a built-in light cell (such as the Olympus OM-2). The light cell reads the light directly that falls onto the film during exposure, allowing no possibility of error because the system takes into account all possible variables such as lenses, apertures, and reflections off walls.
Below: The light output from flash bulbs. The table shows the emission times of two types of flash bulbs compared with electronic flash. The light output depends on the type and size of bulb.

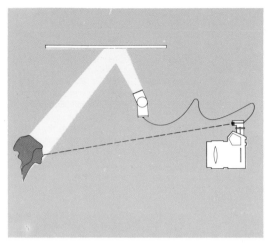

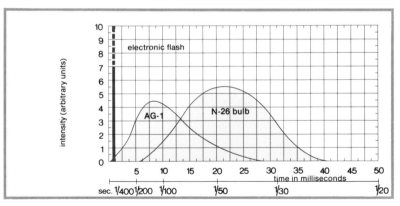

traits. They have one mobile lamp for reflected light and another fixed with less power on the front, providing one small piece of equipment that easily solves the classic problem encountered with interior shots when ambient light is not sufficient. The second flash can be preset for a constant light ratio within a given subject distance.

Choosing a Flash Unit
Power, price, weight, and size are the factors to take into consideration when you shop for a flash unit; normally these parameters increase proportionately. The choice of which automatic system to use depends mainly on what camera you have. Integrated flash units with the same facilities have undeniable advantages over the other kinds, but depending on what you plan to use them for, you may find an adequate compromise among some of the intermediate types that are small but quite powerful. Although small pocket-size flash units are highly suitable for filling in shadows, you need very powerful flash units for studio work.

The Guide Number
The guide number (GN) indicates the maximum power of the flash unit and corresponds to the stop necessary to correctly expose a middle-shade subject at a distance of 1 meter (3.3 feet) from the flash. The reference rating is generally considered to be ASA 100. Bear in mind that the guide number is a stop, and you can obtain the corresponding value for a different speed rating simply by considering that the amount of variation in aperture equals the variation in the speed

with telephoto lenses; although traditional external light-cell systems work excellently for long shots taken with a wide-angle lens, it is extremely useful to be able to control the flash output as a function of the effective

area of the subject being photographed in close-up. In this case, the presence of reflector or absorption screens around the subject has no influence on the exposure.

Twin-Lamp Flash Units
The reason for coupling two lamps in a single flash unit is the frequent need for the soft light of reflected flash combined with a fill-in light. These models are therefore specifically designed for por-

Right: The Fujica twin-lamp flash unit, which allows reflected and direct flash to be used at the same time. Center: The Vivitar 283 flash unit fitted with an accessory to reduce the angle of light output.

Below: A graph demonstrating the progression of stops necessary for correct exposure of ASA 100 film at different subject-to-flash distances ranging from 1 to 15 meters (3 to 50 feet). The six curves represent different flash-unit power levels (from GN11 to GN80), assuming that the light output is always at the maximum level—that the unit is operating manually. The value of the stops corresponding to 1 meter (red line) equals the guide number. Note that each time the distance is doubled, the diaphragm opens by two values in accordance with the inverse-square law. The limit on the distance which an automatic flash can work with a given guide number and a given stop can be evaluated from the curves.

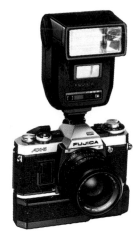

rating. For example, if the guide number is 16 for ASA 100, it would be 32 for ASA 400—two values smaller. However, there is a special calculator disk on the flash unit for rapid calculation of the right stop to use at different ASA ratings.

On the graph, the guide number is indicated by the red line, which corresponds to a flash-to-subject distance of 1 meter (3.3 feet); the six curves correspond to the different power levels of the more common flash units. To get the correct stop for a given distance, divide the guide number by the distance in meters, using the following formula:

$$aperture = \frac{GN}{m}$$

The distance range from 1 to 15 meters (3 to 50 feet) is the area in which flash can usually be used without special auxiliary equipment to modify the light band.

With automatic-output flash units, the guide number does not calcu-

late the necessary aperture for correct exposure but indicates the distance range at which you can work on automatic.

The graph demonstrates why the aperture determines the maximum distance at which the flash can be used on the basis of its power. In fact, even with automatic flash guns, you must set one of the stops recommended on the flash calculator disk for the particular ASA rating used. Then the exposure will be correct within the corresponding distance range.

Synchronization of Flash and Shutter

Electronic flash requires less than 1 msec. to produce its maximum light level, so the X contact is used because its response is almost instantaneous, whereas the M contact can be used only with flash bulbs because of its delayed action.

The drawing at the top of the following page shows that with the M contact, the shutter releases after 16 msec., during which time the electronic flash has already produced all its light. Many cameras have now done away with the M contact altogether. It is used much less, and it can cause irreparable damage with an electronic flash, for if you accidentally leave the switch on the M setting, all the frames taken will be wasted because the exposure takes place after the flash is over. The X contact can be used at all times, provided that you set a sufficiently slow shutter speed to take into account the delay in lighting a flash bulb.

Flash and Existing Light

The focal plane or blind shutter used on nearly all SLR cameras has one

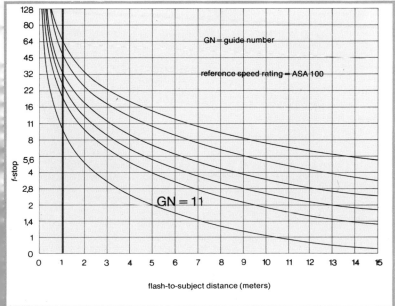

GN = guide number

reference speed rating = ASA 100

GN = 11

flash-to-subject distance (meters)

great limitation in that the time that can be synchronized with flash is never less than 1/125 sec., whereas with the classic bladed-shutter cameras like the Hasselblad, flash can be synchronized even at 1/500 sec. The limitation in the first case lies in the fact that for portraits taken in existing light, the maneuvering range is reduced with regard to fill-in flash.

To understand this more clearly, consider the mechanism that regulates the exposure in the presence of flash light and continuous ambient light (mixed-light shots). Look at the drawing at the bottom of page 124. The minimum shutter speed with a focal-plane shutter and flash light is that which allows the whole surface of the frame to be exposed simultaneously. Unfortunately, at faster speeds (such as 1/500 sec.) there is not even one moment when the whole frame is exposed at the same time, because the exposure actually takes place through a gap in the shutter moving across the frame. With bladed shutters, on the other hand, all the points on the frame are exposed simultaneously, even at the highest speeds. As a general rule (which holds even for focal-plane shutters), the aperture is the only means of controlling the amount of flash light striking the film, whereas the continuous existing light present on the scene is controlled by both the shutter speed and the lens aperture. With a constant shutter speed, any variation in aperture will affect exposure under both flash light and continuous light, but with a constant aperture any variation in shutter speed will affect the exposure

The top graph illustrates the synchronization mechanism for the light output from flash bulbs. One of two methods can be used with focal-plane shutters: either the M contact can be used, which delays the shutter opening by about 16 msec. to give the filament time to ignite; or, if this contact is not available, the X contact for electronic flash can be used, provided that the shutter speed is slow enough to give the bulb time to ignite and burn—1/30 sec. is usually sufficient. The bottom graph, on the

other hand, illustrates the mechanism for exposure with a reflex camera fitted with a focal-plane shutter with electronic flash. When the blind is fully open, as shown at the top of the graph, the light output begins and can last for a minimum of 1/50,000 sec. up to a maximum of about 1/300 sec. The light output is almost instantaneous; synchronization is accomplished by means of the X contact, which has a delay of about 2/1000 sec. to give the blind time to open fully. Reflex cameras with focal-plane

shutters can be synchronized up to a minimum time of 1/250 sec. Any existing light is added to that of the flash and can even become dominant if the exposure time is long enough. Opposite: An example of the use of flash for a daylight effect. The direct flash illuminates the face, but there is also enough light on the background to show the subject's environment.

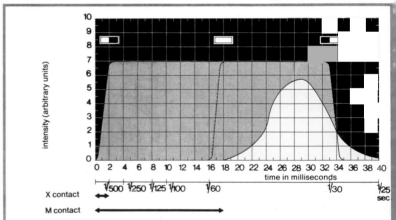

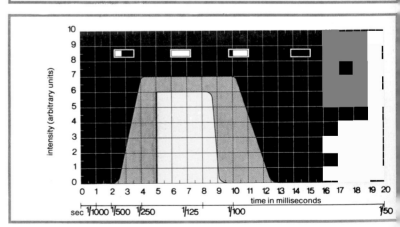

only under continuous light.

Consequently, with shutter speed and lens aperture combinations giving the same exposure value, the exposure will

remain unaltered under continuous-light conditions. But there will be a variation with flash light, so a short synchronization time is useful for providing more freedom

of action, since at faster speeds you can actually cut out the continuous light and let the flash take precedence. With bladed shutters located in the lens, a sufficiently fast

shutter can effectively cut off a relatively long flash, so in this particular case, exposure under flash light also depends on the shutter speed just as for continuous light. The following sections present the most typical conditions in which flash light is used together with ambient light.

Fill-in Flash

Fill-in flash is used to bring up detail in shadows and reduce light contrast. Exposure is determined by continuous daylight only, and the aperture is selected to limit the effect of the flash light to filling in the areas of shadow. This method is widely used in outdoor portraiture in the presence of hard shadows.

Night Effects

At night, the flash seems to be the only light that illuminates the scene; the subject becomes isolated against a progressively darker background. This is the typical effect of instant pictures taken with flash at night and of journalistic pictures. The subject is often presented in an unnatural and unpleasant way, because of either the harshness of the shadows or the rapid fall-off in light behind.

Other Features of Automatic Flash Units

Modern automatic flash equipment offers various features through a system of accessories that can satisfy the most varied demands of photographers and have thus become the pivot on which the true lighting system is based. New creative possibilities that were reserved for specialist equipment until recently are now within the reach of all photographers. The following are some of the most interesting features:

The *variable-reading-angle light cell* eliminates interference from dark and light backgrounds and concentrates solely on the subject.

The *power transformer* enables you to adjust the amount of light emitted by the flash unit, usually by stops. This is particularly useful when you want to graduate the exposure without altering the conditions of shooting even with the extremely fast exposure

times possible with a flash. Some models, like the Rollei Beta 5, have a special button that allows variation of the light output by one exposure unit to facilitate the production of bracketed exposures.

The *correct-exposure light* comes on for a moment immediately after the flash to indicate whether the reflected light read by the sensor was sufficient on the basis of the stop set. This is useful for checking the regularity of the exposure, and it can also be used to find the best aperture in the real conditions of shooting by firing a few test flashes.

The ability to fire a rapid sequence of flashes is an attractive feature which allows the study of movement and is very interesting in portrait photography. The Minolta 320X, for example, permits exposure of two to five frames per second.

The *slave unit* is an accessory which, when connected to the flash, fires a fully synchronized flash when it receives the light from another flash. On some models it is incorporated into the flash unit itself. Slave units, because they eliminate the need for all the usual cables, are very practical and particularly useful in studios.

Improving the Use of Flash

The advantages of flash light are so numerous and so great that photographers cannot do without it now. The only true disadvantage, as has already been stated, is that you cannot see the effects immediately. In fact, you can never be really sure of the results when you have finished shooting. You cannot trust your own eyes to evaluate the lighting properly,

so you have to adopt substitute techniques.

There are certain points to remember when using flash light. First, it should be considered in the same way as continuous light, in the sense that it does not in itself present any different qualities: flash light can be used to get exactly the same photographic effects as continuous light, using the same rules and criteria.

The speed of the light output is a great advantage in photography; with flash you can freeze movements that could not be arrested in any other way. Not only is the problem of blur removed, but the images acquire much greater clarity, which is difficult in traditional continuous lighting without very short exposure times. What is more, camera shake is effectively neutralized, so you can work freehand without problems.

How to Use the Flash Unit

Electronic flash is necessary, or at least useful, in two typical circumstances: in the presence of high-intensity light such as sunlight, when it acts as a fill-in light on the shadows that are too dark and contrasting, and in conditions of low light intensity when a fast light that freezes movement is valuable. Finally, electronic flash is also useful when you need an easily portable light system to take certain shots.

Flash Fitted on the Camera

All modern 35mm SLR cameras have a hot shoe connection which makes taking the flash photograph much easier. But having the flash positioned above the camera produces lighting parallel to the lens axis, which is

not normally advisable in photographs of either the face or the full figure; the resulting images are flat with no depth and with long shadows projected unnaturally behind the subject. You also get the classic red-eye effect, which is caused by light bouncing off the bottom of the retina, which is red. This effect can be produced only with coaxial lighting, as the subject's eyes dilate when he or she is in the low-ambient-light conditions. Because

Above: Portrait of a Burmese actress taken with frontal flash. Below: When flash is used for family photographs, take care to avoid unnatural results.

Opposite, top: Another negative example of a family photograph: bounced flash would not have produced the hard shadows. Center: Flash fitted with an accessory to diffuse the light. Bottom: The Air-Brella inflatable plastic diffuser.

angle, this kind of light produces effects similar to those of the rays of the sun because its direction and intensity are similar to those of natural light. The lamp must be far enough away from the subject that the rapid fall-off in light intensity is not obvious, but sharp, dark shadows are formed which are suitable only for very expressive portraits set against a detailed background.

Reflected Flash
The most efficient and versatile method of illuminating the human form is reflected flash. It can produce a variety of effects ranging from soft to modeled, all highly suitable for portraits set against an interior background. The light can be bounced off a ceiling or light, neutral-colored walls. Alternatively, you can use special reflector screens like the classic umbrellas, which are unbeatable for their practicality and lightness.

Portable Reflector Screens
This kind of diffusion screen is very practical for "on location" shots because of its simplicity and lightness. A white card has been designed for the Vivitar 383 which fits above the flash and significantly increases the size of the source and the softness of the light. The reflection also gives the light a more favorable angle as the source becomes higher and at a greater angle to the lens axis. One side of the card is white and the other is standard neutral gray, so it can also be used for making exposure checks.

Another practical and useful system is the inflatable white plastic diffusers such as the Air-Brella and the Air-Diffuser. These are very

light, easy to set up, and highly portable, making a large circular illuminator that diffuses light efficiently. The technique of illuminating by flash and diffuser is basically simple, but it requires a certain degree of experience because you cannot actually see the shadows produced.

How to Check Reflected Light
With normal flash units and the correct bounced-light techniques, you can produce high-quality images that combine the softness of diffused light with the modeling of directional light. Be careful how the reflected beam strikes the subject, however. As you can see in the top drawing on the following page, a subject can be illuminated by different types of reflection: one provides a beam of light that strikes from above, whereas the other illuminates from below, with very different results. Only the light striking the subject from above, usually at an angle no greater than 45 degrees, produces a pleasant, natural effect. The lower light, on the other hand, creates a theatrical, almost ghostly effect suitable for dramatic settings, which could be useful when it is used as a fill light to reduce the contrast of the shadows. As shown in drawing 4 on page 128, the light can also be bounced off a white surface placed on the floor at the correct distance to give the proper intensity.

The most normal conditions are shown in drawings 2 and 3 on page 128. When you bounce light off a wall, you should visualize the angle of the emerging light in order to estimate the effect of modeling on the face. An intermediate

of all this, lighting parallel to the lens axis generally produces portraits that are unnatural and not very pleasing, and so this effect should be used only for purely creative motives, such as to suggest dreamy, dramatic situations and to create unusual atmospheres in cinematic style.

This position of the flash is, however, suitable for fill-in light because, being parallel to the lens axis, it illuminates even the deepest angled shadows without creating any more shadows of its own. This technique reduces the light-shadow contrast to an acceptable level for the film.

Separate Camera and Flash
This arrangement produces good-quality light because it successfully simulates ambient light. Directed downward from a height at the correct

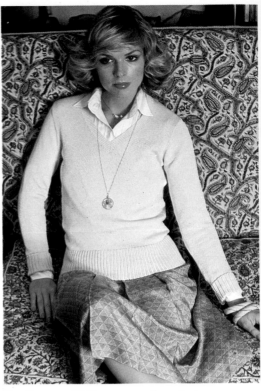

Right: Direct flash was used with a diffuser in a setting with light-colored walls. For the photograph below, a very soft effect was obtained by bouncing the flash off the ceiling and using a "pastel" filter.

2

3

4

The diagrams: (1) The angle of light reflected off a wall determines the quality of the lighting. Here the person is illuminated by reflection from above and below. (2) When flash is bounced off a ceiling, dark shadows can be created on the eyes if the flash is too close, because the light falls from above at an angle greater than 45–60 degrees. (3) Flash bounced off wall; flash unit is positioned for a good light angle. (4) Flash reflected off the floor can be useful only as fill light. (5) With a wide-angle lens, the beam of light from a flash unit may be too narrow for the area in the frame, leaving the sides of the image in shadow. In this case the light should be bounced off the ceiling or used with suitable diffusers. (6) With a telephoto lens, on the other hand, the beam is only partly used because it is too wide; the angle of output should be reduced by means of suitable lens attachments for more effective use of the flash. (7) Inaccurate reading by the light cell of the flash fitted on the camera. The reading is being taken off the wall and not the subject, resulting in inaccurate exposure.

5

6

7

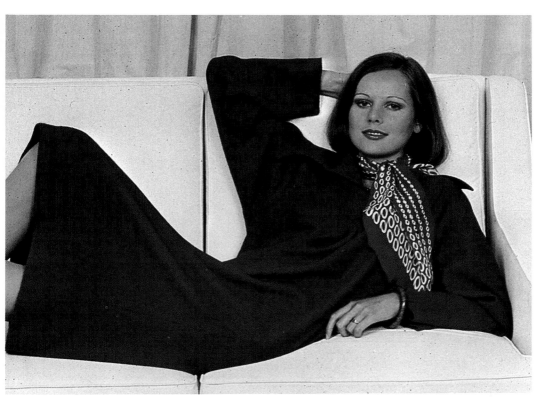

This photograph shows the effect of flash light diffused by bouncing it off the ceiling in a setting with light walls.

Below left: Bounced flash is useful with wide-angle lenses, because it illuminates the whole setting in a natural way. Because of the size of the setting, however, the power might be insufficient; you can supplement it with other synchronized flashes.
Right: When you use flash with a telephoto lens, you can improve the shot by positioning the flash closer to the subject.

angle of about 45 degrees is suitable for any subject and so is the most advisable, at least as a starting point.

When you bounce light off a ceiling, do not exceed an angle of 45 degrees to the vertical. In fact, reflected flash striking the subject from above forms heavy, unpleasant shadows about the eyes, although moving it a bit farther away provides more pleasant and natural illumination. The absorption of the wall in general is not less than 2 EV. Pay particular attention to avoiding walls with a slight color, which give rise to annoying

dominants.

Reflected flash can also be used to provide soft, natural illumination in large settings. This technique cannot be beaten when you use a wide-angle lens for a portrait in a detailed background or one of a group of people. If you were to use a flash fitted onto the camera, you would find two problems: drawing 5 (facing page) shows that the beam of light may be too narrow to illuminate the whole scene framed by the lens, and there would also be an unpleasant fall-off in light between the closer subjects and those farther

away. Both problems are avoided when you use reflected flash, as can be seen in the drawing below left.

LIGHTING

We are used to identifying reality with the image seen, so when a face looks beautiful or ugly in a photograph, we do not instinctively distinguish between the object itself and the particular light image we see. This can be partly justified by the fact that sight is a dynamic process capable of neutralizing considerable differences in light quality, whereas film simultaneously registers one single image. It is a more rigid system, which consequently must be controlled if it is to produce natural and pleasing results that are closer to what we expect to see. Remember that the light and the surface of the subject contribute equally to the formation of the image on film, and although it is often impossible to alter the subject, you can usually modify the lighting. Different images of the same scene and subject can project totally different meanings through the use of lighting techniques. The very essence of photography is obviously knowing how to control the light.

The Principles of Lighting

You must evaluate and understand the effects of light in order to be able to control it at will. Remember too that lighting has basic psychological implications: the quality of the lighting almost always determines the quality of the portrait. Lighting is subject to the following laws.

The Inverse-Square Law

The brightness of a surface decreases as a function of the inverse of the square of its distance from the source. Although this statement

appears to be complicated, it is actually quite straightforward. Look at the diagram below and the one at the top; it is immediately clear that at twice the distance, the same beam of light is distributed over a surface four times as large. This law applies to all spheres of photography, so it is important to familiarize yourself with the concept. We can translate it into photographic terms as follows: by doubling the distance of a light, you lose 2 EV in the exposure.

This is just a general guide, because of course there can be logical exceptions; for example, a ray of light that is artificially made parallel by means of lenses tends not to open out within certain limits, and so the light strikes roughly the same area even at twice the distance. This is the case with a focused beam like a spotlight.

Top: If the distance between a light source and the surface it illuminates is doubled, the intensity of the light is reduced to one-quarter because the same light is distributed over four times the area. Above: When light is reflected from a screen, it retains a certain direc- *tional quality.*
Below: The curve indicates the progression of the light gradient on the basis of the source-to-subject distance.
Bottom: A diagram of the ratio between the f-stop and the distance of the light source.

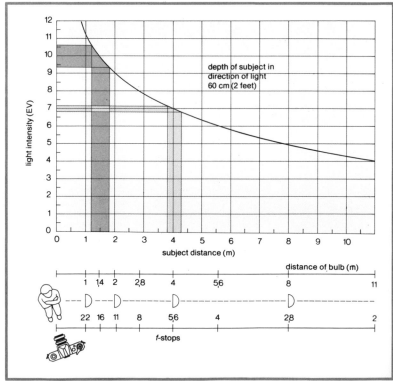

130

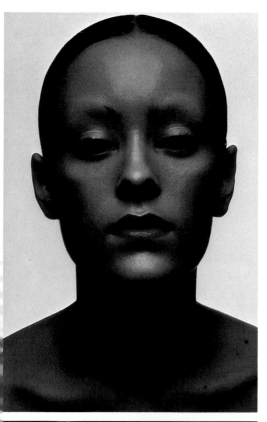

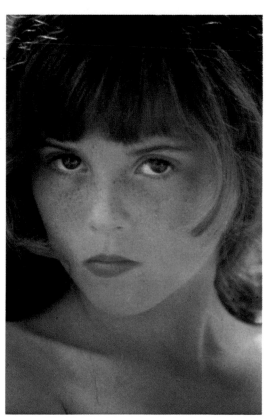

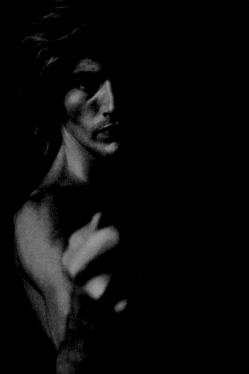

Examples of effects obtained with different kinds of lighting.
Above left: Light from above in a photograph by Pete Turner. Above: Diffused light in a portrait by David Hamilton. Left: Edge lighting in a portrait by Tana Kaleya.

The Law of Reflection

The angle of reflection equals the angle of incidence. The quality of reflected light depends on the characteristics of the reflector surface. On a mirror surface, the light beam changes direction but not characteristics. On an opaque reflector surface, on the other hand, such as a white screen, the reflected light will reflect in accordance with this law, but the angle will be wider because of the effects of diffusion.

The Quality of Light

Different types of light produce completely different photographs. Knowing how to measure and control the quality of the light means being confident of obtaining a given effect accurately. Controlling light is an art that requires sensitivity, a good eye, and imagination, as well as technical skill.

Light has thousands of nuances, and the combinations for lighting a face are infinite, even if at first sight they seem to be quite limited. Yet even when you use the standard lighting formulas, to a certain extent you can obtain different results; this is part of the creative side of photographing people.

The Parameters of Light Sources

The characteristics of artificial light sources depend on the parameters of intensity, color, and brilliance. The intensity of the light is sometimes expressed in candle power or, more commonly, in watts.

The color temperature—the color of the light emitted—is expressed in degrees Kelvin, or the corresponding mireds. The color temperature scale is used to measure the color difference in light from sources which have a continuous-output spectrum. Fluorescent lights have an irregular output, so their light cannot really be compared and included in the Kelvin scale, but for the sake of convenience they are given as close an approximation as possible.

Brilliance is a measure of how bright and intense the source appears; it is expressed in candles per square centimeter of the surface area of the source. In photography the brilliance of the light source is very important; in fact, the quality of the light is closely related to what we can call the

Top: Intense directional lighting creates lines of light, modeling the profile and leaving the face in shadow. Left: An elegant portrait by Hamilton. The lighting is soft, but it has a certain directional quality that models the face. Opposite: Another example, by G. P. Barberis, of directional and diffused lighting used simultaneously. A beam of light falls on the subject at an angle to give the image grace, softness, and contour.

The light field of a point of light in a black box. The light decreases rapidly the farther away it is from the source, following the inverse-square law; its intensity at every point depends solely on the distance between the subject and the light source. This light field casts deep, sharp shadows, typical of flash light at night in the open. Any setting with very dark walls that absorb the light acts as a black box. The image on the opposite page, by Christa Peters, is an excellent example of a photograph taken in these conditions.

The light field of a point of light in a white box. The walls reflect and diffuse the light, so the light field does not depend only on the source, but also on the distance of the reflecting walls.

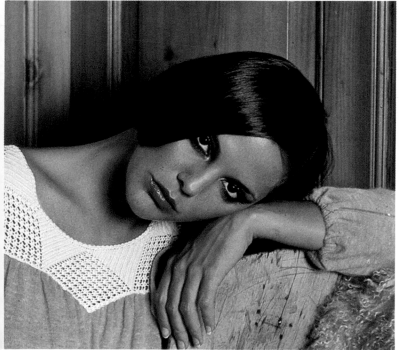

"light density" of the radiating surface. For example, a 500-watt lamp with an internal reflector bulb presents an illuminating surface of about 150 cm² (24 square inches) with a brilliance of 4.1 candles/cm². This kind of light is blinding and annoying, and it produces sharp, harsh shadows. If you put the same bulb into a diffuser that has a surface area of 1 square meter (10.8 square feet), however, the brilliance of the new light source, which has the same total power, would be 0.06 candles/cm²—that is, about sixty times less than that of the original.

To characterize photographic lighting, it is useful to talk in terms of the *light field,* which can be defined as the space in which a given light system is working. You cannot, in fact, separate the light source from the scene it illuminates. These two elements interact constantly, and their interaction determines the photographic image. The illumination of a face in sunlight on a light beach, for instance, will be very different from the same face in sunlight but taken against a dark rock. To show this, let us examine the more interesting light fields.

The Light Field of a Point of Light in a Black Box

The size of the light source is negligible relative to the dimensions of the box, and the intensity of the light in the various points at which the subject can be placed depends entirely on the distance from the source, following the inverse-square law exactly. Walls make no contribution to the lighting because they absorb nearly all the light they receive, so the shad-

Above: The rays of the setting sun in this beautiful photograph by Pete Turner create dark shadows which become the main structure of the image, extending the underlying meaning of the seated couple.
Right: A ray of light breaking through the darkness creates a highly suggestive light field in this photograph by Robert Farber. Both of these photographs are examples of the parallel light field shown in the diagram below.

ows are long, harsh, dramatic, of high contrast, and with clearly defined edges.

The Light Field of a Point of Light in a White Box

The walls reflect and diffuse the light, so the light field covers every part of the box, from the distance both of the source and of the walls. By varying the position of the subject, you get different illumination: closer to the source, the shadows have more contrast, but closer to the walls, they are softer though still with sharp edges. There are

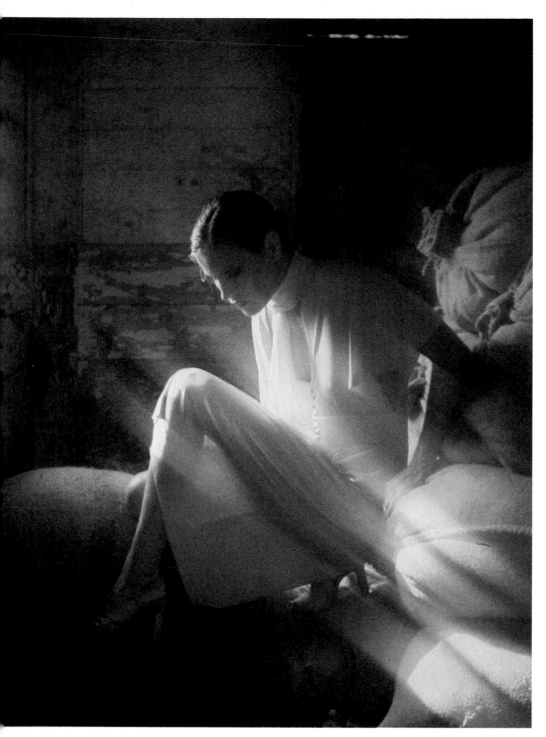

no harsh shadows as in the previous case. These conditions are similar to those of a photographic studio with light-colored walls.

This type of light field and the previous category provide the reference for all the other possible kinds of light fields.

The Parallel Light Field

This is made up of the ideal black box with one of its walls missing, through which a beam of parallel light enters from a source in infinity. This model corresponds to the illumination provided by a ray of sunlight entering through a window, or a spotlight in which the light is artificially made parallel by means of lenses. The intensity of the light is constant over the whole area of the field, and the shadows are very sharp and harsh, following the shape of the subject exactly. This type of light also produces silhouettes and profiles with great clarity and precision.

The Uniform Light Field

This is a box in which the walls make up the light source. The subject produces no shadows, regardless of position, and every variation in tone is

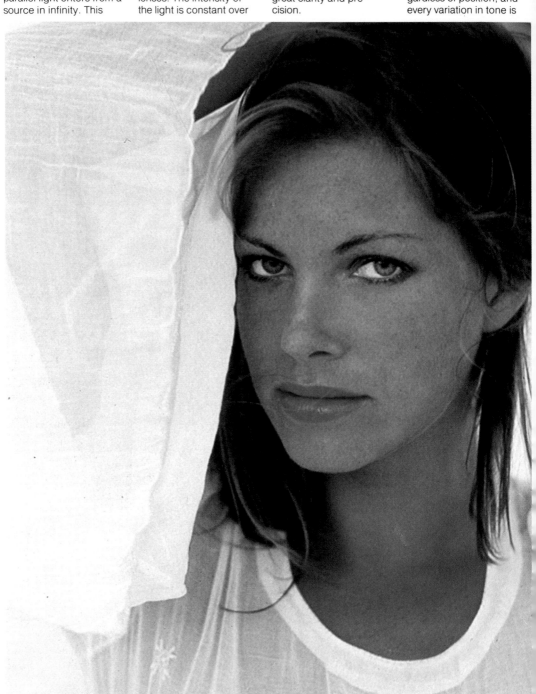

Below: A uniform light field has no shadows whatsoever, and so plays down any flaws in the skin (wrinkles, etc.), but it also removes all sense of volume. The photograph on the facing page shows very soft and highly diffused lighting which could be classed as an almost uniform light field.

The illuminating wall (diagram below) is an important variation of the uniform light field. It creates a wave of gradually decreasing light which has the characteristics of both directional and diffused lighting. It is suitable for portraits because of the excellent way it models the face without creating any harsh shadows. The photograph below by Tana Kaleya is a very good example of this kind of illumination.

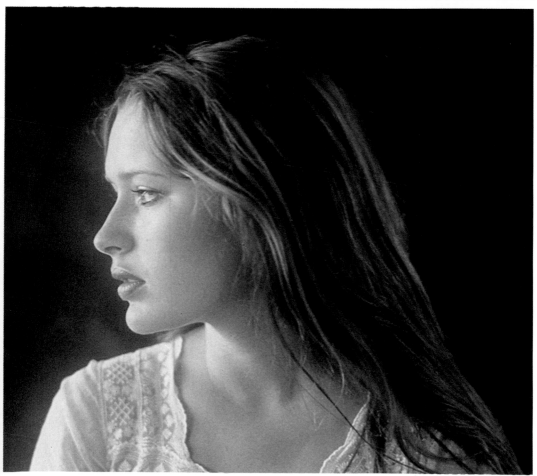

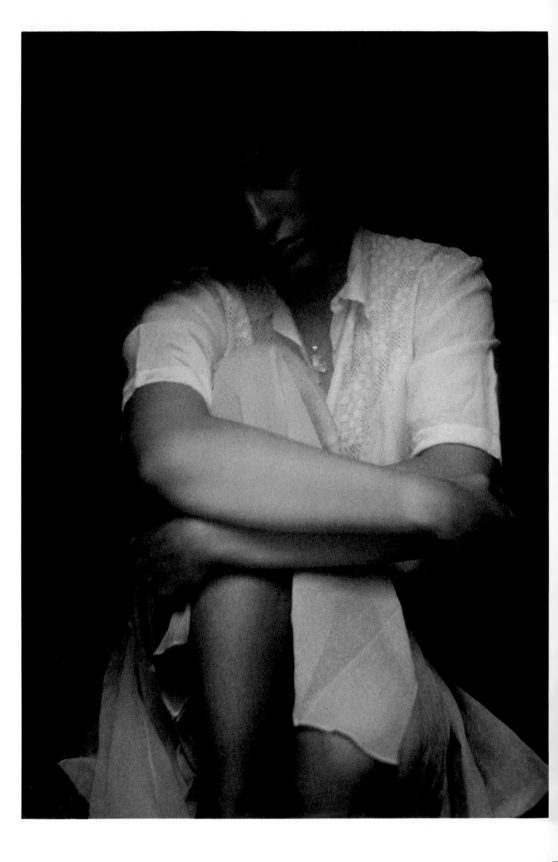

As described on this page, the reduction in light intensity with increasing distance from the source is much more rapid when the source is closer to the subject. As shown in the diagram above, if the subject is 1 meter (3.3 feet) from the light, set the aperture at f/16, but if the subject is 2 meters (6½ feet) away, use f/8; thus you lose two stops—2 EV. In other words, the gradient is equal to 2 at 1 meter (3.3 feet). The lighting conditions are less critical with a low gradient.

Opposite: A beautiful image by David Hamilton. The intimacy is created by lighting that strikes the model with different intensities.

Below: An example of high-contrast lighting.

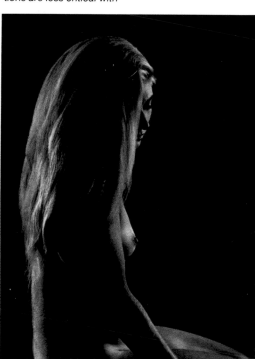

determined solely by the intrinsic characteristics of the surfaces. Consequently, there is absolutely no sense of contour or modeling. As a result, these conditions are ideal for measuring the natural tonal scale of the subject.

The Illuminating-Wall Light Field

This is similar to the previous case, but only one of the walls is a light source. This produces a much more interesting field: a flat light front progressively fading in accordance with the inverse-square law. The illumination of the subject depends solely on its distance from the illuminating wall, and the shadows are soft with diffused edges but with good relief. Examples of this kind of low-brilliance, large-area light source are a north-facing window or a studio light bank.

All the most common forms of illumination fit into one or a combination of these categories. In conclusion, it is the form and structure of the light field that create a photographic effect, not the intrinsic intensity of the light. This important fact explains how it is possible to obtain quality lighting even at low light intensities.

How to Characterize the Light Field

A useful concept for quantifying the characteristics of a light field is that of the *gradient*. In practice, the light gradient can be defined at the point at which the subject is positioned as the number corresponding to the increase in exposure values necessary to get the same exposure when the subject is brought 1 meter closer to the source. In a uniform or parallel light field, for example, the gradient is equal to zero at each point, but in the more common case of the single light source (as in the first two examples described), varying the position of the subject necessarily means changing the exposure. In this way, if the subject is 1 meter (3.3 feet) away from the light, he or she need only be brought about 30 cm (1 foot) closer for an increase of 1 EV; but if the subject is 2 meters (2½ yards) away, bringing him or her 30 cm (1 foot) closer would mean altering the exposure by a third of a stop. Obviously the effect on the subject will be different: in the first case, the illumination will be visibly more intense on one part of the subject than on the other, whereas this effect will be hardly noticeable in the second.

Look at the graph on page 130. If a subject with a depth of about 60 cm (2 feet) is placed 1.5 meters (5 feet) from the light source, there will be a variation in light of about one whole exposure value between the part nearest the light and the part farthest away— that is, double the light intensity. If, on the other hand, the subject is placed at an average distance of 4 meters (13 feet), the difference will be less than a third of a stop.

Lighting Contrast

There is yet another concept that is very important to understand fully if you are to know how to control the light field: light contrast. *Contrast* is a general term used with many meanings, depending on the context; it indicates difference and diversity, and in this case it is closely related to the concept of the gradient.

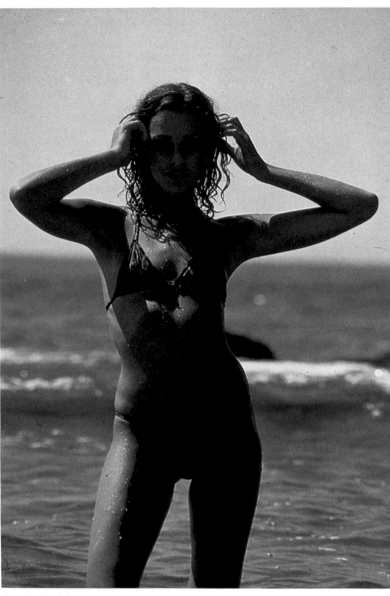

geometrically instead of logarithmically as with exposure values.

The table on page 142 shows the correspondence between these two ways of expressing the same parameter. The term *contrast range* is not, however, always used to mean the same thing; to some, in fact, it corresponds to the effective brightness range between two sources that illuminate the subject independently, in which case the measurement is made by switching off all lights except the one being measured. These different interpretations create a certain amount of confusion.

The contrast range, or shadow-highlight contrast, is the fundamental parameter for controlling the quality of the light and, as a result, that of the image. Selecting a given light-shadow contrast is a creative choice that is part of the general strategy of total control over the image.

How to Measure Light Contrast

Whether in the studio or in the open air, light contrast plays an essential role in the technique of portraiture. It determines the light-shade balance, and is important for achieving a pleasant, modeled portrayal of the face.

Contrast can be measured with an incident-light meter in the following way: Place the meter near the subject, pointing toward the main light source, to get a reading for the highlight areas—the brightness intensity in the lightest areas. Then cover the cell with a diffuser and point it toward the camera, screening it from the main light source, as in the drawing on page 143 on the right. This reading

A subject in full sunlight has heavy shadows next to highlights. In these conditions it is necessary to measure the light contrast and reduce it with fill light.

Lighting contrast is the difference between the brightness of the area in shadow and that in light of a subject at a given point in the light field. In effect, it indicates the contrast range on the subject and how deep and dark the shadows are. Traditionally, light contrast is indicated as a ratio between the brightness of areas in shadow and in highlight by means of a fraction, expressed

Light contrast and corresponding contrast ratios																
Difference in EV between light and shade	0	1/3	2/3	1	1 + 1/3	1 + 2/3	2	2 + 1/3	2 + 2/3	3	3 + 1/3	3 + 2/3	4		5	6
Contrast ratio	1:1	1,2:1	1,5:1	2:1	2,5:1	3:1	4:1	5:1	6:1	8:1	10:1	13:1	16:1	32:1	64:1	

corresponds to the areas of shadow.

The difference in exposure values indicates the shadow-highlight contrast independently of the tonal features of the subject in the same lighting conditions. If you want to convert this value from exposure values to the corresponding brightness ratio, use the data in the table. Or you can calculate it, remembering that each difference in exposure value means double the light intensity—for EV = 2, for example, the brightness ratio would be 4:1.

If you use a reflected-light meter, however, you must use the standard gray card as shown. Place the gray card opposite the main light source close to the subject and measure the brightness of the light that reflects off it; this measures the highlights. Then move the card into the shaded area and measure the reflected brightness in the same way to get a measurement for the shadows.

MEASURING LIGHT CONTRAST

```
                    ┌──────────────┐
                    │    light     │
                    └──────┬───────┘
                           │
   ┌──────────────────┐    │    ┌──────────────┐
   │ measurement of   │◄───┴────│ position of  │
   │ incident light   │         │ subject      │
   └────────┬─────────┘         └──────────────┘
            │
   ┌────────────────┐          ┌──────────────┐
   │ highlight      │          │ shadow       │
   │ pointing to    │          │ pointing to  │
   │ main light     │          │ camera       │
   └────────┬───────┘          └──────┬───────┘
            │                         │
            │   ┌─────────────────┐   │
            └──►│ difference      │◄──┘
                │ △ EV = 2?       │
                └────────┬────────┘
           ┌─────────────┴──────────────┐
   ┌───────────────┐          ┌──────────────┐
   │ medium to high│          │ low contrast │
   │ contrast      │          │ △ EV ≤ 2     │
   │ △ EV > 2      │          └──────────────┘
   └───────────────┘
```

Above left: To measure light contrast with reflected light, use a regular exposure meter or one built in on the camera, as long as it is the spot type. For a practical and correct measurement, read the light reflected off a standard gray card, though you can also measure the light reflected off the face. Take the measurements in both shadow and highlight areas; the difference between the two is the light contrast.
Above: A diagram similar to the previous one which shows how to obtain the light contrast with an incident-light meter. The measurement in the shadow should be taken while the cell is appropriately screened. The table at left summarizes the operations.
Below: The effect of using the sun's rays to illuminate hair. In the one on the right, a reflective white card lightens face.

How to Alter Light Contrast

In a light field of one single light source, the brightness contrast can be altered in the following ways:

· Reduce the brilliance of the source by increasing its surface area, such as through a diffusion or reflector screen.
· Increase the level of diffused existing light by using more reflective walls or screens to diffuse the light from the source.
· Bring the subject closer to reflector walls, or, more simply, use appropriate screens.

In a light field with two light sources, however, you can balance the relative lighting to remove shadows thrown by the

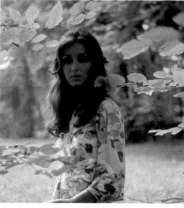

main light. In this way you can completely neutralize all shadows and create a uniform and vague field.

Characteristics of Light Fields Used in Photography

Relatively few light fields are actually used in photography, but those that are used produce an infinite number of effects. The light field is pleasing and seen as natural when it satisfies certain rules imposed by experience and visual physiology.

A natural three-dimensional effect is produced only when one single light source determines the formation of the shadows. Remember that more than two lights should never be used to create the light field in a portrait and that only light falling from above within a relatively limited angle range is accepted as natural and pleasing. The lighting arrangement that could be said to act as the reference is that of the mid-afternoon sun, never the sun at midday. In effect, the light should come preferably from above and to one side, with an angle of 45 to 0 degrees relative to the horizontal direction of the photographer.

Learning to Observe Lighting

It is quite useful to be able to observe light fields, even when you are not taking photographs; doing so helps to enrich your visual experience and transforms the observation of daily reality into an interesting perception of images, forms, and colors with a "scenic" meaning. It is also a useful exercise to pinpoint the types of lighting used in successfully constructed images created by photographers, directors, and set designers, experts who are capable of making the most of the great capacity for expression in theater, films, and TV lighting. The following are the ways to recognize the illumination used in normal environments.

First, you must pinpoint the light source and the field it creates. This means assessing how many and what type of

The photographs on these pages show somewhat different light fields. Below: diffused light softens the image; the shadows have extremely diffused edges. A bluish reflection, presumably off water, lightens part of the face.
Opposite: An example of 45-degree lighting typical of the sun in mid-afternoon. The shadows have very sharp edges that make it easy to deduce the light's direction.

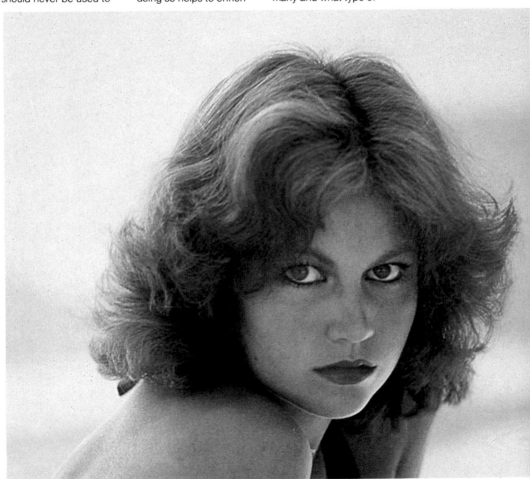

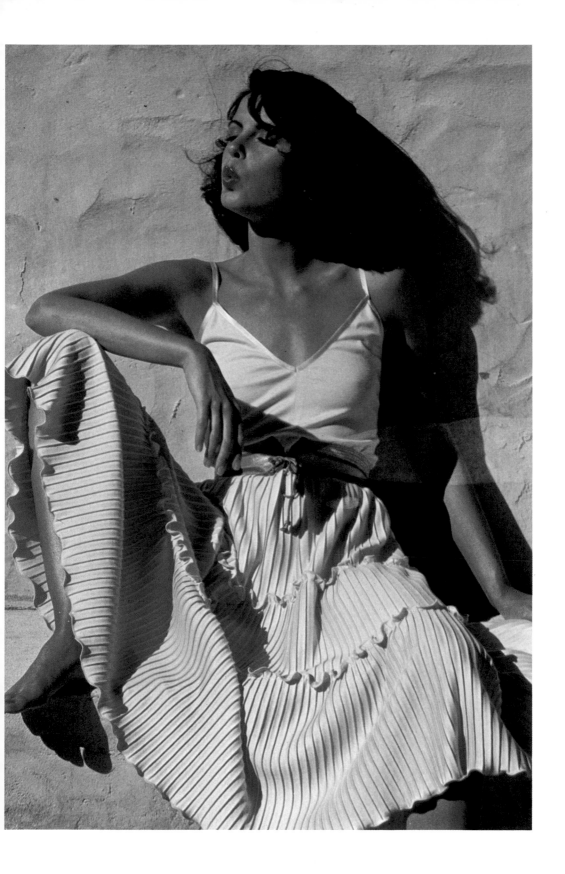

lights are present and which reflective walls help reflect the field. The light field of an illuminated window, for example, is completely different from that of a street lamp. Consequently, you must assess the size, outline, and shape of the shadows, which in photography are a form in themselves, more important and autonomous when the contrast is greater. Shadows also indicate the direction of the light source, and their edges reveal its brilliance through their sharpness and clarity, as well as their distance from the source.

The final step is to estimate the brightness level of the scene.

Diffused and Directional Light

Directional light is formed by a source that is small in relation to the size of the subject and the distance at which it is placed. The light from a flash is strongly directional if it is used to illuminate a face, but it is not so when used to illuminate an insect of a size similar to that of the source from fractions of an inch away. Directional light is characterized by the formation of sharp-edged shadows that have an important aesthetic and psychological meaning. Because of its similarity to sunlight, it communicates vivacity, modeling, decisiveness, and strength.

Light is considered *diffused* when it throws lighter shadows with undefined edges and is obtained with low-brilliance sources that are very wide or close to the subject. Diffused light is comparable to light from an overcast sky and conveys calm, intimate harmony, melancholy, and reflection rather than ac-

tion and decision.

There is no clear distinction between these two important types of light. They are used together at times to create an infinite number of effects. You could say, however, that light loses its directional characteristics when the angle extended by the source (assumed to be circular for the sake of simplicity) exceeds about 10 degrees when measured at the point occupied by the subject. The light be-

The three drawings at left represent the shadows that can be created depending on the type of light source used. In the first case, a light source (such as flash) smaller than the subject throws deep, sharp-edged shadows. In the second case, the size of the light source is comparable to that of the subject, thus

comes definitely diffused when it exceeds an angle of 30 degrees.

Artificial Light

Artificial-light sources fall into two very different categories: continuous light, and short-output light—flash. We have already discussed the use of electronic flash, so now let us have a look at continuous-light sources.

The purpose of using artificial light is to provide lighting that is available whenever you need it and

creating a narrower area of deep shadow and an area of penumbra which depends not only on the depth of the subject but also on its distance from the source. In the third case, the light source is decidedly larger than the subject; the area in shadow almost disappears.

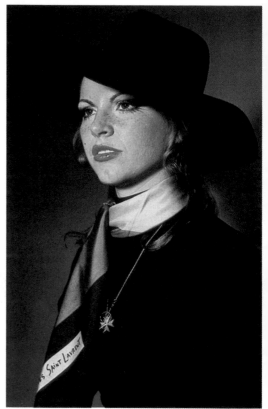

Above: Directional light creates hard, sharp shadows that model the figure and produce aggressive and incisive images of violent contrast.
Opposite: Combined directional and diffused light produces images that are progressively softer, sweeter, and more romantic. In this photograph by Gian Paolo Barberis the light is screened on the bottom, focusing interest on the face.

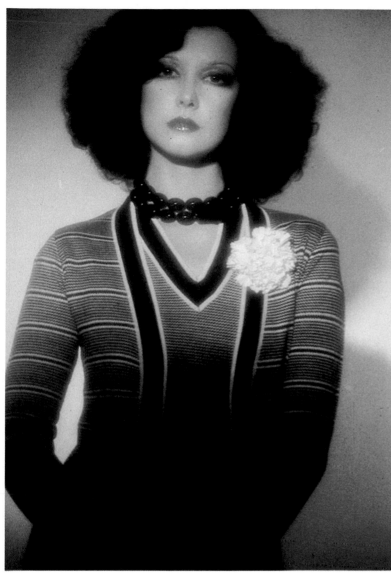

cm (1 foot) in diameter. It is a directional light source useful for studying the shadows and highlights on the face.

Quartz-halogen bulbs rated from 250 to 2000 watts are very bright, though small. They are long-lasting, balanced at 3200 K, and highly suited to artificial-light film. They are available for movie lighting systems in housings that can be used on tripods. The most practical versions have a built-in fan to disperse the great heat emitted. They are not usually used directly because the light is very hard and directional, but they are excellent for light bounced off panels, for they still give a good light level because they are so powerful.

Boosted 3200 K bulbs (like photofloods) are available in various types ranging from 250 to 500 watts. They last on the average up to a maximum of 100 hours. They can be supplied as internal reflector units. These are the most traditional bulbs used in studio reflectors.

Boosted 3400K bulbs are used at a higher voltage and so give out more light, but they have a shorter life of six to ten hours. They are mainly used by professionals with film specially designed for that color temperature.

Fluorescent light bulbs like the standard fluorescent tubes emit noncontinuous irregular light which produces unpleasant greenish tones in photographs taken with daylight film. Consequently, it is not advisable to use them with color film, but they do have advantages when used with black-and-white film for two important reasons: they are available in large sizes and they produce a cold light.

can be controlled as desired. Continuous light is used almost exclusively in interiors, while flash light can be used just as easily indoors or out. The big advantage of continuous lighting, however, is that you can check the illumination directly, but it does also have practical disadvantages in that it requires much more cumbersome equipment which has to be plugged into a power source, and it gives proportionately less power than flash light

from the same-size equipment.

Continuous-Light Sources

Tungsten bulbs are the simplest and most common method of continuous lighting. Many types are available, but the following are the most popular.

Normal *household bulbs* can be obtained in various shapes and power ratings with clear or frosted bulbs; they are also available as internal

reflector bulbs. Only those over 200 watts with a frosted bulb are recommended for photography. Depending on what they are going to be used for, they may also be silvered. Their color temperature is about 2900 K, and they need correction filters for use with color film. A simple beginning lighting system that is both useful and functional is composed of a 250-watt bulb fitted in a light and economical aluminum parabolic reflector about 30

TOTAL IMAGE CONTROL

With the subject's cooperation, you can build a portrait piece by piece in the same way as a painting, calmly considering the variables in the composition and expression with the skill of a craftsman, so that the result depends entirely on your own sensitivity, imagination, and ability. Although creativity is a personal talent, ability is based on a practical and rational understanding of the techniques that allow you to obtain certain results. All the characteristics of the final portrait have to be considered, felt, and planned in advance. This can be done in a studio, where you work in an environment in which you control all the photographic and aesthetic variables, but in fact any location can effectively serve as a studio, either indoors or out, provided that you can construct the image exactly as you wish.

In the final analysis, though, there is always an intangible element in photographs of the human form, something that no one can really be sure of capturing exactly: the expression on the face.

What combination of elements really creates the image? First, there is the photographic system used: the film, the camera format, and the shooting techniques all determine the choice of language and the type of image produced. Then there is the lighting. At this stage the light can really be considered equal to the artist's brush because it decides the quality and style of the image. Finally, there are the setting and the clothes, position, and expression of the subject. These are the aesthetic and cultural choices that depend on the photographer's artistic sensitivity.

Control of Final Image Contrast

By controlling the final image contrast you can produce a photograph exactly like your pre-visualized image. The techniques described here are designed for control of image quality solely through the lighting and the parameters of the shot, based on the assumption that no modification has to be made during the development and printing stages.

We have already seen that the photographic and sensitometric characteristics of black-and-white film can be modified creatively using the techniques summarized in the discussion of the zone system. This cannot be done with color film however; the only practicable modification that can be done in the lab with the latter is

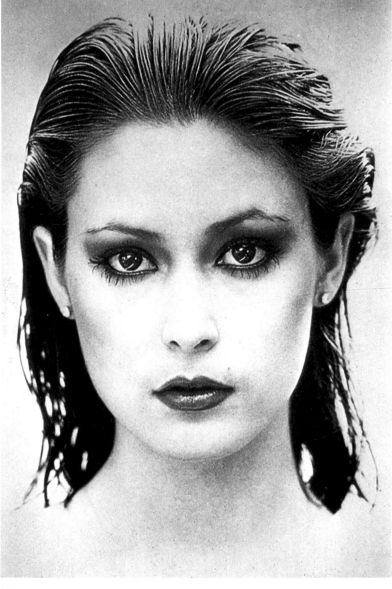

Contrast control in black and white depends largely on the printing process, which allows alterations of the tonal scale. With color film, however (opposite), the contrast in the final image depends only on the tonal scale of the subject and the light contrast. An additional element is the color scale.

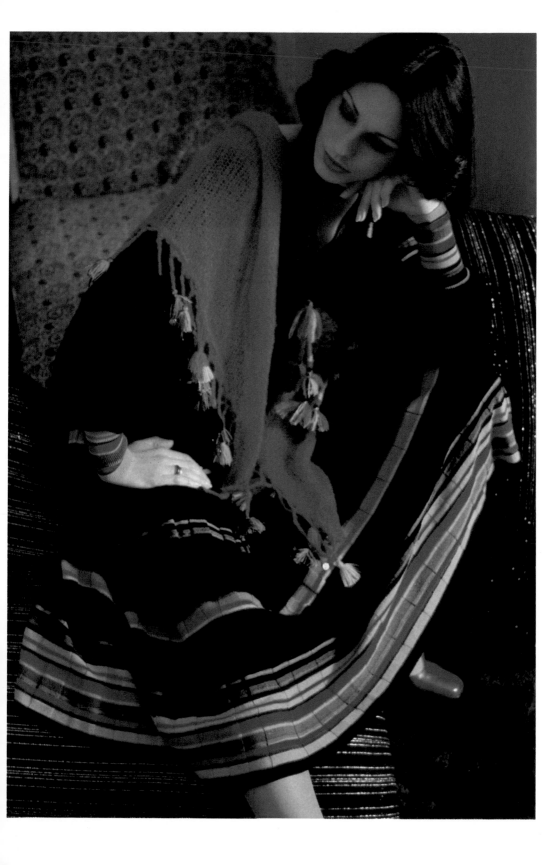

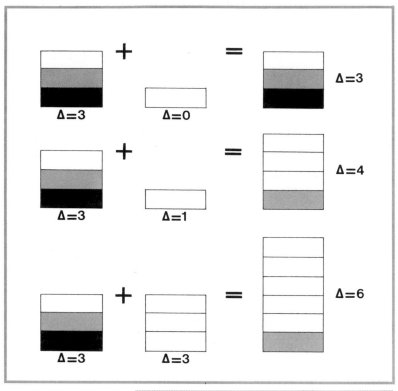

MEASUREMENT OF TONAL CONTRAST

subject → measurement of reflected light ← uniform lighting

eliminate:
· lights
· areas of absolute black and white

measurement of reflected light → lighter area / darker area

difference: Δ EV = 2?

Δ EV > 2 medium contrast

Δ EV ≤ 2 low contrast

The tables on these two pages summarize the text and are quite simple to interpret. The table at the top of this page is a graphic representation of the concept of additive tonal contrast and light contrast.

The table at right refers to the measurement of tonal contrast of a subject in a uniform light field.

The table on page 151 describes the logical way to control the final image contrast, explained in the text on the same page.

uprating by increasing the development time. However, you can use techniques for controlling contrast during exposure with any type of film. The principle on which contrast control is based is the additive nature of the contrast.

Let us see how this works. First, we can define the *tonal contrast* of the subject or the *tonal range* as the difference in exposure values between the reflected brightness in the highlight areas and that of the darkest shadows on the subject that still manage to show detail—those that are not absolute black or white.

Measuring Tonal Contrast

If you have an SLR camera with a spot meter, or an exposure meter with a narrow reading angle, it is easy to measure the tonal range on the subject (see the diagram at the bottom of the page). Place the subject in a lighting area with no shadows, center the meter on the lightest area of the subject, and take the reading; repeat the process on the darkest area. The lightest area of a portrait could be the skin, and the darkest could be black hair. The difference in exposure values between these two readings is the tonal range of the subject. Any bright reflections or direct lights that may be present should not be included in the measurement, nor should any black or white zones in the background that do not contain any details of importance to the meaning of the image. The maximum range on a normal subject is about 5 EV, which corresponds to the difference between nonreflective white cloth and opaque black, so a subject whose tonal range is between 2 EV is considered to be

CONTROL OF FINAL IMAGE CONTRAST

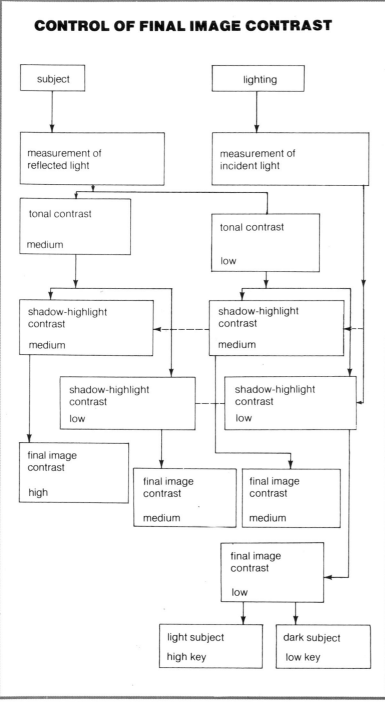

simple procedure to pre-visualize the final image contrast. There are three points to consider:

1. The final contrast is the result of the tonal contrast of the subject plus the light contrast on the scene, expressed in exposure values.

2. The final image contrast must be within the maximum limit of the film: with black-and-white film the tonal range can go up to 8–9 EV, but with color usually is less than 6 EV.

3. The light contrast must be established on the basis of the tonal contrast of the subject to remain within the limits of the film used. Suppose that the tonal contrast of the subject in the example on page 150 (drawing at the top) is an average of three units. Placing this subject in three different lighting conditions would give three different cases. In the first, the subject is uniformly illuminated, thus giving only the three grades of the subject itself; but in the second case, there is a difference of 1 EV in the lighting (corresponding to a brightness ratio of 2:1), so the final photograph would have an extra grade in the tonal scale equal to $3 + 1 = 4$ EV, corresponding to a ratio of 16:1—double that of the previous grades. In the third case, if the light has more contrast, say a highlight-shadow contrast of 3 EV, the final contrast will be $3 + 3 = 6$ EV, corresponding to a ratio of 64:1, which reaches the limits of normal color film.

You can get an overall idea of the strategy for creating an image of pre-determined contrast by studying the table on this page. For the sake of simplicity, we have considered two contrast levels for both parameters and taken a value of 2 as

low-contrast. Of course this is a rough approximation, serving only as a reference point in the classification of the tonal scale; it cannot be taken as an absolute value. The

simplest way of altering the tonal contrast is to change some article of clothing.

How to Determine and Previsualize Final Image Contrast
If you know how to measure both the tonal contrast on the subject and the light contrast, it is a

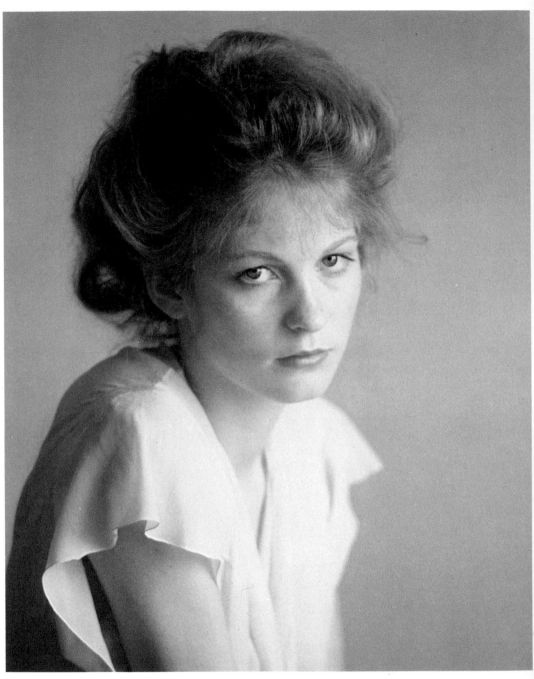

the border between low contrast and medium or high contrast. Having seen how the two independent parameters combine on the final image, we can categorize the possible results into three basic groups:
· high-contrast images,

when there is a lot of contrast in both the tonal scale and the lighting;
· mid-contrast images, when middle and low values of the two parameters come together in any combination;
· low-contrast images, when both variables have

low contrast.

These images are usually defined as high or low key, depending on the average tone of the original subject.

In the graph at the bottom of page 153, you can see that *low-key* photography is that which uses

only the lower part of the sensitometric curve shown; that is, only those tones from black to middle gray are present. Conversely, *high-key* photography is that which uses predominantly the top part of the tonal curve from middle

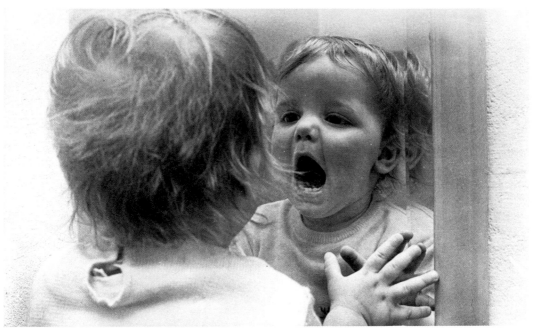

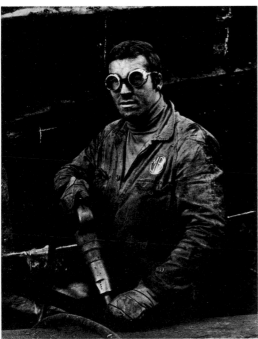

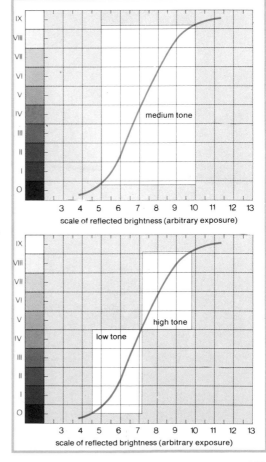

gray to white. The effective result of this type of image also depends on the chosen exposure level, which must suit the style of the image.

Photographs in mostly high tones (top) and low tones (above).
Right: Sensitometric curves showing the parts used for high-, medium-, and low-key photographs. Opposite: A beautiful photograph by Tana Kaleya.

153

FILTERS

Filters can be used either to correct the color performance of film or to manipulate the image creatively, modifying the tone, contrast, and sharpness. The different types of filters are as follows:

Glass filters with screw fittings are highly suitable for frequent use. The screw thread must fit the lens diameter, so it is obviously an advantage to have the same-diameter thread on all your lenses.

Gelatin filters are made of a thin film and are delicate but economical. They are available in various sizes and countless shades. They do, however, require a special rigid holder.

System filters can be made of glass or special plastics and must be used with a special multiple filter holder which allows you to use several filters at the same time. One advantage is the ability to use all your filters with different-diameter lenses simply by having the right filter holder for each lens.

The Filter Absorption Factor

Most filters affect exposure by absorbing light. If you use an SLR camera, however, the exposure-meter cell takes the filters into account when determining the exposure, so no manual adjustment is necessary. Inaccurate readings occur only in special cases.

Although it is not often necessary, it is useful to know the factor of the filter you are using, because it can significantly alter the exposure conditions. This filter factor is expressed as a number followed by an × which is the factor multiplying the exposure time. For example, a filter with a factor of 4× makes the exposure time four times as long.

Protection Filters

The *UV filter* blocks ultraviolet radiation and is absolutely neutral, so it is the best way of protecting the lens from dust and fingerprints.

Skylight filters can also be used in this way. They give a very light amber shade which tends to add warmth to the image.

Conversion Filters

Conversion filters allow color film balanced for artificial light to be used in natural daylight and vice versa. The two filters, 80A and 85B, are fully complementary; if positioned one above the other, they form a neutral gray.

Neutral Filters

The following filters can be defined as neutral because they do not add any color variation to the image, but do allow variations in the exposure, contrast, or definition of the image itself.

ND Filters

ND filters are gray filters with a density calibrated from 0.1 up to 3 absorption units. Their sole function is to absorb light and thus allow longer exposure times. The expo-

Above: An example of the creative use of filters. The dominant yellow, the sky darkened by a polarizing filter, and the setting contribute to the atmosphere of this beautiful image. Opposite: A photograph taken by Jacques Bourboulon shows the typical specular reflections on wet tanned skin, which a polarizing filter controls well.

154

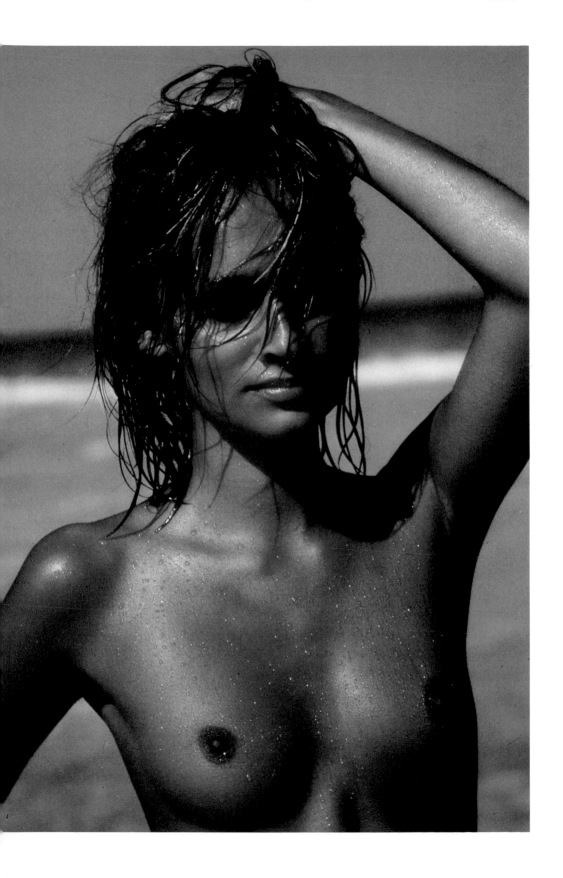

A polarizing filter in the correct position can block light waves reflected off nonmetallic surfaces. Compare the two photographs above to see how this filter has screened the reflection of the sky on the windshield. Polarizing filters are also useful in color photographs to intensify the blue of the sky.

sure must be doubled for each 0.3 increase in density units, so these filters are useful when you want to alter the exposure without affecting any of the other photographic parameters. In outdoor photographs, for example, it is often useful to keep the aperture quite large to get the background in soft focus.

Polarizing Filters
Polarizing filters, made of a special gray screen in a swiveling holder, cut out any polarized light on the scene. You can check the effect on the focusing screen by rotating the filter to find the angle that most effectively eliminates polarized light. The usefulness of the filter depends on the amount of polarized light present: it is generally found when a ray of light strikes a surface that is even slightly reflective. The maximum effect is obtained with angles of reflection of about 30 to 45 degrees. With intense directional light, polarizing filters have a remarkable effect on the tonal reproduction of skin, making it look silky, opaque, and saturated because of the elimination of reflections. They are particularly useful in outdoor portraits taken in sunlight because they allow you to graduate the effect at will. They also allow you to cut through haze in landscapes, to darken blue sky, and to alter substantially the tonal balance between foreground and background. This often proves extremely important in outdoor portraits where too light a sky would otherwise create problems.

Polarizing filters are truly practical only when they are used with SLR cameras because you can see the results immediately through the viewfinder. Also, the built-in exposure meter measures exactly the amount of light that passes through the filter, simplifying the exposure.

Graduated Filters
Graduated filters have a gray area that gradually fades into a clear area. In practice, they enable you to bring out the subject more strongly by cutting out areas that are too bright or too contrasty. To use them properly, remember that the separation line between the two colors is sharper at smaller apertures and that the exposure must be calculated through the clear part of the filter, corresponding to the part of the image occupied by the subject. The separation effect is more marked with a wide-angle lens than with a telephoto lens.

A certain degree of experience is required to control the effect so that it focuses interest on the subject and improves the understanding of the image, not just to use the filter as an end in itself. In fact, the filter should not be noticeable in the photograph, but its use should be fully justified from the point of view of both composition and expression.

Diffusion Filters
These filters are a simple way of reducing the definition and sharpness of a picture.

Because modern lenses achieve excellent definition, the technique of controlled diffusion has become increasingly important, particularly with color. The use of diffusion filters often determines the style of a portrait and the gradation of the subject. A close-up of a girl that mercilessly reveals every slight imperfection may have undoubted creative validity,

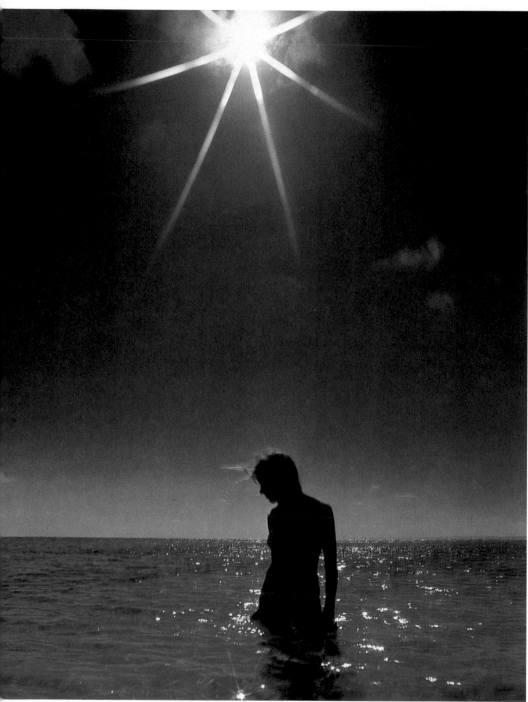

out it will certainly not please the model very much. The problem with diffusion lies in the degree to which it is used: it should be sufficient to give the skin a soft and natural look, but it should

not be too noticeable. Like any other special effect, diffusion is better when it is not too obvious. You cannot achieve diffused results simply by inexact focusing—the image should be

clear and in relief—but you can obtain pleasing effects by superimposing low contrast onto a clear, sharp original image. This softens the tonal differences, particularly in the light areas, producing a

As this photograph shows, graduated filters allow you to reduce the brightness of areas that are too light, such as the sky. A cross screen produced the star shape around the sun.

157

halation that leaves the structure of the image intact.

To produce this effect, you can use a normal filter, treated to create soft focus or soft halo diffusion on the main image. The simplest way to do this is by breathing on a neutral UV-type filter that is already in position; if the climate is right, the resulting condensation (which normally vanishes in a few minutes) is more than adequate to give a soft effect. Methods for achieving similar effects a little more permanently include the use of oil, transparent grease, or lacquer distributed relatively evenly over the filter.

There are even specially produced diffusion filters made of optic glass which use different methods to obtain the diffused effect, such as concentric circular grooves, small lenticular cuts, or surface abrasions on the glass. These filters can be obtained in different grades and allow a certain amount of control over the effect, often with excellent results.

Two photographs by David Hamilton. The one on the opposite page was taken without filters and the one on this page with a diffuser, which increased the sweet, romantic atmosphere of the image.

Diffusion can also be obtained by using disks that have a large central hole surrounded by a series of smaller holes, which can be of different shapes and sizes and which form staggered low-density images overlapping the sharp image to create the soft halo effect that can be controlled as desired with the aperture. The wider the aperture, the more holes contribute to the formation of the final image. Because of the way these disks work, they are more effective when fitted behind the lens. Some manufacturers like Mamiya and Fuji have portrait lenses in their catalogues which include these accessories for the control of soft focus.

Finally, another technique for achieving this effect does not use filters,

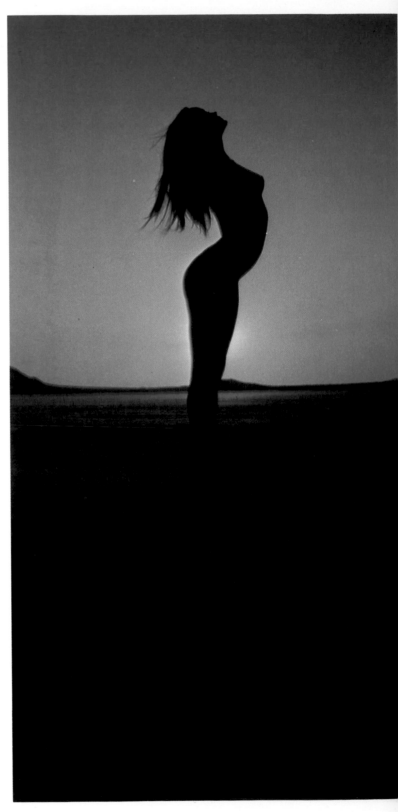

*Above: The Mamiya
Sekor 150mm f/4 portrait
lens with its set of perfo-
rated disks to control
diffusion.
Right: The creative use of
a green filter in an ele-
gant image by Pete
Turner makes this nude
in backlight almost
abstract.*

but a special optic prop-
erty, spherical aberration,
which is specifically intro-
duced into some of the
elements in the lenses for
complete and regular
control over the soft
focus. This is the most
effective method because
it provides a perfect and
constantly available facil-
ity for controlling the
image softness.

To summarize the
points to remember when
using this equipment:

1. Diffusion consists of
a light halo effect which
invades the dark areas
when achieved during ex-
posure of the shot. If
obtained during the print-
ing stage, however, the
effect is the opposite:
black halation invades
the light areas.

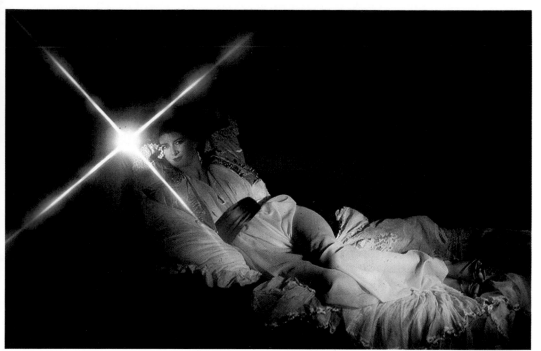

2. The most effective degree of diffusion is usually that which softens the image, slightly lowering the contrast but leaving the maximum density unaltered. This means that there should be no result-ing smoky blacks.

3. The degree of the effect obtained depends to a large extent on the aperture used and the contrast of the image; the higher the contrast and the wider the aperture, the more noticeable the diffusion effect.

4. Finally, because the soft-focus image tends to have less contrast, it re-acts better to over- and underexposure, which in these conditions can cre-

Above: Filters can create light rays showing the spectrum.
Below: A light-diffusion filter is all that was needed to give this por-trait a soft, pleasing tone.

ate more suggestive
effects.

Filters to Control Color Temperature

We know that blues lower
the psychological and
color temperatures of im-
ages and that conversely,
orange or yellow tones
make photographs
warmer. Because of this,
lightly colored blue or
orange filters can change
the psychological tem-
perature of a portrait. In
general, it is always better
to use warmer tones,
which suit all human sub-
jects, whereas blue domi-
nants have to be justified
for precise motives of ex-
pression. In artificial light,
these filters control the
reproduction of skin
tones. By making suitable
tests, you can modify the
shade of the complexion
to produce exactly the
image you want.

Black-and-White Filters

Although the various
types of neutral filters
produce similar effects
with all types of film,
some deeply colored fil-
ters are used mainly with
black-and-white film to al-
ter total reproduction and
contrast. A filter of a
given color lightens the
shades of that particular
color and darkens all the
others, so you can select
filters that separate a sub-
ject from its back-
ground—for example,
darkening a blue sky by
using a yellow or yellow-
green filter. You also af-
fect the shades on the
face, such as darkening
of the skin and particu-
larly of the lips.

Special-Effects Filters

Various types of filters are
designed to alter the im-
age through optical or
color effects. These tools
are capable of suggesting
fantastic or dreamlike im-
ages which on the one

*Graphic effects obtained
with a prismatic filter to
produce a multiple image
(left) and a cross screen
(below).
Opposite: A red filter
made this otherwise com-
monplace image more
interesting.*

hand reveal the infinite creative possibilities of photography, yet on the other hand can become quite tiresome. In general, however, they can be useful in realizing a precise idea, projected like a painting on an easel.

In summary, the final image must have its own

meaning and harmony, and the technique used must be the means, not the end, of the image.

Infrared Film

Infrared film is a special material sensitive to thermal radiation that is used mainly for scientific purposes but occasionally to create unusual and un-

real effects. Ektachrome infrared film produces completely unnatural colors and is usually exposed with a yellow or red filter to produce strange settings for creative and dreamlike images. As shown in the example on page 165, the skin becomes green, the sky an intense blue,

and the vegetation is reddish.

Lens Hoods

When you work in the presence of strong directional light such as the sun or studio lights, glare caused by a light ray directly striking the front element of the lens can damage photographs,

COLOR-CONTROL FILTERS

CONVERSION FILTERS

	Type of film	Type of light	
80A	5500K	3200K	
80B	5500K	3400K	Blue filters that eliminate the orange dominant obtained in artificial light.
85	3400K type A	5500K	
85B	3200K type B	5500K	Orange filters that eliminate the blue dominant that can be produced in natural light.
FCD	5500K	fluorescent (neon)	
FCB	5500K	fluorescent (neon)	Reduce or eliminate the dominant green produced by normal fluorescent lighting.

Note. Blue and orange filters can also be used with black-and-white film to alter the tonal reproduction of skin.

COLOR-CORRECTION FILTERS

81A, 81B, 81C	"Warm" orange-amber filters that allow you to make slight alterations in the color temperature and to vary the tonal reproduction of the skin.
82A, 82B, 82C	"Cold" blue filters that adjust the color temperature in the opposite way.

NEUTRAL FILTERS FOR IMAGE CONTROL

ND3	Available in various grades from 0.3 to 3.0.
ND6	Most common are 0.3, 0.6, and 0.9.
ND9	Absorb light, allowing you to use slower shutter speeds and/or larger apertures.
POLARIZERS	Saturate colors, screen reflections, and can be used with other filters.
SMOKY GRAYS	Allow you to darken selected parts of an image (such as high-brightness areas), reduce contrast, and allow attention to be concentrated on the subject. The smoky-gray area can cover half the filter or fill a circular crown area.
DIFFUSION FILTERS	Reduce lens resolution and soften images, partially or completely, in a controlled way.

PROTECTION FILTERS

UV/HAZE	Protect the lens from dust and fingerprints.
SKYLIGHT	Tone down mist in landscapes.

SPECIAL-EFFECTS FILTERS

CROSS SCREEN	Create star-shaped reflections.
DIFFRACTION	Break down intense lights into the colors of the spectrum.
PRISM LENSES	Form multiple images.
PASTEL and similar	Produce very soft-focus effects and delicate shades.
COLORED HALF FILTERS	Add certain color tones to parts of an image.

Note. There are also many other filters and screens that are best used for graphic experimentation and for constructing imaginative images. Some systems allow several filters to be used at the same time, thus increasing the creative possibilities.

BLACK-AND-WHITE FILTERS

YELLOW	Make clouds stand out and darken blue sky.
YELLOW-GREEN/ GREEN	Improve reproduction of vegetation and lighten the green of foliage; improve reproduction of skin tones and darken lips in outdoor shots.
ORANGE (85, 85B)	Lighten skin and tone down blemishes and freckles.
BLUE (80A or B)	Darken and add contrast to skin.

and so it is advisable to protect the lens with a suitable hood. The hood is even more effective in portrait photography, when you are usually working with a medium telephoto lens. With two or more light sources, you can screen the lens even further with special cards placed at the proper distance or even with the screens supplied with certain types of reflectors. These precautions are necessary with standard or wide-angle lenses, but a lens hood is usually sufficient for telephoto lenses. Unless there is a hood already incorporated into the lens, use a folding rubber hood which is recommended because of its lightness and practicality.

Infrared color film, used here with a yellow filter, creates unreal images. This photograph could have been sent from another planet.

SUMMARY OF SHOOTING TECHNIQUES

Shooting technique is based on certain essential factors that should be used as reference and constitute a useful guide for all types of shot.

Framing. Get close unless there is a reason not to.

Focusing. Always focus on the eyes, and especially on whatever is closest to the camera.

Minimum subject distance. Never less than 1½ meters (5 feet).

Viewpoint. A safe starting point for photographs of the face is a slightly raised, angled shooting position.

Depth of field. This must be sufficient to get the tip of the nose in perfect focus.

Aperture. Choose the aperture on the basis of the necessary depth of field; as a rule, it is narrow at short distances and wide at average distances to have the background out of focus.

Diffusion filters. These are advisable for small apertures in close-ups, particularly in traditional portraits which tend to flatter the subject.

Exposure. Base exposure on the correct reproduction of skin tone. Take the tone of standard middle gray into consideration when measuring reflected light off the face, and act accordingly.

Shutter speed. Speeds longer than 1/60 sec. are not normally used; shorter times are recommended unless you are using electronic flash.

Background. Always keep the background simple or out of focus unless it is specifically required for the image or has a precise meaning.

Lighting. Reduce the contrast in the shadows in natural light by means of flash or a white screen. In artificial light, the shadow-highlight contrast should not exceed 4:1 with the key light at 45/45 degrees, as explained in the section on lighting techniques.

Focal length. Use a short or medium telephoto lens for close-ups, a medium-wide-angle lens at close range for the full figure, and a normal lens or a medium telephoto lens at long range.

THE PHOTOGRAPHIC STUDIO

Any setting can be converted into a studio. The equipment depends on your preferred photographic techniques;.

daylight, flash light, or artificial continuous light.

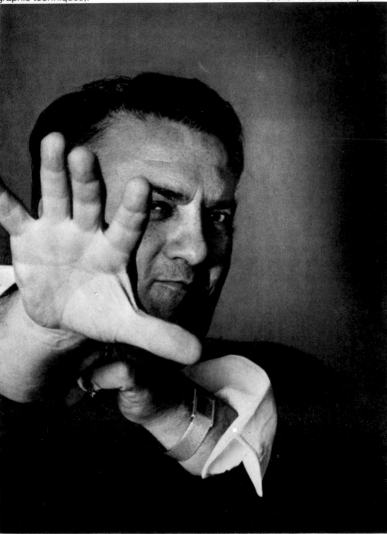

much on the individual's ability to strike poses that are almost theatrical and to dress in clothes that reflect the personality that the photographer seeks. This can be quite

The problem of expression is not easy, even when there is perfect mutual understanding between the photographer and the subject. The photographer should direct the session to create the image he or she desires through the psychological and aesthetic interpretation of the subject's personality; the subject has to be able to interpret the ideal personality that the photographer sees. This is not easy and takes a great deal of cooperation from what we could call the actor subject, combined with a good dose of intuition and human sensitivity on the part of the photographer.

The simplest solution for a portrait is to photograph the person's normal appearance, the smiling, calm, but superficial "social mask," for even in simple portraits with no pretensions to an intellectual style, there are always many hidden elements and silent body-language signals to reveal a lot more about the subject than may be evident at first glance. An "honest" portrait that shows an everyday but vivid side of the subject effectively is quite an achievement in itself.

Alternatively, the photographer can decide to work in the realm of the imagination, to produce portraits showing the many hidden facets of a subject. Each one of us has thousands of hidden faces that give rise to exercises in interpretation as well as fascinating journeys of discovery. Even a normal expression is only one of the many masks we find ourselves wearing in life.

This theatrical style of portrait requires no special techniques; it is based entirely on attitude and body language and requires just a few

equally good results can be obtained with complex professional equipment or simple makeshift accessories,

You could say that what constitutes a studio is a suitable background and what creates the photograph is the quality of the light and the lenses; all the rest merely makes it easier to achieve your aims. You can use

Controlled Conditions: The Actor Subject

It is common that a person in a photographic. studio becomes uneasy. The subject, though perfectly willing to cooperate, may lose all spontaneity and take on rigid and stereotyped poses.

The expression of the image depends very

easy if the subject is used to posing in public, as are actors, politicians, models, and successful people who have already devised their own standard ways of posing for photographers and journalists, but it can be quite difficult for the ordinary person who has never had to control his or her own expressions in public.

touches—hairstyle or clothing and, for women, makeup—to change the subject's presentation.

Finally, there is the particularly artistic style of portrait that successfully combines the symbolic interpretation of the personality, the expression on the face, and the aesthetic value of the image to express a "universal" idea of a human situation or emotion. This type of image is particularly difficult to achieve, but all portrait photographers

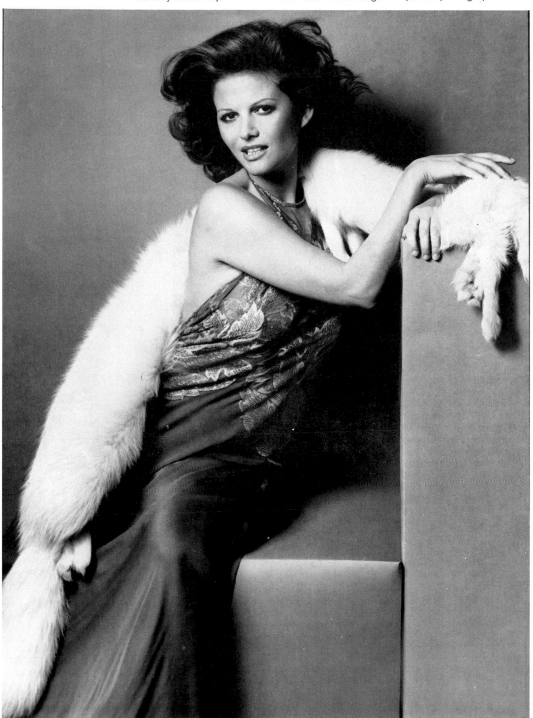

Above: The essence of
Louis Armstrong is cap-
tured in this portrait—his
personality as one of the
greats of jazz, his theatri-
cality, and his human
warmth.
Opposite: A theatrical
portrait, both dramatic
and aesthetically interest-
ing, taken by Hideki Fujii.

How to Direct the Subject

To direct your subject,
first examine his or her
appearance carefully and
try to get a good idea of
personality. You must
analyze the person phys-
ically to draw accurate
conclusions about how
photogenic he or she is
and to establish strong
and weak points. You will
have to emphasize one
side, depending on the
type of portrait you want
to produce, on the basis

seek it. It is a stimulating
but rare product of ex-
ceptional creative ability.

of your own judgment
and interpretation.

The cooperation of the
subject is essential. You
can obtain it mainly
through conversation, a
soft, calm, continuous,
and relaxing chat. Getting
the subject to talk and
involving him or her in a
discussion provokes re-
actions that "thaw" facial
expressions. Music is
often used for its relaxing
effect. It also makes the
waiting much more pleas-
ant between shots, par-
ticularly if you have to
adjust equipment. Alter-
natively, you can use a
motorized camera to en-

able you to take a
"spectrum" of consecu-
tive expressions in rapid
succession.

The "Psychological Temperature" of a Portrait

Portraits can be defined
as warm or cold, not only
on the basis of the domi-
nant color, but also on
the basis of a parallel
"psychological tempera-
ture." For example, a
subject who is looking
straight at the camera es-
tablishes immediate vi-
sual contact, creating a
positive or negative reac-
tion on the part of the
observer, depending on
how cordial or unpleas-
ant the subject's facial
expression is. A subject
who is deliberately look-
ing in another direction
suggests detachment, in-
difference, and a lack of
cordiality, whereas an
open, sincere smile com-
bined with a direct look
immediately involves the
onlooker and establishes
a warm rapport.

The psychological tem-
perature is influenced by
many other factors that
are only partly related to
the subject: the dominant
color; the type of light, be
it hard or soft; the frame,
viewpoint, perspective,
and background. If the
photograph contains
more than one individual,
any relationships that can
be seen in the eyes be-
come important and
meaningful; they can
unite or divide the figures
almost as much as their
distance from each other.
The positions of the
hands and bodies are
other signals that deter-
mine the harmony among
the members of a group
and help to create a psy-
chological temperature.

To Smile or Not to Smile

The photographer has to
decide two key factors

169

lighting that seem to be generally valid and are common to various types of art, ranging from painting to films and obviously photography as well, but they should be used only as reference and as starting points from which to work out your own personal choices. Three variables determine the structure of a portrait: the viewpoint, the position of the face, and the direction of the light. Let us use the subject-lens direction—the lens axis—as reference, regardless of the position of the face.

The type of lighting is determined by the arrangement of the main light source relative to the lens axis; for example, a light parallel to the direction of the shot always produces a flat picture. To get a natural reproduction of texture and depth, just one light source should produce the shadows; by definition that source is the main light or modeling light. Whether the main light is large or small, directional or diffused, its

that relate to the subject's expression in every shot taken under controlled conditions: should the subject smile or not, and should he or she look directly at the camera? You should always ask yourself if there is a good reason for asking the subject to smile, for a smile is usually better when it is spontaneous. As a general rule, serious expressions are better in formal portraits, but in other types a slight smile and eyes that look straight at the camera can also be an advantage. If the subject assumes this expression spontaneously, it is part of his or her personality to do so. Never force a subject to assume expressions that are not natural or that are forced.

Lighting the Face

No matter what equipment you use to illuminate the face, the rules are invariable for obtaining a natural and pleasing portrait. Existing light, flash light, and reflected light can all be used to advantage; the choice is not one of method, but of quality.

There are, however, certain basic rules of

Above: The coldness of an evasive look. Below: The same woman is shown here with a range of expressions. Opposite: An image that plays on the expressiveness of a look and a color.

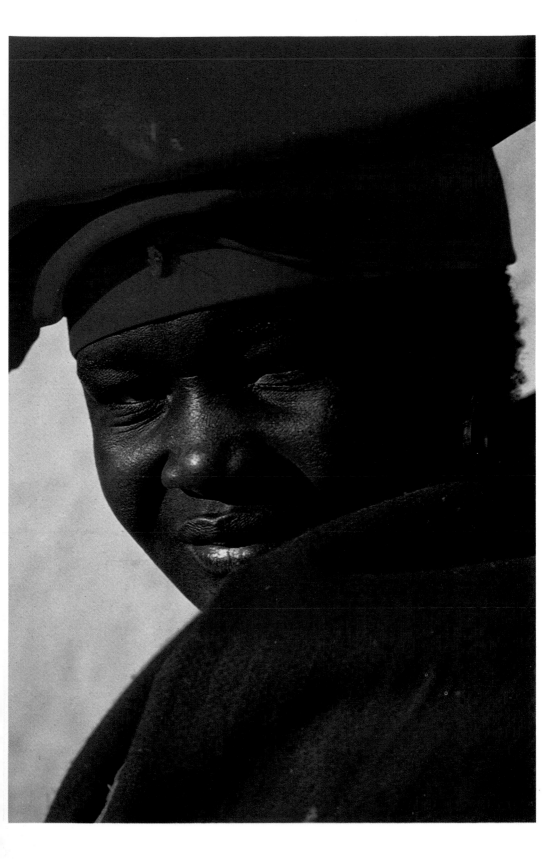

Above: Directional light, sharp shadows, and contour in Medusa *by Caravaggio.*
Above right: The characteristic offset lighting of the portraits painted by Rembrandt.
Below: Diffused light in a portrait of a lady with a unicorn by Raphael.

function is to create the basic form of the shadows. All the other light sources are secondary; they do not create the light field in which the subject is positioned, but merely create light effects. Rim light, for example, creates a bright outline or light profile on the hair or the figure, but it should not create any visible shadows conflict-

ing with those from the main light. The difference in brightness between the areas of highlight and shadow—the light contrast—determines the quality and style of the portrait as well as how clearly the face can be seen and understood.

We have already seen that because of the sensitometric characteristics of color film, shadows become too dense when the light contrast exceeds 2 EV and the film cannot register details. The light contrast can therefore be adjusted by using a fill-in light whose purpose is to lighten the density of the shadows.

The various possible angles of artificial light will be discussed fully under "Studio Lighting Techniques."

The Lesson from the Great Masters

When studying lighting techniques, you cannot ignore the lessons of the great masters of painting. They understood and evaluated the importance of lighting in representations of the human form centuries before the invention of photography.

In fact, when you examine the works of the great masters with a photographer's eye, particularly the portraits painted during the Renaissance, you find extraordinary similarities to modern lighting techniques: directional and diffused light, contrast ranges and light angles. We have given here three examples of portraits painted in different styles: a Renaissance portrait by Raphael using diffused light, a portrait by Rembrandt with his characteristic angled lighting, and Caravaggio's *Head of Medusa*, showing directional light producing hard shadows and intense modeling.

The Position of the Subject

Once you have determined the correct illumination with the right light and shadow contrast, the position of the subject is not critical. Different positions have different meanings, for they alter the projection of the face onto the film and change the relative importance of the facial features. There is one position, however, that

can be used as a reference: with the person at an angle of about 30 degrees to the direction of the shot and with the camera pointing slightly downward from a height of a few degrees above the eyes. Portraits taken in this position are spontaneous, natural, and quite well molded, communicating maximum information about the face. Even the body has a level and natural perspective.

The frontal position, on the other hand, exaggerates the flat, geometric perspective of the shoulders. There are three classic types of portrait—frontal, three-quarters, and profile—and in each case you should examine

solute rules regarding them, but we can give some advice that can be taken as a valid but variable reference, for the choice really depends on your own personal requirements. It is better to have the subject in a comfortable seated position or leaning against something.

The innumerable factors of body language also affect the choice of pose, so pay close attention to the smallest details in the subject's position; these are always amplified in photographs. For the portrait to be a success, the subject must be relaxed and show no muscular strain. A good position is one in which

The subject, whether standing or sitting, also appears more relaxed and less static when one leg is a little in front of the other, which breaks the symmetry of the figure.

Remember that because of the effects of perspective, when the arms and legs are pointing toward the camera, their effect is diminished and they lose all weight in the composition. Conversely, when the arms are held close to the sides of the body, they tend to form a square, solid, and somewhat static structure.

clothing are difficult to evaluate. The photographer cannot always be sure of having seen to every detail, so when everything seems ready, it is quite useful to take a test shot with instant-picture film. Testing the shot in this way helps you to decide how to alter the infinite creative variables. It is very useful in evaluating the effects of a filter, for instance, or the juxtaposition of colors, or even makeup in a glamour shot.

the subject to see which perspective most successfully describes the face and personality.

Lighting and the position of the subject are fundamentally creative and interdependent choices. There are no ab-

the trunk is turned toward the camera, a pose that conveys attention, availability, and interest. A frontal position is advisable when you want the subject to convey a sense of authority, sobriety, and confidence.

Instant-Picture Film for Studio Shots

In studies of the human form, the variables of shadows, lights, color juxtaposition, background, composition, and

Two classic subject positions used in portraits: the three-quarters position (left), and (above) three-quarters but with the shoulders in the opposite position.

HOW PHOTOGENIC IS THE FACE?

Each face is so different from every other, and yet so similar, that it seems an overwhelming exercise to try to classify faces. It is a fact, however, that certain problems are common to certain types of facial structure. Analyzing the face means becoming aware of all these problems and thus increasing the probability of success.

The great portrait painters of the Renaissance preferred to use a kind of ''palette of faces,'' a compilation of facial

Below: The oval face is the most photogenic. Opposite: In this photograph David Hamilton captured the provocative sweetness of the model with masterly skill.

Right: The areas of the face on which a light shining from above creates reflections are the forehead, the cheekbones or cheeks, the nose, and the chin.
Below: If you examine a face carefully, you find that its shape is often similar to one of these four: square, oval, round, and oblong or triangular. Try to make the face as oval as possible through makeup, lighting, and the angle of the shot.

structures that were more suited to their style of expression, painting, and sensitivity. The importance of the face in conveying certain impressions and emotions is undeniable and can be seen in the stereotyped facial types found in the theater and films.

The Geometry of the Face

When you frame a face in the camera viewfinder, try to see it as a sculpture; pick out the dominant lines and shapes, the symmetry, proportions, and especially the highlights and shadows. The areas in highlight are determining factors in understanding the geometry of the face. There are five areas on which a light shining from above would create light reflections: the forehead, the cheekbones, the nose, and the chin. Consider carefully the shape, position, and intensity of these light points to create a modeled and three-dimensional image. The areas in shadow, on the other hand, are "recessive"; the darker they are and the less detail there is, the less they contribute to conveying the shape of the face.

The outline of the head is another fundamentally expressive element in relation to the shape of the negative area of the image.

The oval face is usually considered to be the most regular and pleasing, at least in Western figurative traditions, and it can generally be considered as the model to aim for. This involves manipulation of the photographic parameters in such a way as to make the face appear as oval as possible without changing the subject's face in the portrait. This is necessary because all expressive

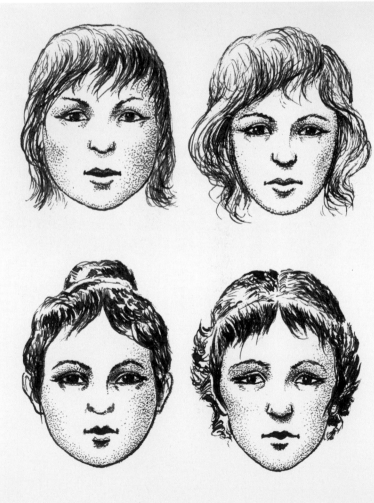

signals tend to be exaggerated in photographs, and so the shape of the face is controlled to a certain extent purely to make it appear as natural as it does in reality.

The triangular face is characterized by a wide forehead and a narrow chin. It looks natural when an angled shooting position is used and the subject's face is turned upward in a more favorable perspective. The camera can be at a slightly lower level than the eyes, and the light should fall on the narrower part of the face to give it more graphic weight.

The narrow face presents similar features to the triangular face, and so the method of reproducing it naturally is similar. A slightly lower and offset viewpoint with the face fully illuminated is the technique to use. Frontal shots are not recommended because they emphasize the vertical shape of the face.

The square face looks solid and typically masculine because of the heavy jaw. To soften the lines of the face, photograph it at an angle from a slightly raised viewpoint to minimize the jaw and narrow the shape of the face.

study symmetry and proportion, make three copies of the print, and print one of them in reverse. Cut this copy and a normally printed one in half along a vertical line passing through the midpoint between the eyes to get two right sides and two left sides. Put these together to show the two "unknown" faces of each individual: the right and the left.

Also make prints of the two profiles to examine the evenness of the cheeks and the setting of the eyes. You should take these exploratory shots before actually venturing into the field of studio

mark off the following areas: the *lower band,* which is designated by the horizontal line across the bottom of the chin and the line touching the base of the nose; the *middle band,* which extends from the line at the bottom of the nose to the line of the eyebrows; and the *upper band,* ending at the top with the line across the hairline and thus containing the forehead. These bands, which can vary in depth from one person to another, show how regular the face is. A triangular face with a wide forehead, for example, will have a wider top band,

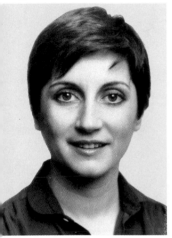 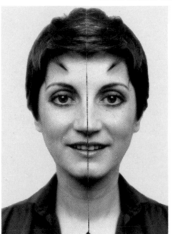 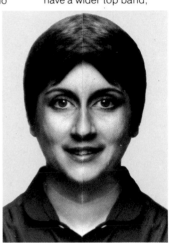

The two halves of the face, the right and the left, are normally a little different. With two identical photographs, one printed in reverse, you can construct two montages to obtain two images, one formed by the two right sides and the other by the two left sides. This is a useful trick for determining which part of the face is more photogenic, so that you can emphasize that part by using a suitable angle of shot and the proper lighting.

The round face is characterized by prominent cheeks that seem to form a whole with the chin. It can be made to look more oval by using the traditional and ever-functional three-quarters position. Narrow lighting leaves the other half of the face in shadow and creates a shadow formation that models the cheeks and lengthens the face.

The Symmetry of the Face

Study facial features by analyzing photographs taken in diffused light from a frontal position and also in profile. To

portraiture. Other, more immediate systems are the "mirror method," which consists of reversing the image and comparing it with the original (which makes it easier to see any asymmetrical elements), and examining an image of the face upside down. Having analyzed the symmetry of the face, you have the elements necessary to help you decide which of the two parts of the face to concentrate on.

The proportions of the main facial features can be determined on the basis that a regular face usually has equal spacing between the lines that

whereas a square face could have a wider bottom band. If the face has regular proportions, the resulting photograph will obviously be better and easier to obtain. If not, you can obtain useful information from this test to help you take the photograph.

Remember that the eyes and mouth have a great graphic impact in photographs and influence how photogenic the subject is.

Criteria for Correct Reproduction of the Face

Because the facial features are translated onto

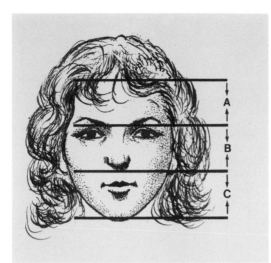

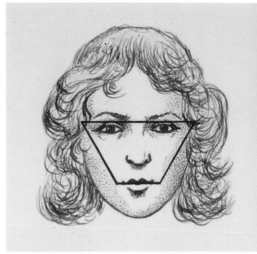

Above: The three bands of the face discussed previously. If they are the same distance apart, the face is harmonious and in proportion. Above right: The geometric shape obtained by joining the eyes and the mouth, the two fundamental facial features, shows how regular and symmetrical the face is.

the photograph by projection onto a plane, the methods for correcting imperfections are based essentially on perspective, which alters the projected image, and on highlight and shadow, which emphasize or play down features. The viewpoint is also very important; it takes only a few degrees to change the

proportion between the different areas of the face.

In a close-up portrait, the viewpoint most commonly considered normal and neutral is at the level of the subject's eyes. A higher viewpoint brings out the upper band and the eyes, while compressing the lower band, reducing the mouth and

cheeks, hiding the neck, and emphasizing the hair.

A viewpoint just a few degrees higher proves more natural in the majority of cases and gives a pleasant perspective to the head. A lower viewpoint brings out the middle and lower bands of the face, shortening the nose and emphasizing the mouth; it shows up the neck and hides the hair while giving prominence to the chin.

Generally speaking, altering the vertical angle of the viewpoint changes the shape and attitude of the head and neck as well as the direction in which the eyes are apparently looking.

The Horizontal Angle of the Camera Relative to the Subject

If you consider the subject to be in a fixed position and imagine rotating the camera around it, you can pick out the angles that show precise characteristics of the face. In practice, three types of shot are the most important.

Frontal shots suit regular faces and produce direct and simple images in which the modeling and contours are created

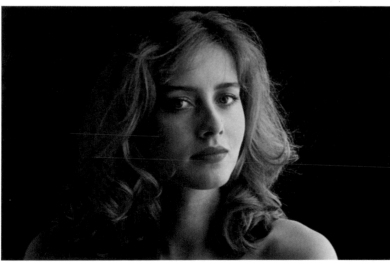

A close-up of the face with the camera at the height of the subject's eyes. This is the "neutral" shooting position, which does not correct the features in any way.

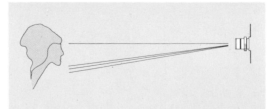

only by the lighting.

Angled shots (30–60 degrees) most often give a natural and molded perspective to the face. An angle of about 30 degrees can be universally adopted for all kinds of face, and so can be used with perfect confidence.

Profiles are used only to a limited extent because the features in profile are not often easily related to the frontal features, but do give additional information to complete the analysis of the face. Some people have good profiles but difficult faces to photograph from a frontal angle and vice versa.

The viewpoint from which you photograph a subject is therefore a determining factor in the way the features are reproduced on the image. By combining the effects of vertical and horizontal angles, it is possible to obtain an infinite variety of portraits.

The Angle of the Head and Shoulders

The angle of the head relative to the shoulders is very important to the dynamic meaning of the body position. Having the shoulders square to the camera tends to suggest stability and rigidity, and it exaggerates any lack of symmetry. Consequently, it is suitable only for elegant and well-proportioned figures.

Having the shoulder line parallel to the lens axis is better suited to profiles. Having them at intermediate angles is much more common; this position conveys movement and vitality without emphasizing any asymmetrical elements.

A common shoulder position, often chosen for its adaptability and suitability to all kinds of facial features, is three-quarters

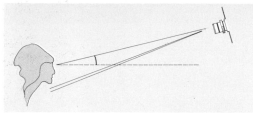

A high angle brings out the upper band of the face and the eyes, which are closer to the camera, and shortens the neck.

to the camera; the face can be turned toward the camera or in the same direction as the body.

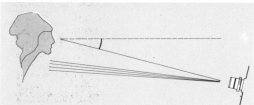

A low angle brings out the middle and lower bands, emphasizing the neck, the chin, and the mouth, and shortening the nose and forehead.

The photographs on these two pages are examples of portraits in which the subjects were photographed from different angles and with different shoulder positions.

STUDIO LIGHTING TECHNIQUES

To learn to use artificial lighting, you must know how to build up an image with a single light source. You can use a directional light such as direct flash, or diffuse light such as that obtained from a reflector panel, but you should always start off with just one source to study the effect of the lighting on the subject. The other lights have an auxiliary function, to improve the photograph through the creation of light effects that do not form new shadows. To establish the position of the key light, first work out, on the basis of the brilliance of the light source, at what distance the light best shows the lines of the face, gives it modeling, and forms highlights—the bright points of reflection on the skin, which brighten the portrait.

If the light is too close, you can get a "burned" effect in the chalky-white areas where the light intensity is too high. Conversely, if the key light is too far away, it produces flat images that are uniform at each point of the illuminated area. As a result, both the distance and the angle of the key light have a creative and expressive function.

Light Angles

Depth and contour in the shape of the face and the full figure are conveyed through the highlights and shadows, so the lighting has to be arranged to achieve the desired effect. It is useful, however, to know that in the initial stages, when you lack experience, the simultaneous use of several light sources nearly always produces disappointing results.

Look at the diagram on this page and the one on page 184, which assumes that the viewpoint remains unaltered. *Side lighting* is usually limited to within 60 degrees to the right or left of the lens axis, whereas *vertical lighting* is usually contained within 10 to 45 degrees upward. It is easier to make the face look natural within this limited range. This arrangement is suitable for any type of subject, at least to start.

Frontal Lighting

Frontal lighting with a vertical angle of between 30 and 45 degrees gives a pleasant aspect to the face. It forms the characteristic, vaguely butterfly-shaped shadow below the nose: according to the classic tradition, the shadow below the nose should not exceed about half the distance between the bottom of the nose and the upper lip. (Long shadows reaching the lips are always unpleasant; avoid them at all costs.) This angle also illuminates the eyes fully, making them look natural. Frontal lighting does not bring out the texture of the skin and so it is suitable for portraits of women. It can be used on all subjects with regular features.

Angled Light

Offset light is perhaps the most popular in portraiture. It is certainly effective in emphasizing the contours and modeling on the face. The light falls on the subject at a horizontal angle between 30 and 60 degrees and a vertical angle of 45 to 10 degrees, so part of the face is in shadow and

Below left: This diagram shows the vertical angles of light compared to the camera-to-subject axis. The photograph below was taken with the light shining from above and slightly to the right. Bottom left: An angled light positioned at the height of the camera. Bottom right: Light from below—usually of no interest in portraits.

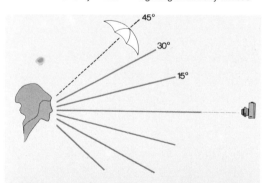

part in light. This particular light-source position creates a triangle of light on the cheek under the eye (though that is in shadow) and corresponds to the typical classical illumination of Rembrandt's portraits, from whom it takes its name. It is a harmonious type of illumination in which the shadow of the nose joins the dark side of the face without darkening the lips. It is particularly suitable for correcting faces that are too wide or too narrow, because the area in shadow is less marked and tends to disappear— it becomes a recessive zone. For example, a wide or round face is easily made to look more oval, and consequently more attractive, if the shaded part of the face dominates the frame. Conversely, you can widen a narrow face by concentrating on the area in light from a suitable viewpoint.

The direction of light that is most commonly preferred is contained within 30/30 degrees and 45/45 degrees (horizontal/vertical respectively). When you use this type of lighting, in which nearly half the face is in light and the other half in shadow, remember the background: to avoid having one of the two

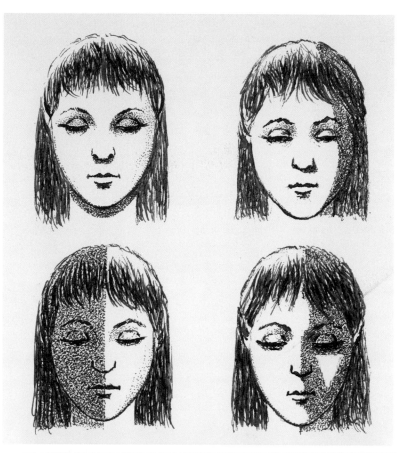

The drawings at the top of the page illustrate the shadows produced by the most common types of lighting used in portraits. Clockwise from top left: frontal lighting, 30-degree side lighting, 45/45-degree lighting, and 90-degree edge lighting. The photograph at right shows the effect of light from above directed at a slight angle.

sides of the face merge with the background, use the method of contrasting the light area with a dark one and vice versa.

Ninety-degree Edge Lighting

Lighting at right angles to the direction of the shot creates a strong, dramatic characterization, increasing the texture and emphasizing any minor blemishes on the skin. It is good lighting for underlining the structure of hollow and lean faces furrowed with wrinkles, but it certainly is not flattering. Use this type of lighting with care when you are trying to produce aesthetic effects or theatrical effects and graphic studies. If you photograph the face in a frontal position, you can get some interesting results with strongly expressive subjects, but it is more commonly used in profile shots.

Backlighting

Lighting at an angle of over 90 degrees is mainly effect lighting that creates reflections on the skin and face—lines of light rather than shadows. These reflections tend to be dominant and create original designs that dra-

matize the image, making it intense and theatrical. The part of the face turned toward the camera is completely in shadow, although it may be filled with existing light.

There is a clear difference between this kind of light and backlighting from auxiliary light sources (rim lighting): in the first case there is a key light with no other light sources, and in the second case the rim light creates light reflections without throwing any shadows in the presence of a regular key light.

The Position of the Face Relative to the Key Light

A close-up portrait has a relatively limited number of basic positions, although the variations that can be derived from them are numerous. As we have seen, there are three basic positions of

Below: A diagram of the possible combinations of the positions of the face and of the light in terms of the subject-to-camera direction. The effects of these combinations are shown at right.

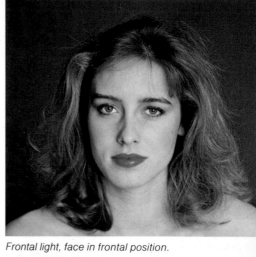

Frontal light, face in frontal position.

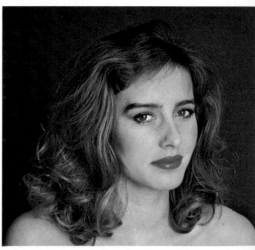

Frontal light, face in three-quarters position.

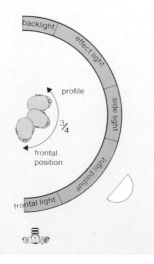

Frontal light, face in profile.

184

Angled light, face in frontal position.

Side light, face in frontal position.

Angled light, face in three-quarters position.

Side light, face in three-quarters position.

Angled light, face in profile.

Side light, face in profile.

the face relative to the camera—frontal, angled, and profile—and there are similarly three basic positions of the key light—frontal, offset, and side. Let us examine the combinations that are more commonly used, although you can obviously find many other valid combinations.

A Universal Recipe: Offset Light and Angled Subject

This combination is the most successful because it can be used for any type of face. It presents the subject in an immediate and pleasing way without emphasizing any one part, and it leaves the expression of the face or the position of the body to supply the meaning of the image. The position of both the subject and the camera can be varied

Portraits taken with different lighting positions. Top left: One single backlight. Top right: A backlight and an angled light in front. Center: One single light angled at the back (rim light). Left: An angled light at the back and one at the front.
Opposite, top: The diagram, drawings, and photographs show the effects of part of the face in shadow and part in light.

within a certain radius without affecting the quality of the image, and by altering the parameters of this formula—the angle, distance, and contrast ratio—you can find the best way of dealing with all types of faces.

There are two equally valid alternatives to this formula. In one case the camera frames the illuminated part of the face, and in the other it frames the part in shadow, thus narrowing the facial features.

Frontal Portraits in Nearly Frontal Light

This method suits faces that have regular features or that are slightly narrow but harmonious. It brings out the ovality and plays down any flaws in the skin. You can use it confidently for a wide variety of subjects, and it is often the simplest method to use when you do not have special supports for the lamps and the flash.

Remember that the direction of the lighting is horizontally the same as the lens axis, but there is a vertical angle of usually about 30 to 45 degrees that is important for good images. Dead frontal lighting parallel to the lens axis (such as elec-tronic flash fitted onto the camera) is not so suitable for portrait photography.

Moving the head helps to produce more flattering images for harmonious but slightly square faces, and bending it up a little enables you to emphasize the eyes.

The Profile

If you choose to do a portrait in profile, it is usually to express some-

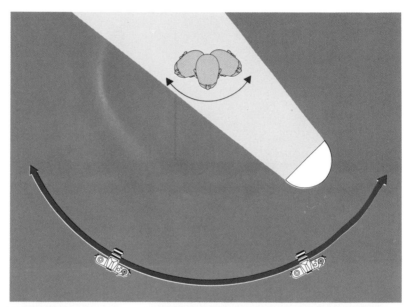

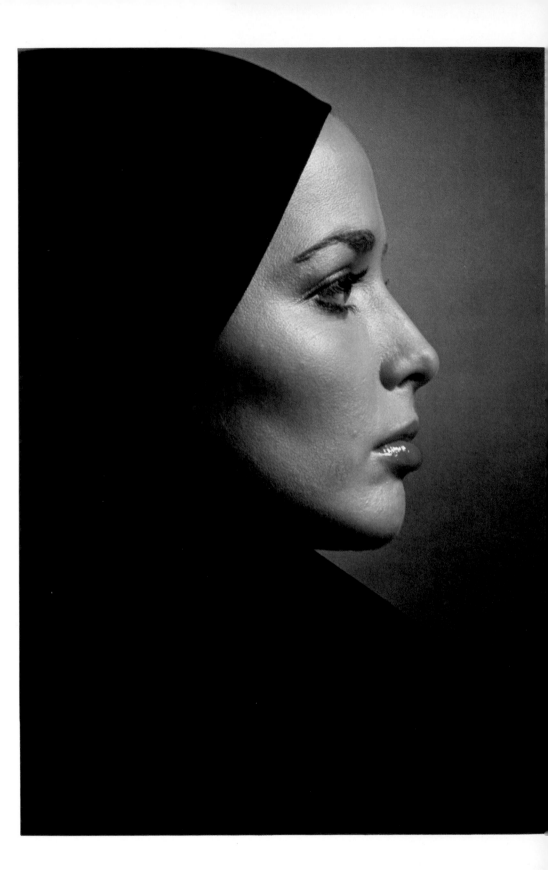

thing about the character of the subject. The job of the lighting in that case is to bring out the line of the profile, which normal frontal or 45/45-degree lighting does not do adequately, as it gives an overall flat image lacking contour. The importance of the background is also significant: it must be clean and of a contrasting tone.

Key Light for Effect

The type of lighting that enables you to emphasize a profile by giving it a brilliant continuous highlight is shown in the diagram above. The key light can be at 90 degrees to the lens axis (frontal to the face), or slightly angled at about 60 degrees. An extra directional light is arranged at an angle of about 135 degrees to produce a reflection on the line of the profile. You must screen the light rays so that they do not strike the lens. The rim light should be positioned to create the reflection without producing any shadows. The vertical angle is about 30 degrees for both lights, and the background should be dark.

The Profile in Soft Light

Illuminating a profile with soft lighting at the usual position of about 45 degrees creates images with little modeling. It is better to have the light at an angle of about 60 degrees and a height of 30 degrees to illuminate the eyes effectively and delineate the jaw. The background should be quite dark to contrast with the outline of the face. Do not forget that rim lighting may overemphasize the texture of the skin.

The Silhouette

The silhouette is a black figure on a white background with no detail visible in either the light or the dark areas. The outline of the figure is composed of the sharp line that separates light from shade; it corresponds to the shape of the negative area in the composition. You can produce it by photographing the figure against a well-illuminated white wall with no ambient light.

The diagram shows another quite simple method. The beam of light from a slide projector throws a clear, sharp shadow with good con-

Above left: Profile lighting with a rim light; the face is illuminated with a side light (1), while the light from a spot (2) with an appropriate screen creates a rim-light effect, bringing out the profile with a line of light.
Above: Diffused lighting for the profile. The face is

illuminated with a single lamp in a more or less angled position.

Below: An example of a profile illuminated by a line of light.
Opposite: An example of soft lighting.

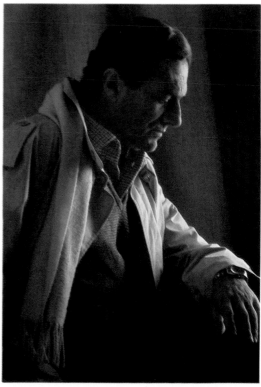

trast onto the screen, which you can then photograph easily. Remember to use a conversion filter or film for artificial light with color film. Determine the correct exposure with test shots to get a deep black shadow on a white background. If you measure the reflected brightness of the white screen without the figure, use an exposure of at least 2 EV more, so that the illuminated area is perfectly white in the photograph.

Fill Light

Having decided on the position of the key light, you must think about the light-shade contrast. You already know how to measure it; the next step is to see how to alter it.

The purpose of fill light is to control the contrast in order to obtain good, detailed shadows, so arrange it in such a way that it does not form any other shadows. The safest and most tested position is along the lens axis; in fact, with this arrangement any slight shadows will not be seen.

The fill light can be direct light, or better still, it can be bounced off a screen to tone down the shadows. It should be soft and less intense than the key light.

Fill Light and the Highlight-Shadow Contrast

When and by how much should the light contrast be reduced? The contrast between highlight areas and shadow actually depends on three variables: the key light, the fill light, and the existing light. The brightness reflected in the highlights on the subject is determined by the total of these three factors, whereas in the shadows you have only the sum of the fill light and the ambient light.

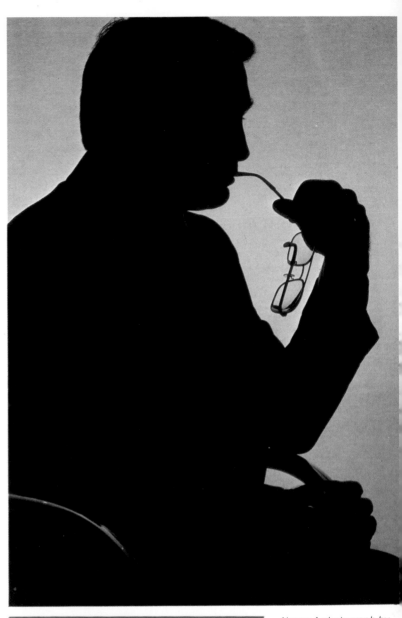

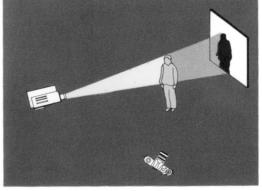

Above: A photograph by William Rivelli which is an example of a silhouette done with taste and great compositional value. Left: A drawing that shows one of the ways in which to photograph a silhouette.

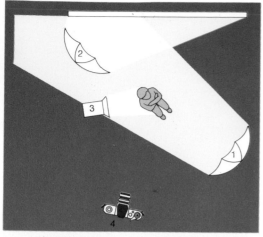

amount of ambient light can be useful in creating portraits in soft conditions without special equipment, but in general you should establish the position of the fill light so that the contrast range in the shadows lies within the acceptable limits of the film. In effect, the contrast range between light and shadow in most cases should lie within 1.5 and 2.5 EV, which corresponds to a contrast ratio of about 3:1 to 6:1. With color film in particular, the classic range is

Rim Lighting

This is an effect light that creates a bright outline. It does not change the exposure, but it does make the subject stand out from the background and increases the contouring to an almost tangible level. Introducing this white continuous highlight has a significant graphic impact: the contour formed can take on the primary role in the composition, powerfully capturing the attention of the eye. The effect of rim

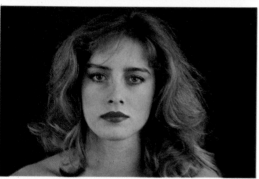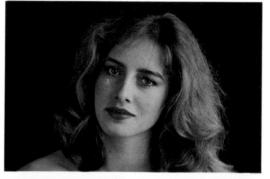

Top: A diagram of studio lighting with multiple flash. (1) Key light; (2) background illúmination; (3) rim light to illuminate the profile, the hair, or even the full figure; (4) a small fill light (fitted on the camera).
The sequence of photographs was taken with key light coming from the right; two secondary lights were progressively reduced in intensity.

Consequently, you can use fill light to increase the detail in the shadows, but at the same time it will increase the brightness of the highlights. Obviously, if there is sufficient brightness in the existing light (diffused brightness), the contrast can never be too great. For example, if you are working in a room illuminated by relatively intense daylight, the ambient light can act as a fill light on its own. A certain

reduced to a ratio of 3:1 or 4:1. Remember that the shadows should generally be a little lighter than may seem necessary to give a pleasant contoured effect.

In conclusion, regulate the distance of the fill light so that the measurement of the shadows gives a value of not more than about 2 EV difference from a reading taken at the same time from the lights.

lighting is obtained by a beam of intense directional light that strikes the outline of the subject at a variable angle of around 135 degrees horizontally and between 45 and 50 degrees vertically.

The background must be dark enough to let the effect of the outline be clearly visible. Usually, the position of the rim light is adjusted while the background is kept dark; then the brightness of the

backcloth is balanced. The maximum effect of rim light is obtained when the axis of the beam of light is pointed toward the outline of the figure, because the central area in the beam of light from a directional reflector is the most intense. Adjusting the angle of incidence of the light beam allows you to see the variations in the brightness of the illuminated outline, so it is better to have two small light sources on either side of the figure, instead of one source located centrally.

A simple method of getting a rim-lit effect around the figure, similar to a halo, is to put a small bare bulb behind the subject's head. This creates radial illumination around the whole figure as well as on the background unless it is well screened. Take care to prevent any direct rays from striking the lens.

The Background

The importance of the background in determining the type of portrait has already been mentioned on numerous occasions. If you decide to photograph the subject in his own or her own environment, you get a meaningful image in which the subject forms part of a whole made up of physical and symbolic elements from real life. If, on the other hand, you put the subject in front of a neutral background, he or she becomes isolated and delocalized; the subject becomes the expression. This is a form of abstraction of the individual from concrete reality that is comparable to the actor on a stage.

It could be said that the studio often revolves around a neutral background, but what should a neutral background be? A background is any sur-

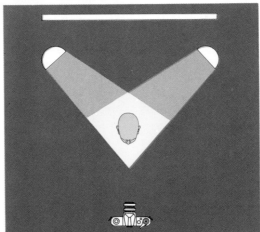

face that indicates no specific location. It should harmonize with the tonal characteristics of the subject. Paper or cloth backgrounds can be used and should be large enough to cover the area in the frame. You can use a projector screen for close-ups if it is large enough; if one is

not available, you can use a piece of cloth at least 1 meter (1 yard) square, hung on the wall.

In long shots, however, you need a proper background, which can be made from a roll of strong paper hung between two supports on an aluminum pipe. A continuous background will contribute to

Rim-lighting effect can be achieved with two lights positioned symmetrically, as in the diagram above left, to produce a line of light around the head, or (above) with one light placed behind the subject, an arrangement that is particularly useful for highlighting the hair (top photograph).

192

more professional results, giving you more freedom to compose the image and choose the frame without the annoyance of a floor line, which always looks bad and often cuts the image in two. The continuous background should be big enough to allow long shots. It can be made of paper or cloth, with an opaque surface, and must be strong enough to withstand frequent use without crumpling or creasing. Many colors are available, but only a few are really useful: white, black, deep blue, blue green, and brown. With a white background, you can create the various shades of gray through correct lighting.

A blue background is quite suitable for portraits traits. A good rule to follow is to harmonize the background with the figure from the point of view of both composition and color. For example, a light subject tends to contrast too much with a black background, and conversely, a dark subject tends to project from the photograph if the background is too light. With color film, choose a background that suits both the flesh tone and the clothing; the choice is mainly one of personal taste, but it also depends on the style of image you want to create. The background should not have vertical or horizontal stripes of any kind, because the subject should be free of compositional structures. Backgrounds made of curtains create problems, so avoid them.

Lighting the Background

The background composes the empty space in luminated in various ways, depending on its shape. To control the lighting on a continuous flat background, you need two floods with cross beams; a semicircular background can easily be lit with one single lamp. By changing the distance or the intensity of the light you can obtain any combination of background from uniform to graduated. In fact, it is sometimes useful to add asymmetrical elements to the background lighting to introduce areas of shadow that enhance the composition.

Top: How to make a continuous background. Above: Two lamps are needed to illuminate a flat backcloth make a uniform background. The curved background (above right) is easier to illuminate and can create a wide variety of graduated effects.

because blue is the complementary color to flesh tone and the subject stands out well against it. It is also reminiscent of the sky, thus forming an excellent natural background for portraits. Violent colors are suitable only for theatrical and fantastic portrait styles, rarely for traditional por- the image—the negative area—so if you change its brightness, you vary the impact of the negative area of the photograph. Consequently, it is useful to be able to vary the brightness of the background independently to balance the composition of the portrait.

The background is il-

NATURAL LIGHT

Natural lighting would seem to be the simplest to use in photography, but its great disadvantage is that it is not easy to control. It cannot be directly manipulated, so you must learn to be in the right place at the right time with the appropriate equipment.

Daylight, actually light coming from one single source falling onto the subject from a height, is the reference for all types of illumination of the human form. All types of artificial lighting are used to reproduce the characteristics of this basic type of light in one way or another.

To understand how natural light fits logically with artificial light, it is useful to know how the intensity of the light on the earth's surface varies during the day. Look again at the graph on page 92: the curve shown is obtained by measuring the light at different hours of the day with an incident-light meter. The average range is about 15 to 20 EV. In this curve you can see three areas of clearly defined characteristics. The central area of high luminosity corresponds to daytime. As a function of the atmospheric conditions, it varies from 18 EV maximum to 12 EV minimum in overcast sky. The quality of the light can vary significantly too, for direct sun creates hard shadows and consequently strong contrast, whereas a cloudy sky creates diffused brightness with soft shadows. The ideal conditions for portraits lie between these two—with the sunlight diffused by clouds to cast light shadows.

The intermediate periods at sunrise and sunset are characterized by rapid variations of light intensity and color, in which there are moments of relatively color-balanced diffused light which can be used effectively in portraits.

The Color Temperature of Light

Sunlight at midday is white by definition. The Kelvin scale for color temperature is used to measure the color difference in the light; alternatively, the corresponding mired scale can be used. The first of these two scales is better known than the second, which was introduced to simplify the calculation of color-dominant correction. In practice, the mired scale is a different mathematical way of expressing the Kelvin scale.

Mireds are obtained from the Kelvin value with the equation

$$\text{degrees mired} = \frac{1,000,000}{\text{degrees Kelvin}}$$

Mireds are constant throughout the scale; for example, a difference of 10 mireds between two light sources will always have the same chromatic value, corresponding to a variation in color of equal intensity. A range of 10 mireds is the minimum amount that can be seen with the naked eye.

Mireds decrease in value as the color temperature rises, so the correction of a reddish

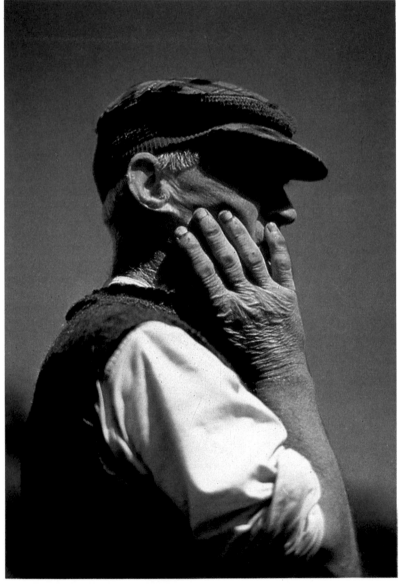

dominant with a blue filter is indicated by a negative number and vice versa for the opposite correction. In fact, if you want to calculate which filter you need to neutralize a particular light color, compare the mireds of the light and the film. For example, if you use daylight film set for 5500K with artificial tungsten light of 3000K, you would have mired (film) = 1,000,000 ÷ 5500 = 182 mired (light) = 1,000,000 ÷ 3000 = 333 Therefore, the difference is 182 − 333 = −152. This number corresponds to the difference in color temperature between the film and the light actually used. To return the balance in the lighting, use a filter with this value in mireds, which is given on the filter or can be found on a table. With a little practice, it is easy to calculate which filter is necessary to neutralize the most common dominants caused by using artificial lights. Remember, though, that the light output from fluorescent tubes has irregular characteristics that do not fit in well with this type of calculation.

It is important to check the color temperature because it has a determining effect on images. Sunlight, which is yellow and warm, provides a sensation of vitality, happiness, and dynamism that is completely lacking

Natural light is variable, but can be very effective in portraits. In the photograph on the opposite page, direct sunlight has created strong contrasts, with brilliant colors. The photograph at right was taken under an overcast sky, so the light is diffused, with no shadows, and less vivid colors.

in the cold, gray illumination of cloudy days. In photographs taken in these light conditions, skin has an extremely unpleasant and depressing bluish hue which completely alters the atmosphere of the portrait.

Portraits in Natural Light

Outdoor portraits are always disappointing when the quality and direction of the light create defects in the image or even

make it look excessively normal or downright boring. It is therefore essential to evaluate the lighting and shadows carefully. Direct sunlight, particularly in summer, always forms very hard shadows.

The direction of the sun's rays must be offset to give pleasant modeling to the face and to avoid glare on the subject; looking into the sun makes people ill at ease and causes them to blink.

Morning light (particularly in the early morning) and that of late afternoon are especially suitable for portraits; the direction of the sunlight is a favorable 30 to 45 degrees on the horizontal, the shadows softer, the light warmer.

It is always advisable to measure the highlight-shadow contrast to establish whether the shadows should be filled in with an uncolored reflecting surface. A typical example is the fill-in effect

natural light	T Kelvins	T mireds	notes	artificial light
	10 000	100		
	9 000	111	blue sky north light	
	8 000	125		
	7 000	145	low clouds	
	6 000	167		
	5 500	182	daylight film range	electronic flash
	5 000	200		
	4 500	222		
	4 000	250	dawn and dusk	
	3 500	285		
			artificial light film range	halogen bulbs
	3 000	333		
			projector lamp	tungsten bulbs
	2 500	400	150–200-watt bulbs	
	2 000	500	25-watt bulbs	candle

This diagram shows the color temperatures of natural and artificial light expressed in Kelvins, and alongside in mireds, which are obtained from Kelvins with the formula $M = 1,000,000/K$. The mired scale is practical for calculating the filter needed to balance a color.

of sand on the beach or snow in the mountains.

Finally, remember that the quality of the background is often neglected when shooting outdoors and this is the most common reason for substandard and confused results. The sky, a green field, or an evenly colored neutral wall are the classic traditional backgrounds that do not disturb the image but actually add to its value.

Natural Diffused Light

You can take advantage of the few moments during the day when the light is particularly suitable for portraits. There are nearly always a few seconds at dawn and dusk when the sky acts as a huge diffuser of the sun's rays. The sunlight is filtered and toned down, it becomes soft and white, but it still has a certain direction. This condition is usually found when the sun has just sunk below the horizon and is no longer the intense reddish-orange color that often precedes the "magic moment" of diffuse white light at sunset or follows it at dawn.

A similar kind of lighting can be found at other times during the day in the presence of white clouds, which act as an effective diffuser of the sun's rays. Even dark clouds can create an extremely effective illumination field in certain cases, simulating studio lighting and setting up some dramatic effects.

The Portrait in Partially Controlled Natural Light

Direct sunlight nearly always produces too much contrast in the light, so in these conditions only "salon"-type dramatic portraits can effectively be created.

When the sun or sky is covered, the position of the sun still determines the direction of the lighting; the sun can be compared to the key light in studio shots. Therefore, you can adopt the same classic positions described earlier, but this often still leaves two problems to be resolved: cutting down the light contrast and eliminating unwanted reflections. White diffusion screens can be used if they are of the right size to clear the shadows effectively and give the desired contrast (usually 4:1).

Unwanted reflections can be eliminated with any kind of absorbent

screen. In this way the illumination field on the subject becomes more uniform and you get a more pleasant contoured effect. A polarizing filter can also be used to reduce unwanted reflections on the skin.

These photographs show how natural light can help create images rich in atmosphere at certain times of the day. Right: A portrait enhanced by the light of a winter sunset. Below: An unusual image with a fascinating hint of mystery taken by the cold light of twilight.

DAYLIGHT IN THE STUDIO

In the studio, work in daylight is based on the use of sunlight controlled by the techniques of reflection and absorption screens. The equipment required is simple and economical: a backdrop, a tripod, and a few screens that can easily be made at home. The disadvantage of this type of studio is that it depends on atmospheric conditions. But the equipment also constitutes the basis for any other type of studio; with the addition of a few more pieces, it can easily be adapted to electronic flash light, which is the only kind that can be mixed with natural light. It also constitutes the basic portable kit for outdoor shoots.

Technically, there are great advantages to using screens for the lighting if you consider that high-quality lighting is much more easily obtained from large light surfaces.

Altogether, there are many advantages to the use of screens: limited cost, simplicity of operation, high-quality light, portability, and suitability for all types of light source. The lighting technique is quite simple: the laws of reflection determine the angle of the screen, which must be equal to or larger than the area in the frame. Remember that screens are useful in studying the lighting because they allow direct evaluation of the effect of the light on the subject.

Types of Reflector Screens

Reflector screens differ from one another in size and surface type. White screens give soft light and are excellent for filling in shadows, whereas silvered or aluminum-coated screens give more directional light and function better as key lights. Black screens absorb light and have the opposite function of white screens in that they cut out unwanted light and eliminate reflections, thus increasing the shadow contrast. Gilded and blue screens are also available to alter the chromatic equilibrium.

Small screens of 20 × 20 cm (8 × 8 inches) to 40 × 40 cm (16 × 16 inches) are used to diffuse directional light from small sources such as electronic flash. There are also the classic inflatable diffusers such as the Air-Brella and the Vivitar 283 reflector card. They are useful screens for close-up shots because they significantly soften the light for this kind of portrait.

Average-size screens of 50 × 50 cm (20 × 20 inches) to 125 × 125 cm (50 × 50 inches) are the most commonly used for studio portraits and can be made in different shapes and materials. A regular projector screen also makes an efficient reflector with the advantage that it is already fitted with a stand. This category also includes the various types of round and square umbrellas which are portable and unbeatably light. In effect, an umbrella can substitute for a range of indirect reflectors; it is easier to move about and costs less. Some white umbrellas can also be used for the transmission as well as reflection of light to produce even softer and more uniform effect, although usually with a greater amount of light absorption. The most versatile umbrellas can even be used flat for a wider and more diffused beam of light that covers a larger area.

Large screens can be the size of a door and are usually collapsible and rigid. They are the most useful for lighting the full figure and can also be used outdoors to screen the subject from unwanted light. To be more manageable, these screens have to be made of light wood or polystyrene. Double-sided screens are also available, both white and silvered, made of plywood sheets hinged together to make them collapsible.

How to Use Screens

Lighting with reflector screens is easily adjusted, and the effect can be evaluated directly, so any modifications to the angle and the distance from the subject can be made immediately. The presence of the screens influences the exposure, so measure the light when they are already in position. Screens also make good backcloths.

Mirrors

Finally, there is another type of reflector screen that is not often used: the mirror. Its function is purely to change the direction of the beam of light without altering its properties at all, so it can be useful, for example, when you need top lighting for the hair and it is difficult to arrange a spot on the ceiling. In this case you can get the same results a lot more easily by fixing a mirror in a suitable position. Another useful application of mirrors is with sunlight that enters through a window in a direction that cannot be used; with a mirror, you can direct it to where it can be diffused or reflected at will.

The Absorption Factor of Screens

When you use the same reflector screen frequently, it is useful to know its absorption factor. To determine this, you need a reflected-light meter. As shown in the diagram below, measure the light reflected off a

Far left: An example of how to organize a daylight studio at home. Left: A white screen (reflective) and a black one (absorbing).

standard gray card illuminated by continuous light from a lamp positioned at a given distance away; then repeat the measurement with the light reflected off the screen before it reaches the card, ensuring that the light rays travel the same distance. The difference in exposure values between the two readings gives the constant absorption factor, valid for both flash light and continuous light.

Light Entering Through a Window

This is the most practical and the simplest form of lighting for a portrait, but a shot taken indoors always presents certain difficulties. As a rule, you should use medium or fast film combined with shooting techniques normally associated with low light levels, unless of course the windows are wide. The main advantages of this kind of light are its quality and the ease with which it can be used. In fact, the size of a window generally corresponds to that of a large illuminating panel at the least, and the light intensity, although not very high, is quite constant over a sufficiently wide area. In addition, there is not the rapid fall-off in

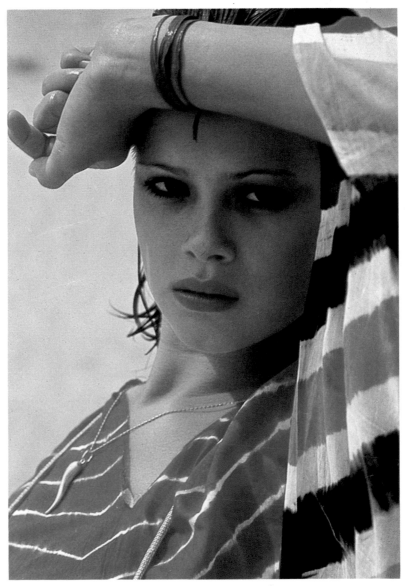

To measure the absorption factor of a screen, check that distance A equals distance B + distance C; then measure the light received by a gray card from a direct source and by reflection off a screen. The difference in exposure values between the two readings is the absorption factor. Top right: The woman's arm screens her face from the harsh light; the face is filled with light from a reflector screen.

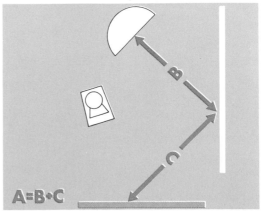

A=B+C

Above: Light from a window is particularly favorable if it strikes at an angle of about 45 degrees. If the window is too low, however, it should be screened at the bottom, to avoid reflections from below. The same applies to a door-size opening (right).

Light entering through a window can be more or less useful in portraits, depending on the type of exposure. Not only the quality changes, but also the amount of light, which could limit the usable area of the room.

light that is typical of artificial lighting. There are also quite considerable disadvantages, however. The quality of the light depends on the weather and on the width of the window, its height off the ground, and its direction toward the sun.

The width of the window determines the amount of brightness; a large opening not only supplies more light, but also makes it possible to use a larger area in the shot, which permits the subject more freedom of movement. A small window lets in a narrow beam of light that is more directional than diffuse, whereas a wider window gives a softer and more enveloping light.

The height off the ground determines the angle of the light striking the subject. The best-quality light that models the face effectively falls at the classic angle of about 30 to 45 degrees. A low window or a french window, on the other hand, produces a less pleasant light which is also less uniform because the greater part of the light beam strikes the floor and creates one or more intense reflections from below, for an unpleasant and unnatural effect. In these cases it may be better to change the light beam by screening the bottom part of the window. In general, however, you can control the reflections from the floor by using dark, black, or even light material positioned on the floor in front of the subject.

The direction of the window relative to the sun is a very important element that establishes the quality and type of the lighting. To use a window that is directly illuminated by the sun, you must use the technique of reflection from panels or diffu-

sion with semitransparent screens. With a north-facing window, however, you get diffused light that is less intense, soft, uniform, and constant throughout much of the day. Windows on the ground floor in built-up areas do not have much exposure to the sky and are therefore influenced by all kinds of colored surfaces such as walls, plants, and fields, giving rise to dominant colors in the presence of intense sunlight. One very enviable situation is a window that faces a large white surface exposed to the sun. Such light is not only intense, but also soft and uniform. Windows on up-

per floors give a more intense and less angled light which penetrates farther into the room.

The color of the walls is another factor that determines whether a room can be used or not. The presence of a large colored surface creates a dominant on the image, but a light, warm tone is generally advisable, because it balances the color of the sky, which tends to be quite cold. It is also suitable for portraits in a homey setting, which need a warm and relaxed atmosphere.

How to Adjust Light Through a Window

Roller blinds are useful for adjusting the overall light intensity. They do not improve the quality of the light, however, because they cut off the top part of the light, which is often the most effective for portraits, so it is necessary to fix dark paper or cloth to the window to block the lower part of the aperture. White or neutral curtains that are not too thick are useful for diffusing sunlight, and even a sheet hung over the window works well.

Techniques for Lighting with Direct Sunlight

Sun rays entering through a window create very high-contrast light that is definitely not suitable for portraits. It can be used only for formal studies in high contrast such as the nude.

A ray of sunlight breaking through clouds certainly has a special fascination and has often been used in the figurative arts. The problem in using this vivid and suggestive light in photographs is reducing the contrast to a level that is compatible with the technical characteristics of the film; you must tone down the shadows by using an appropriate fill light.

Diffusing sunlight with a piece of white cloth (such as a sheet hung over the window) creates a true high-intensity and chromatically perfect light panel which supplies full and intense lighting. A black cloth limits the area to improve the quality of the light.

Light from a window often illuminates large areas of a room and allows portraits in which the subjects are in a natural atmosphere and setting.

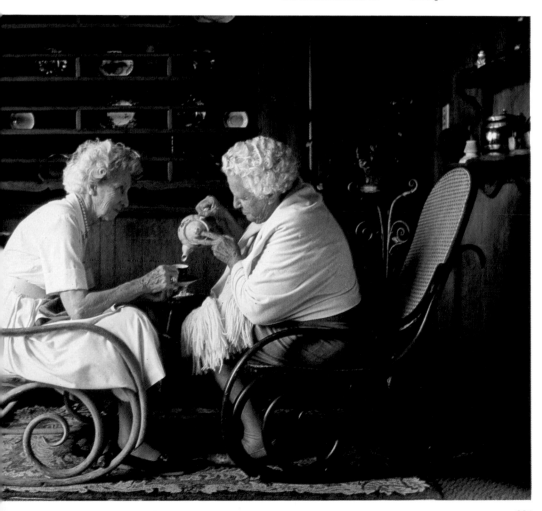

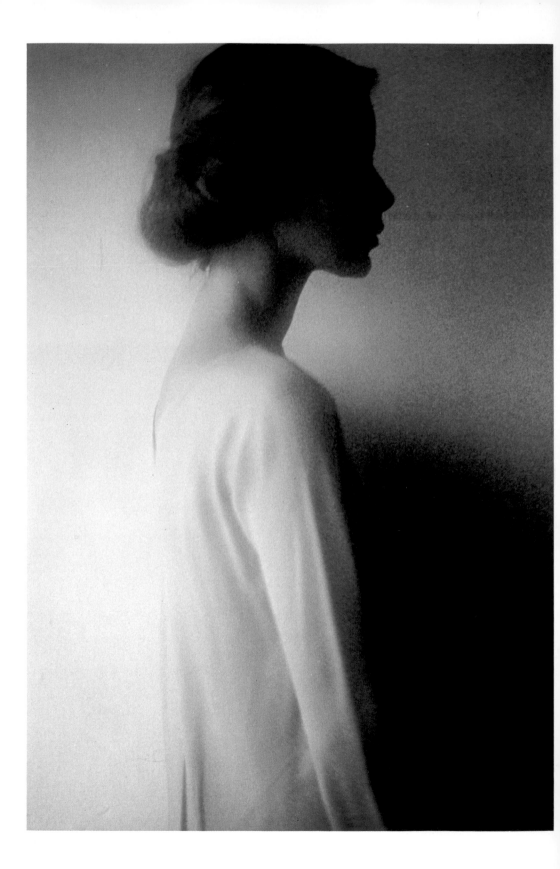

Using the Sun for a Rim-Light Effect

Direct rays can be used by reflection off white or aluminum-coated screens. A particularly suggestive type of lighting, suitable for glamour photographs of women and children, can easily be obtained by using a white reflector screen if you have a window that is sufficiently wide and high to allow in a full beam of sunlight.

In practice, direct sunlight is used for a rim effect to bring out the outline of a figure, while the reflected light acts as the key light. The subject is either completely or partially backlit, so that the sun's rays outline the form with a brilliant line of light. A reflector screen can also be used to reflect part of the sunlight to give the face effective modeling. By adjusting the distance of the screen, you can vary the intensity of the resulting key light to get the right contrast.

Equipment for a Studio Using Ambient Light

The basic equipment for taking shots in daylight in a studio is the following:
• cameras with a short telephoto lens and a zoom for close-ups, or a medium-wide-angle lens for figures set against a background;
• fast film, which makes taking the shot easier, particularly in low-light conditions;
• a neutral background, which can be an ordinary projector screen;
• a pair of white reflector screens, an aluminum-coated one and a black absorption screen; the sizes depend on the type of portrait (close-up or long shot).

In addition to these basic pieces of equip-

In the photograph above, the main light is from a window (acting as a rim light); in the photograph at right, the sun creates lines of light on the hair; reflection off a screen provides the key light. Opposite: Light from a window is a simple but valid source of illumination. Natural and pleasing effects can be achieved even when part of the subject is in the shade. Right: How to arrange a screen to reflect the sun's rays onto a subject.

ment, strong white and black paper or cloth can be useful for partially screening the window or diffusing the light. Chairs, low stools, and cushions are also useful for posing the subject at various levels off the ground, and a small flash is useful for fill light. Continuous tungsten lights should not be used at all because they have a different color balance from natural light.

nounced contours and modeling. This is the most controllable and most favorable lighting for indoor portraits.

Frontal light. The diagram on the right shows the camera positioned next to the window, framing the subject, who is illuminated frontally by the beam of light. If you do not want a black background, place a light backcloth behind the subject at a distance calculated to give the desired background tone.

Techniques for Using Light from a North-Facing Window

A window that does not receive direct sunlight can be treated effectively as a lighting panel, and so the quality of the light similarly depends on the distance from the window and the angle of the light. The diagram alongside clearly shows that the lighting on the subject differs according to the distance from the window. The area next to the aperture has a single, mainly enveloping light which is intense and diffused, whereas farther away, at a distance of over half the width of the window, the light intensity drops and shines at an angle of less than 45 degrees, creating soft images with more pro-

The drawings above refer to light entering through a window. (1) Direct light that strikes the subject frontally is enveloping, and the resulting portrait is soft. A light background proves useful. (2) Light reflector screens are useful for controlling contrast; dark absorption

screens limit the direction and extent of the surface illuminated by the window. (3) With side light the face is softly illuminated, because a reflector screen reduces the contrast. A backcloth makes the background the desired tone. (4) The light is very diffuse in the

area nearest the window, but away from it the lighting has a narrower angle. (5) With backlight the window acts as a background, and a screen fills in the shadows (if close).

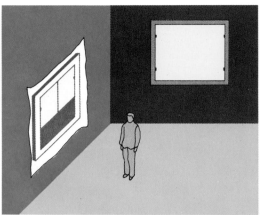

Lighting from two windows, one of which supplies the key light and the other the fill or effect light. The window on the left, illuminated by the sun, is covered with a sheet to diffuse the light and blocked off at the bottom by a black screen to limit the negative effect of bottom lighting.

A delicate portrait by David Hamilton taken with window light.

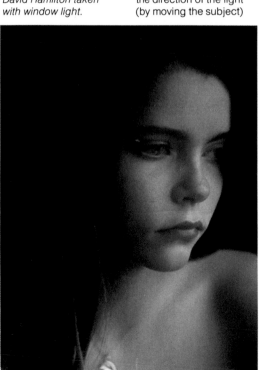

The face should be at a certain angle to the direction of the light to give more contouring. This kind of lighting is always natural, pleasing, soft, and flattering.

Offset or side lighting. If you move the shooting position to the side of the window, you must modify the lighting technique accordingly; in fact, you need a reflector screen to reduce the contrast. Altering your position and the direction of the light (by moving the subject) produces soft and well-modeled images in the direction of the window, or you can get harder and more intense images with a rim light. In this way you can obtain a large number of effects simply by changing the position and the distance of the screen and the subject from the window and by changing the type of reflector surface on the screen (white or aluminum-coated).

Backlight. Although in side shots the reflector screen serves its usual purpose of filling in the shadows, the screen creates the key light when you are shooting in backlight. The background is made up of the window opening, which consequently has to be cleared of distracting elements. With the subject near the window, you get a softer, enveloping light.

Lighting with Two Windows

A room that has two adjacent windows, preferably at right angles to each other, lends itself well to acting as a twin-light studio. The window with the greater light intensity can be considered the key light and the other window becomes a secondary light. A particularly good situation is when one window lets in direct sunlight and the other diffused light.

The shooting techniques are essentially similar to those already described, but in certain cases the second window can increase the ambient light to reduce the shadow contrast without reflector screens. When you measure the light with an exposure meter, you should find the area at which the two lights are equal; depending on the circumstances, you have to decide on using one or the other as a key light. You can use the two windows for rim light from both sides of the face or the figure, and use a reflector screen to give the key lighting.

Using Absorption Screens Outdoors

A uniform light field produces flat images of little interest that do not show up the modeling on the subject, so it can be difficult to obtain satisfactory results when you photograph outdoors under an overcast sky. You can, however, improve this kind of lighting by using absorption screens; the problem lies in correcting the lack of direction in the light because the light strikes the subject equally on all sides. With a black absorption screen you can remove all the light that is not useful and obtain results comparable to those produced in a studio where the lights are positioned in accordance with the classical rules. This procedure can actually be compared to the erection of a window in the desired position next to the subject. Consequently, this technique can be considered an outdoor variation on window lighting.

Once the subject has been appropriately screened, measure the light level again; obviously it will be much lower. House walls or any other available walls can also be used as absorption screens, but bear in mind that light from above in a city street, particularly if it is a narrow one, is never very pleasing because it is too high. In these conditions, the eyes remain in shadow, forming black hollows that disfigure the face.

FLASH LIGHT IN THE STUDIO

The addition of electronic flash to a natural-light studio makes it more versatile and complete. In fact, flash light is perfectly compatible with natural light and allows you to extend the usefulness of your equipment. Thanks to its great speed and intensity, flash light eliminates blur and even enables you to use slow color film, but you still have the disadvantages of this type of light—it is impossible to evaluate its effects directly, and in many cases there is a degree of uncertainty about the exposure.

The basic equipment for a studio using artificial light consists of two mid-powered flash units fitted with reflector screens or umbrellas, together with the equipment previously described for natural lighting. The choice of flash unit depends on what you expect from it. Normal automatic flash units with a separate cell such as the Vivitar 283 are sufficient for setting up an amateur studio at home. Those who have more professional requirements only have to make the choice between the many high-quality (and reasonably priced) models that are currently used in professional studios, characterized by ease of use, sturdiness, and power. The quality of portraits does not depend on the price of the equipment; amateur accessories can produce very high-quality photographs.

Professional studio flash units have a feature that can be of great interest to amateurs: modeling lamps that are low-intensity, light halogen bulbs incorporated into each head on recent models to show the effects of the lighting immediately, thus eliminating the biggest

disadvantage of flash systems. The continuous light is used to choose the quality of light, although the exposure is actually done under flash light. Similar results can be obtained by coupling a small reflector to each amateur-type electronic flash.

Remote-control synchronization systems such as slave units or infrared transmitters mean that a flash-light studio no longer needs all the connection cables between the various light units and the camera. Modern professional light systems include a central power pack which controls the light units, giving the photographer complete control over the lighting.

Lighting Techniques

Lighting techniques differ according to the type of equipment used. Because it is impossible to see the highlights and shadows directly on the face with amateur flash units, it is necessary to organize a working system. Because the bulb is so small, direct flash produces harsh shadows that require accurate control of the light contrast. It is therefore advisable to use the reflection technique with umbrellas or screens that produce a soft and more easily controlled light, leaving a margin for error in the angle of the shot or even subject movement, as well as making it possible to work without fill-in · flash. In practice, therefore, with a single flash unit and an umbrella, you can easily create good-quality light and allow the sensor built into the camera to set the exposure automatically. If you use professional equipment,

however, you can study the illumination directly through the modeling lights, which make the technique similar to that used with continuous light, but with greater flexibility, practicality, and convenience. Modern studios now use only this type of equipment.

Professional flash units are modular systems: the lighting unit, consisting of a quartz bulb and an electric discharge tube for the flash, can be used on its own or with various types of reflector heads. In reflective surroundings, the direct light from a bare bulb can be used to give low contrast with sharp-edged shadows, and beams of diffused light can be produced to a greater or lesser degree with reflectors of various shapes and sizes. Alternatively, flash units can be used with traditional reflector screens or diffusers.

Exposure with Flash Light

The systems for controlling exposure with electronic flash vary according to the type of equipment used. In the simplest models, a simple calculation based on the *guide number* allows you to adjust the lens aperture manually on the basis of the subject distance. Since this is usually done during a studio shooting session, there should be no problems.

With an *automatic flash unit* with a built-in cell, or, better still, an independent cell fitted onto the hot-shoe contact on the camera, the flash unit itself calculates and supplies the necessary amount of light, automatically regulating the duration of the flash. This is a safe and practical method, particularly for the techniques of reflected flash.

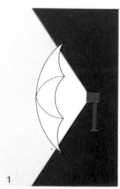

Above: Umbrellas made of white cloth can act as diffusion screens (1) or reflection screens (2). Left: A light but functional lighting system—an electronic flash unit with an independent cell fitted onto a tripod and equipped with a silvered umbrella.

But the most accurate method is still direct-light *TTL flash measurement.* This is truly infallible, provided that it is the key light that is piloted by the camera.

The exposure can also be calculated by using *flash exposure meters* which are irreplaceable when you are using multiple lighting systems for which the exposure is not based on a single flash unit. The most complete models measure both continuous light and flash light and can distinguish between the two or even combine them.

Fill-in Flash

The most practical and convenient method of reducing the light contrast is by using a flash. The technique of reflected flash is often the only way of controlling the lighting in portraits taken indoors and out.

Remember that to clear the shadows, you have to illuminate the subjects to reduce the highlight shadow contrast to a range of 1 + 2/3 − 2 EV, corresponding to a contrast ratio of about 3:1 or 4:1. With a higher ratio at 5:1 (2 + 1/3 EV), the effect of the flash is almost negligible. The flash should be positioned near the lens axis, so it is simplest to insert it in the hot-shoe contact, though at times this can lead to very slight double edges on the shadows which are not very pleasant. To improve the quality of the lighting, diffuse the flash through a reflector screen placed in the most suitable position, often a little lower than the camera on the same side as the key light.

You can easily control the amount of fill light by varying the light output with automatic flash units. Because the necessary intensity is often rather low, it can be useful to reduce the light with simple devices such as covering the flash with a layer of white cloth, like a handkerchief, to absorb about 1 EV, or even covering half the flash itself and thus halving its exposure.

How to Calculate the Exposure

Let us see how to reduce the light contrast to the classic value of 2 EV, corresponding to a ratio of 4:1. The exposure of ambient light is calculated in the usual way, by setting a shutter speed not less than that required for the synchronization of the flash. Take note of the required aperture, let us say f/11. Set *double* the ASA rating of the film used on the flash selector and see if the set aperture is included within the range of those recommended; if it is, the flash unit will adjust the output accordingly within the set distance range. If not, take the closest aperture and alter the shutter speed to suit.

When you use the flash outdoors, its efficiency is less than in a closed setting because of the lack of reflections; the light loss falls within 1/2–1 EV. This shows that even if you calculate the exposure of the flash light at the real ASA rating of the film, the clearing of the shadows will be less than it should theoretically be (ratio 1:1) and will in fact be closer to 2:1.

In practice, to vary the highlight-shadow contrast, you need only set a different ASA rating on the flash; setting just a 50 percent greater rating will give you a ratio of 2:1, whereas with 150 percent more, you will reach a ratio of 5:1, which is the maximum recommended.

A flash-light studio also incorporating daylight that can be set up in the home.

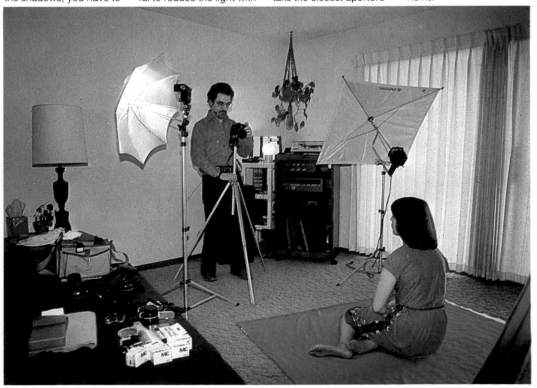

CONTINUOUS ARTIFICIAL LIGHT IN THE STUDIO

Continuous artificial lighting, the prototype for the photographic studio, used tungsten bulbs and reflectors. In modern studios, however, continuous light is used only for checking illumination, as in the case of modeling lights; flash light is used for exposure. This allows you to use sensitive films balanced for natural light and eliminates the need for high-intensity lights, which overheat the equipment and the environment as well as creating annoying glare that makes subjects look quite the opposite of relaxed and causes them to close their eyes halfway.

A simple continuous-light studio is the basic way for the beginner to learn about lighting techniques; however, to get around the low light intensity, you can use fast black-and-white film and thus avoid the problem of color balance.

Equipment
The most commonly used equipment for producing portraits under continuous-light conditions is the following:
• a main light consisting of a small parabolic reflector, preferably with indirect light, usually of no less than 500 watts;
• a fill light composed of a floodlight placed behind the camera, of the same size or larger than the main light, but softer and of lower intensity;
• rim lights supplied by small spots beside the subject, one pointing at the hair and the other at the outline of the figure for emphasis with continuous lighting;
• one or two small floods to illuminate the background.

When you equip your

first studio, it is better to buy a few inexpensive pieces to do the job of the more complex professional equipment, although the latter performs better and is more reliable in the long run. A basic beginner's outfit could consist of two regular-size lamps complete with adjustable stands, a neutral background with a corresponding small floodlight, a reflector screen, and a tripod for the camera. For light sources, you can choose between tungsten bulbs like the *photoflood,* which are fitted with parabolic reflectors, or halogen bulbs, which are smaller and so produce harder, more directional light, which is better bounced off an umbrella or screen.

Reflectors
The type of lighting provided by reflector units varies according to the constructional features of the equipment.

The diameter of the reflector opening is usually between 25 and 60 cm (10 and 24 inches) and is the most important factor in the use of the flood because it determines the quality of the light. The other determining factors are the internal finish on the reflector disk, whether matte white or reflective, and the shape of the curve, or parabola. Every reflector produces a different light, even if the difference is only slight, with a specific balance between the directional and the diffused light. Wide reflectors that diffuse light often have a built-in mirrored section over the bulb to screen out any direct rays. In general, a 30-cm (1-inch) parabolic reflector supplies adequate key light-

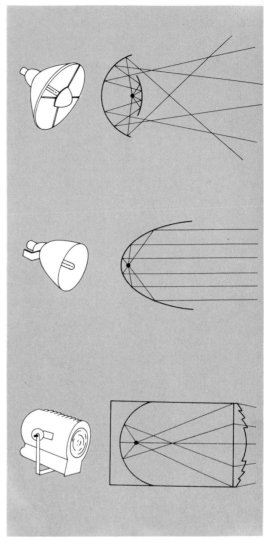

ing, but you need more diffuse light for fill-in lighting, using a reflector that is the same size or a little larger.

Top: An indirect reflector unit, a typical way of providing soft light for portraits. A small screening section softens direct rays.
Center: A parabolic reflector produces a beam of light that is almost parallel; depending on the type of bulb used, it can supply strongly directional or soft light. Bottom: The light from a spot is focused into an adjustable diverging or converging beam.
Left: A simple yet practical reflected-light illuminator.

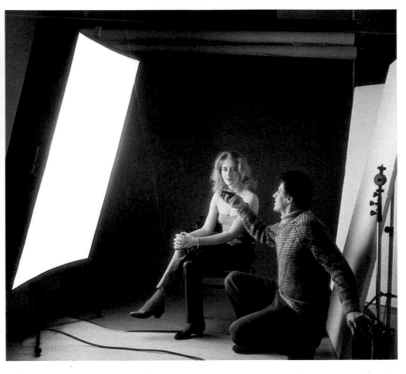

Important accessories for reflectors are screening fins, which protect the lens from light rays.

Spotlights

Directional lights, called spots, are used to create areas and lines of light on the figure. Professional spotlights produce a beam of light that is focused by means of lenses and is adjusted by altering the position of the lamp. For selective illumination, the beam of light must be suitably screened and adjustable in size. It is useful to have a cooling system to dissipate the heat produced by the bulbs.

Power Transformers

Taking a portrait involves careful examination of the image, and so you must be able to move the lights quickly and easily. Therefore you should have a power pack with which you can control all the lights without moving

from your position.

Another useful piece of equipment is a circuit to reduce the output of the lamps while you are making your preparations and adjusting the setting. You can use a transformer to reduce the voltage, or a simple circuit that enables you to switch the lamps from being in series to parallel.

Lighting Banks

For particularly soft lighting, you can get professional equipment consisting of large light boxes which provide lighting similar to that obtained through a window. These make up illuminating walls with easily adjustable direction and so are highly suited to photographs of the full figure.

Lighting Techniques

Techniques for incandescent light follow the same general rules as described previously. The

arrangement of the lights depends on personal preference and the style you want to achieve in the portrait, but you should bear the following points in mind.

The position of the key light is always the first thing to decide. This means determining the distance, height, and angle relative to the direction of the shot; all the other lights are secondary and so are used only to refine and complete the image created by the key light. It is easier to get natural illumination with a large light source, such as bounced light.

Fill-in light is used only when you have to reduce the shadow-highlight contrast, but you can avoid using it by working in a studio with sufficient existing light; using fill light complicates the light arrangement.

Spotlights are useful for making the subject stand out against the background, such as by

creating rim lighting to add contour to black hair, which tends to form a black mass completely lacking in detail. Spots are not necessary if you use soft lighting.

Background illumination, however, is very important. It not only allows you to balance the composition, but it also determines the style and psychological temperament of the image.

To get an effect of fading shadows on a part of the body, use a translucent screen at a suitable distance from the source to form zones of half-light, as seen in the diagram above. In this way you get a soft, continuous merging of light and shadow which enables you to tone down excessive brightness of white clothing and focus interest on the face.

ANALYSIS OF HIGHLIGHTS AND SHADOWS IN A PORTRAIT

If you look very carefully at certain details in the highlights and shadows of photographic portraits, you can to a certain extent determine the lighting techniques used. The highlights are created by reflections of a greater or lesser degree of brightness on the different planes of the figure. Reflections in the eyes are the first and most obvious clue to the source of the lights. Obviously, the face must be in close-up for you to be able to identify the eye lights accurately.

The number of white reflections indicates the number of lights used and their relative size or distance. Typical indirect light reflectors can often be easily pinpointed; they produce a circular crown reflection because of the presence of the small light-covering screens. Windows and illuminating panels create square reflections. Only lights that are at a great angle to the face do not create these eye lights, which make the eyes look brighter and more vivacious.

The other reflections you might see are those on the lips and on the various planes of the face: the forehead, the cheeks, the line of the nose, and the chin. If the lighting is sufficiently directional and the skin sufficiently shiny, there are usually highlights at these points to indicate the angle and height of the key light.

In a good harmonious portrait, both the highlights and the shadows should be produced from a single source, so there should not be any reflections under the eyebrows, for example, which are typically caused by lighting from below and could be caused by unwanted reflection of sunlight on the ground.

The edges, direction, shape, and density of shadows provide a great deal of information. Shadows with sharp edges are produced by small or distant lights, whereas shadows with hazy edges indicate large lights or lights positioned close to the subject. Shadows falling behind the subject are rarely found in studio portraits, but are found in location portraits. They reveal the direction of the key light or the more intense light, such as sunlight in the open, even when the subject is illuminated with reflector screens acting as the key light.

Two shadows are nearly always present in portraits: those beneath the nose and beneath the chin. These can reveal the light contrast, the presence of fill lights, and the position of the key light. A shadow below the eyebrows is usually lighter, present only when the vertical angle of the light exceeds the classic 45 degrees. If done properly, shadow fill should not leave any trace on the photograph except in the eye lights.

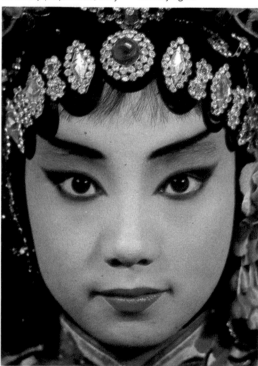

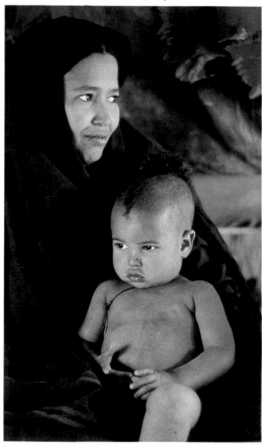

Above: Two points of light in the eyes and a double shadow at the sides of the nose indicate the use of two symmetrical lights. Right: The shadows and *the reflections in the eyes imply that two side flash lights were probably used with a diffuser.*

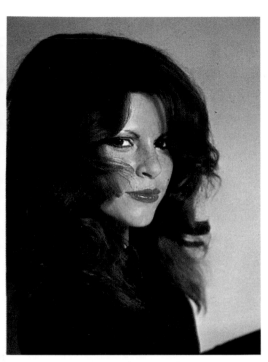

Left: There are reflections on the lips and skin caused by an angled directional light striking from a raised position. Below: The use of 90-degree key lighting is clearly visible here. A frontal fill light is reflected in the eyes.

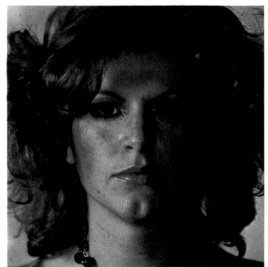

Left: The lighting from a large side reflector panel can be detected in this formal portrait, in the limited reflection on the glasses.

Above: A light arranged at about 60 degrees horizontally and 45 degrees vertically has created heavy shadows.

CHILDREN

People may never be photographed quite so often as when they are children. Family albums are collections of photographs of children taken on the many special occasions that mark the stages of their physical and psychological development.

Babies, like animal cubs, evoke feelings of tenderness and protection because of their wide eyes, chubby cheeks, rounded foreheads, and their bodies, which are devoid of sharp angles, and their heads, which are always relatively large compared to their bodies. Their frank expressions, defenseless looks, and unsure or clumsy movements convey submission, calm abandon, and cries for help. Infancy can be considered the immobile age, in which the child explores reality with his or her eyes, but then childhood is the age of curiosity and constant movement.

During the next period, adolescence, the child gradually changes and acquires a self-consciousness, so being photographed no longer seems a carefree and enjoyable game but makes the adolescent feel the center of interest in an adult world.

Because children are so receptive to others, the photographer has to be capable of communicating friendship and being accepted as a friend in order to be able to capture calm, spontaneous behavior. He or she must therefore be open, available, patient, and able to communicate with children and gain their trust and affection.

The Technique

Recommended equipment is that which en-ables the child to be photographed in his or her own surroundings, whether at home or in the open air. Automatic cameras with a zoom lens are very practical, because they allow you to follow the subject's movements closely and quickly. The 2¼-square reflex camera with chamber viewfinder is also good because working with the camera on a shoulder strap puts it at the correct height for the photograph.

Natural soft lighting is the best kind for this type of photograph, and a fill-in flash can prove useful outdoors in full sunlight. Reflected flash is recommended indoors; it simplifies the shot by freezing movement and produces soft, spontaneous, atmospheric images. Alternatively, lighting from a window lends itself well and is ideal for the unexpected photograph of a child absorbed in play.

If the child is the only subject of the photograph, shoot at the child's height for a neutral and natural perspective. A high-angle shot shows the adult's point of view both physically and symbolically; conversely, taking the photograph from a low angle, with the camera at floor level, shows the child apparently playing at being adult. This can produce particularly vivid, effective, communicative, and warm images, especially when the subject's expression is serious and intense.

Children are a never-ending source of expressions that follow each other in rapid succession with thousands of nuances. To capture spontaneous images, the photographer should act quietly and discreetly, without interrupting the child but continually at-

common, although they still constitute a significant part of professional portraiture. Nevertheless, this change is less of a decline and more of an evolution from a posed, static, and carefully studied portrait that ill suited the natural spontaneity of the subject; popular taste now prefers portraits with atmosphere, created with a less rigid and more vivid style, made possible through flash techniques.

With a minimum of experience and equipment, anyone can now take reasonable and often very good photographs of children without too many problems, thanks to modern photographic technology, whereas in the past only professional photographs could be · taken with the correct techniques.

Above: A tender image of a sleeping baby taken by Enzo Arnone.
Below: A photograph of a group of children in an interesting setting.
Opposite, top: A delicate portrait taken by the light of a window.
Bottom: Even tears can be photogenic.

tracting his or her attention to the camera. In this way the child becomes accustomed to being photographed.

At other times the photographer can play with the child and take photographs unexpectedly. This trick often results in amusing or very vivid

photographs, but it requires accurate techniques for freezing movement, as well as time, patience, and numerous attempts.

Studio Portraits

Once a very popular tradition, formal portraits of children are now less

sional portrait clearly stood out in comparison to the Instamatic pictures taken by family members. The former showed the subject in close-up, but in the latter, the child could hardly be recognized because the photographs were taken from so far away.

Parents try to capture a fleeting image of the child who is changing visibly and continually, almost from day to day, but the artist tries to symbolize childhood in the portrait and contrast it to some extent with adult reality. There is a difference between the two types of portrait: one is a physical portrait showing the child specially dressed and combed for the occasion in which he or she is almost idealized; the other is a more symbolic portrait that shows a more cultural or psychological interpretation of childhood.

Once children have passed the age of fidgeting, they will often cooperate willingly with the photographer as if they were taking part in some game, but they still tire of it quickly. It is helpful to set up the studio equipment in a background familiar to the child and keep equipment to a minimum. Natural light combined with flash is the best, for as well as being simple to use, it enables you to take spontaneous, direct, and natural photographs. Rather than arranging the child in a pose, put him or her at ease in a suitable position for the shot.

Above: Two highly spontaneous, beautiful expressions: the lovely smile on the face of the little girl who has gladly agreed to be photographed, and the suppressed laughter of the girl in the background. Left: The exuberance and vitality of a child who is proud of his costume. Opposite: An up-to-date version of the classic portrait of a child in a pose. This image by Fulvio Roiter has been set quite successfully.

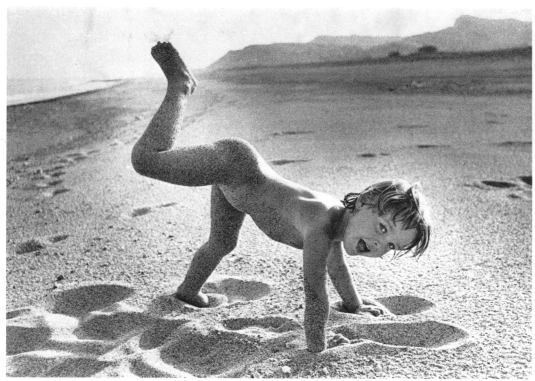

Children and Adults

The classic example of a formal group portrait is that of the family nucleus: father, mother, and children. It is not easy to get a fresh angle on this scene which has been represented in thousands of ways, both in paintings and in photographs. To add to the difficulty, it also presents all the problems of a group photograph complicated by the restlessness of children.

When you are constructing the image, bear in mind the traditional examples that are a good and reliable point of reference: the child is gener-

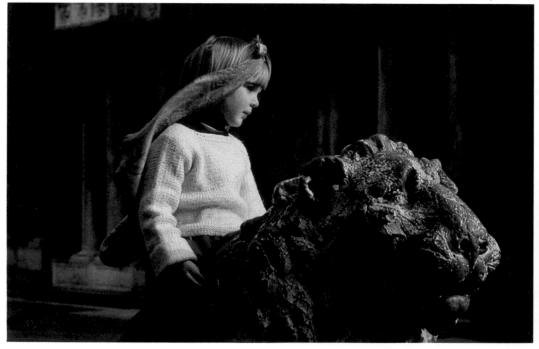

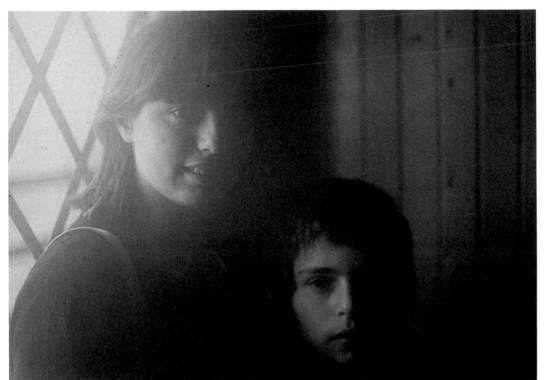

ally the center of interest and is therefore the focus of the composition. The most vivid and effective images are obtained when the parents seem to be having a dialogue with the child. The direction of the eyes and the arrangement of the people thus form a triangular structure, avoiding the static and monotonous positions typical of portraits in which the subjects pose in a line and stare at the camera.

Remember that when there are adults and children in the same photograph, you have to create a suitable arrangement to harmonize the symbolic and compositional weight of the image.

Above: In this photograph window light and a pastel filter produced the softness. It is handy to photograph children *while at play or when they are occupied in some activity to get spontaneous results. The "nude" by Marzia Malli* *(opposite, top) is an elegant example of how useful this trick is.*

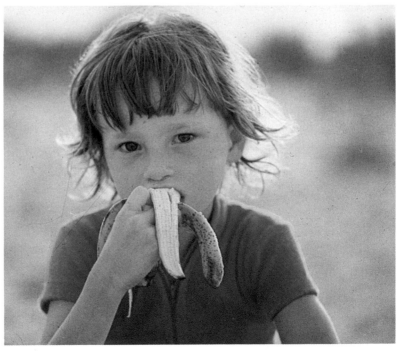

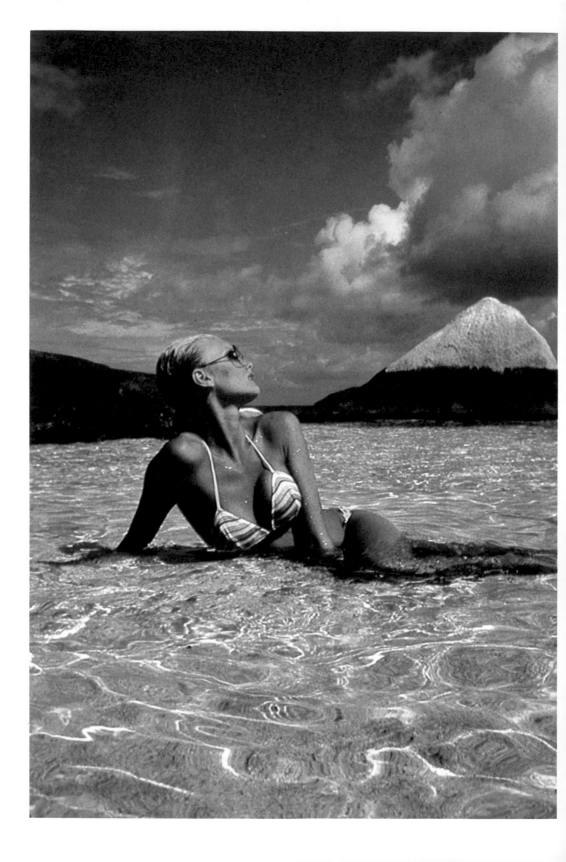

WOMEN

In portraits of women, the most important factor is usually the search for form and beauty, so you should adopt shooting techniques that allow you to build up the ideal image of the person being photographed. You are no longer dealing solely with a study in personality and a documentation of facial features, but are involved in an aesthetic study, the discovery of femininity and that secret and fascinating order in the human form which arouses the emotions.

Women are difficult subjects for the photographer, however, and it is not enough to have an attractive model and good technical equipment. In fact, valuable images are quite rare in this field and are always the product of the creative effort that is necessary if you are to translate the sense of harmony into the language of the photograph.

The creation of an attractive and pleasing photograph requires an effort that cannot be underestimated. You can expect all sorts of surprises from the complex mechanisms used to transfer the image to film, so analyze the facial features of the subject carefully. With a certain amount of intuition you can get good, intense, and harmonious portraits that successfully convey more about the person than an Instamatic picture would.

The Female Subject

The photographer must understand the personality of the subject in order to be able to previsualize possible portraits, and the subject must in turn cooperate actively without being nervous. It is there-

fore important to develop a relationship of mutual trust between photographer and model; each must help the other to build good images, and so they must be aware of all possible negative aspects on the face and body in order to avoid them. For this reason, it is often useful to take a few test shots of the model's face without makeup, in soft and direct light with no shadows, choosing different angles when she is relaxed.

Photographs of women allow more control and manipulation than those of men; a woman's style and facial features can actually be altered quite significantly just by changes in makeup, hairstyle, clothes, and position, which is very important in conveying femininity and grace of carriage. Remember also when preparing to photograph a woman that her image is determined by various elements dictated by tradition, fashion, and particularly by her personality and self-image. The creation of an attractive look is often the result of constant and conscious attention to detail and the harmonious balance of the figure, which should mirror the personality and culture of the woman.

Remember that the camera registers a lot more than the photographer can control. If the model is not in form, if she is depressed, tired, or simply bored, you cannot hope to produce a vivid, happy portrait. In these cases it would be better to postpone the session to a time when the subject can really show herself at her best.

Makeup Techniques

Makeup can be an excellent ally for the photogra-

pher, provided that it is light and balanced to give the face a fresh and natural look. Only young and especially beautiful girls can do without any kind of makeup in front of the camera.

Generally, skillful use of makeup enables you to enhance the attractive features of the face. Every model, even stand-ins, should know all the variations of basic makeup that enable her to correct or emphasize certain features.

It is important to check the makeup under the same lighting that is to be used for the photograph; soft frontal lighting, such as from an illuminating panel, is suitable.

A type of makeup that is advisable in all cases, even for men, is a makeup that hides spots and pimples, which always show up clearly but are never wanted in the portrait. Apart from this

elementary operation, more sophisticated makeup techniques require experience and sensitivity, so as not to risk lowering the quality of the portrait instead of improving it. A pure, fresh, healthy, and attractive complexion is essential in portraits of women, so always use the proper tinted foundation when the model's complexion is not quite perfect. In this way you will get pure-looking, evenly colored skin that is the base for any further cosmetic or corrective operations on

Below: Makeup can play a very important role in women's portraits. It helps create personal elegance—an ideal image that reflects their culture and their life-style.
Opposite: Women and the sea are a combination photographers often use.

the features. Using creams lighter than the skin color changes or creates highlights on the face which become dominant factors in defining the features; darker creams tone down the less attractive elements.

The eyes and mouth are the two features that are noticed first in the portrait. With the right makeup, you can improve their appearance and clarity of expression by emphasizing their shape or covering imperfections. Makeup is usually applied to make the eyes larger by lengthening the lashes, and to define the mouth by using warm, young, natural colors. Lip gloss makes the lips look wet and shiny and adds vivacity to any portrait.

The heaviness of the makeup depends on the face, style, and characteristics of the facial features, but it also depends to a certain extent on the type of film you

use; with black-and-white film, the makeup should be heavier than for color, because black-and-white film obviously does not distinguish between the colors used. A touch of blusher on the cheeks, for instance, must usually be accentuated to be visible in a black-and-white photograph.

It is clear from the foregoing that the model should have all the necessary makeup with her during the session, so that she can make herself up as the photographer advises, though it should be pointed out that it is not easy for the photographer to evaluate the effect of makeup and make suggestions without a certain degree of experience. The simplest and most practical way of finding out whether the makeup is too heavy or light is by taking a few Polaroid pictures. This also establishes a closer rapport with the subject, who can contribute to im-

proving the image.

Another point to remember is the shininess of the skin: the lips should always be moist and shiny, but avoid reflections or zones of too intense light on the face, which make it look greasy and are not suitable for normal portraits, both formal and spontaneous. You can take the shine off the face with ordinary powder.

Hair
The hairstyle and the cut are certainly very important to the person's appearance: clean, soft, and well-cut hair looks attractive, and a flattering style can help emphasize the better features of the face and play down any imperfections. If the facial lines are regular, you have more freedom to choose the style and still get good results, even when you change the style of the portrait.

These photographs show the importance of makeup. Above left: A model before (top) and after (bottom) using makeup. The photographs above and at the top of the facing page, taken by Ian Miles, show how different styles of makeup combined with lighting and background can greatly alter the meaning of an image. Opposite, bottom: An example of professional makeup. The shading on the cheeks slims the face.

Clothing
Clothing plays an important role and should always be carefully considered, for it adds to the aesthetic composition. To a great extent the color and design of dress determine the tonal scale and influence the balance of the composition. Clothing also gives precise information about

the subject's social status, environment, education, and so on; you often do not need to be an expert to guess the period or even place in which a photograph was taken.

It is generally better to avoid clothes that create or give rise to high contrast, such as black and white clothing, and it is also better to avoid flamboyant clothes whose strong graphic elements could distract attention from the true subject. In this case, you risk making the portrait look too much like a fashion shot. Bright colors are traditionally suitable for the young, because they tend to dominate the image and add vitality, but they easily become distracting and tiring. Delicate pastel shades, on the other hand, are easier to harmonize and cause fewer problems of composition and tone. They are suitable for any subject.

Another important

function of clothing is controlling the sexuality of the image. Tight-fitting, clinging, or revealing clothes convey sexual messages more than loose-fitting cothes that make it hard to discern the shape of the body.

Fashion Photography

The main purpose of fashion photography is to present new styles; it is basically publicity work designed to sell an idea or a stylistic creation rather than a particular product. Born at the beginning of the century with formal portraits of famous women wearing elegant and expensive clothes, fashion photography has developed over the past few decades along lines that have made elegance more democratic. It has now become the model for all types of spontaneous and formal portraits of women of any age or social class.

Dozens of specialist magazines present impeccable fashion photographs every week, creating an immense repertoire of portraits where each woman can easily find her ideal model of polished beauty and personal elegance. This is therefore a genre that the

Left: Clothing can quite clearly signal culture and traditions.
Below left: Elisabetta Catalano took this elegant portrait of the actress Emanuela Kustermann. The intense, expressive face dominates the refined and simple elegance of clothes and makeup. Below: A well-known model interprets the aggressive character suggested by her clothing, which is the center of attention.
Opposite: An image that deliberately re-creates the old-fashioned quality of discreet and exclusive elegance.

photographer must consider whenever preparing to take photographs of a woman; consciously or otherwise, she will compare the results with the photographs she sees every day in the fashion magazines, where there are no heavy shadows, unpleasant expressions, or awkward poses, or pimples in close-up.

Fashion photography covers a wide range of styles chosen to suit a particular public. Fashion is now looser, freer, and more informal, and it is directed mainly at the modern, independent

Hans Feurer skillfully employed the art of dressing up for this image, whose combination of tones and textiles seems inspired by the East.

woman. Models with porcelain faces are more and more frequently giving way to real, vital women who symbolize an undemanding everyday elegance. The settings in the images are less refined and more spontaneous, taken from everyday life but always with accurate attention to form, aesthetic meaning, and elegant harmony.

The photographer can also choose typically movie-style sets as an alternative to create movement or suspense: the model wears a given article of clothing as if identifying with a part in a play, interpreting the dress as if it were a character role. Fashion photography can thus at times simulate reportage shots and theatrical portraits.

These images have an undeniable influence on the techniques of portraiture because they are so widespread and popular. They can provide stimulating references.

Glamour Photography

The obvious intention of the glamour photograph is to display the fascination and charm of the model. The style of the images often recalls theatrical or movie-style portraits and especially fashion photography, because the clothing has to be chosen even more carefully and adapted to enhance the figure.

Glamour photographs commonly include an erotic message. Although they can be pleasantly stimulating, they must always remain within the limits of good taste. A fresh and harmonious beautiful woman's face certainly contains a soft sexual message which can be accentuated by a vaguely provocative expression or pose.

You might ask yourself what the dividing line is between glamour and erotic photography styles. The answer obviously varies from country to country and from community to community; in areas where the spread of erotic messages through the media has exploded the myths about the sexuality of the female form, photographs

A seaside fashion photograph of the kind that regularly appears in women's magazines.

that might be taboo in other places will not be considered indecent.

What does distinguish a glamour photograph from a nude or more obviously erotic picture is that the former must always be "clean," so that you could show it to anyone, yet it should still be stimulating and loaded with vitality and charm; it should not slip into bad

Top: A famous photograph of Marilyn Monroe. Although the image is definitely "chaste," the setting, the bed, and the gesture of hugging the pillow supply erotic overtones. Left: An image whose impact hinges on the fascinating look on the woman's face and the aquatic setting. Opposite: Another "glamour" portrait.

taste or offend other people's finer sensitivities. Technically, when taking this kind of idyllic and myth-creating photograph, you should use every possible device to remove imperfections and create vitality, harmony, and grace. Good makeup on the model often solves many of the photographer's problems. Particular attention should be paid to the clothing: it should emphasize the model's good figure, fit with the style of the photograph, and not disturb the composition. Also, the clothes should not be too closely tied to the fashion of the moment—this would immediately date the photograph—and they should be neither so elaborate that they attract all the attention, nor too simple and homey, which would create an unnatural atmosphere for

the image.

Swimwear is certainly suitable if the photograph is taken outdoors, but there is no psychological justification for using it in the studio; such a photograph would look like a publicity shot for an underwear catalogue. The best kind of clothing is evening wear, better still if it is simple and a little sexy, leaving the shoulders bare and fitting the figure closely. A very simple piece of clothing which enables you to take the classic bare-shoulders close-up can be made with a simple piece of black or white cloth, fastened around the model with a pin to leave the shoulders bare. A sheet is often a simple and readily available · answer.

The best lighting is often soft and diffuse and can be obtained by reflection from large

screens, or by natural light through a window falling frontally onto the subject at a slight vertical angle.

Finally, do not forget how useful filters are. They allow you to manipulate the photograph at will, softening it by diffusion or making the atmosphere warm with amber filters, generally enabling you to use all sorts of tricks on the image during exposure. The background is also important to the image, irrespective of whether you have the model against a detailed setting or a continuous neutral background.

Some photographers have become famous for the precise and immediately recognizable style of their glamour images. One of the masters of the genre is David Hamilton, who has created his own very personal style of ethereal images .

Above: A classic calendar-type glamour photograph. The woman is beautiful, the colors are pleasing, and the basket of fruit symbolizes opulence—but the image as a whole is somewhat superficial.
Opposite: A delicate, harmonious image by David Hamilton which conveys formal study in the style of painters rather than a representation of the personality or the face of the subject. The woman here functions purely as a symbol of beauty.

MEN

Portraits of men demand much greater skill and sensitivity to interpret the personality and culture of the subject than photographs of women. The style is more descriptive than aesthetic. By way of confirmation of this, note that various portrait photographers prefer a certain type of personality that is more in line with their artistic temperament and their particular brand of figurative poetry. Yousuf Karsh, for example, is very well known for his magnificent portraits of famous political and cultural personalities. There is no doubt that the photographer can interpret a certain personality correctly only if he or she fully understands and deeply senses the subject's meaning and fascination. Because of this, a portrait of an older man with an intense face is often more effective than one of a younger man who still does not have a defined personality.

The Technique

As in other kinds of portraits, the shooting technique should suit the style of the image. A medium or long shot is better than a close-up, because it introduces descriptive elements about the personality through careful choice of position, gestures, and setting. The medium shot is preferable since the hands play an important role, although they can also create problems. The simplest way to achieve a natural pose is to occupy the hands with something that has relevance to the subject's personality.

The choice of lighting is strictly expressive in portraits set against detailed backgrounds. The light should suggest a natural situation that almost theatrically recreates the particular moment in life that you want to record. Consequently, natural lighting or reflected artificial light is highly suitable.

Highly contrasted rim light can be used to very dramatic effect in portraits of hard and characteristic faces in which you want to emphasize an enigmatic expression or

A portrait of Winston Churchill by Yousuf Karsh (below) and one of Matisse by Henri Cartier-Bresson (bottom)—two veritable masterpieces.

signs of a difficult and intense life. To get maximum expression, you can experiment with various types of illumination

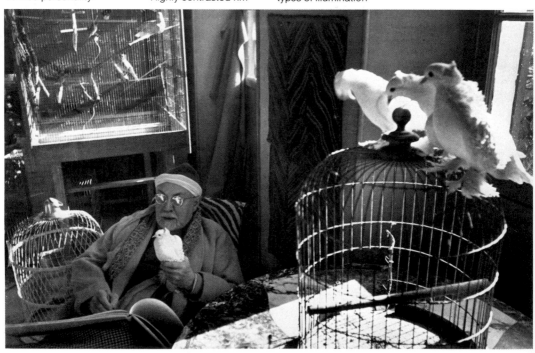

of the person.

You would usually use soft illumination, however, achieved with light bounced off screens for good contrast in the shadows, good modeling, and a calm atmosphere for most subjects. You can make the lighting suit the subject by regulating the distance and angle of the lights to give very different settings, ranging from warm and intimate to cold and refined.

Spontaneous, lively portraits can be obtained

An excellent example of interpretation in a photograph: Alberto Moravia through the eyes of Elisabetta Catalano.

by using a single light; this is the technique recommended to beginners in studio photography because it is so flexible, and you do need to know how to use one light effectively as a key light before you can bring in a sec-

ond light.

Another element to consider in male portraits is the hairstyle; avoid rebellious or asymmetrical tufts of hair that are not specifically required, because they alter the shape of the head relative

to the background. A quick comb solves the problem.

A frontal or 30-degree angled position is the most frequently adopted in close-ups. The head can be angled slightly to give movement to the

composition and contribute to the expression. The direction of the eyes greatly alters the meaning of the image. Cast down, they suggest unease or even anxiety; when they look right or left, and the subject smiles, it indi-

cates that the subject is interested in something at the side of the photograph. Eyes looking straight at the camera with a relaxed expression convey immediacy and friendliness.

In portraits of men, pay particular attention to the ears: if the face is in a frontal position, they tend to stand out too much if not covered by the hair, so you can tone down the lighting or photograph

normally worn, they almost become part of the individual's face and should not be removed, though it is often a good idea to take a few test shots without them so that you can study the

wanted reflections, and make sure that the eyes can be seen, so that you can see where they are looking. Avoid dark glasses, which hide the eyes and make the person look unfriendly.

To avoid reflections in the glasses, it is usually enough to photograph the face at a slightly forward angle, but you can leave a point of light on the lenses as long as it does not cover the eyes. In practice, the problem is easily resolved with SLR cameras and continuous illumination, when you can comfortably find the position that gives the best compromise. With flash, however, you have to find the right position by using a modeling light, for which even a simple portable flashlight will do.

Finally, remember that the background brightness must harmonize with the subject's tonal scale. Always take into account the fact that a subject seems lighter on a black background and darker on a white background. When you are photographing a man who is very suntanned or black, for instance, the background should not be too light, because it would accentuate the contrast. In effect, this rule is useful for making faces that are too pale seem darker against a light background, and similarly making suntanned faces look less dark by using a medium background a little lighter than the color of the skin.

Above: Fashion designer Giorgio Armani. The background obviously refers to the subject's profession.
Opposite: The glasses are an element of composition in this portrait of Truman Capote.

the face in a three-quarters position, which almost always eliminates the unpleasant effect of ears that stick out too much.

Another typical problem with photographs of men is glasses. If they are

facial features better. In some cases, glasses characterize the personality more successfully, but in others they make it too heavy. When you photograph a person with glasses, consider two problems: avoid un-

THE NUDE

The first requirement for taking photographs of a nude is to have a model. Professional models who pose for painters and photographers may be found through agencies or art institutes in large cities. Another possibility is to find a model who is prepared to pose for you from among your own friends and acquaintances, but the most common possibility, particularly for amateur photographers, lies in finding a suitable model at home; girl friends and wives are natural subjects for the classic nude photograph, not only because they are more readily available, but also because the aesthetic study of the body requires time, understanding, concentration, and attention on the part of the photographer, as well as endless patience from the model.

What are the attributes that make a woman a suitable nude model? If you are not specifically trying for an erotic effect, the woman's body does not necessarily have to be sexy. A slim and elastic figure and a regular but not voluptuous build are generally preferable—photographs usually exaggerate weight. The choice of model is in fact an aesthetic one, depending on personal taste and style of expression. In both painting and photography, the idea of femininity has undergone a continuous evolution from the full-figured, solemn woman of the fifties to the slender, elegant figure of the seventies and eighties fashion model. As a result, quite apart from the style and techniques used, even a nude study can reveal the period in which a photograph was taken.

The pose, the position

of the hands, and the expression of the face in the selected frame reveal the psychological climate of the shot through silent body language. They also indicate clearly what the conscious or subconscious aesthetic references of the photographer were.

To be photogenic, the body must have healthy and elastic skin, free of marks, blemishes, and pimples; small imperfections can be removed with body makeup. The clear marks of a bathing suit on suntanned skin have sometimes been used to effect, but they can limit the type of image you obtain.

Shooting Techniques

The photograph of a nude is very often a photograph that has been carefully considered and created under controlled conditions in a studio, so it is an advantage to use larger formats as well as the practical 35mm camera, because they enable you to obtain better definition and more modeled images even with big enlargements.

A nude shot must be accurately planned and prepared. This can cost time and money, whether you are a professional or a skilled amateur, so the session should be programmed to make the best possible use of the model's time. Usually it is better to take both black-and-white and color shots, particularly of the better frames. The interchangeable backs available for the 2¼-square-format camera prove particularly practical in this regard. Depending on the type of frame, from close-up to long shot, you must use suitable focal lengths from the medium-wide-angle to the telephoto

lens; the viewpoint and the lens are fundamental expressive choices that determine the style of the nude photograph. Interesting examples of skilled use of viewpoint and focal length are the landscape nudes of Franco Fontana, who uses color as a basic element of expression. This photographer takes his inspiration from the female form for formal studies of abstract beauty.

Nude studies in medium or long shots, on the other hand, make use of the techniques common to all types of portrait that describe the personality and physical features of the subject with maximum expressiveness and formal effectiveness. Obviously, however, in the case of a nude portrait the center of interest extends from the face to the body, explaining why the shot is

not centered on the eyes. They do, nevertheless, keep their basic importance in the meaning of the image. The height of the shot is chosen on a purely compositional and formal basis; the whole figure is considered as a sculpture whose image changes significantly when you alter the viewpoint.

A nude study inevitably involves many shots, but they should not be fired at random in volleys; take them regularly, with forethought, following your own intuition in combination with a previously formed plan of operation based on preliminary test shots.

Lighting

The lighting techniques boil down basically to those described elsewhere for portraits. Consider the whole figure framed on the same level. Consequently, when you take long shots of a nude figure, you need lights with a sufficiently large surface area; it is better to use reflector screens that produce compact light waves giving modeling to the entire figure.

Remember that frontal lighting at a slightly raised angle to the lens axis produces a soft and pleasing effect because it cuts down on shadows that might reveal imperfec-

A "nude landscape" by Franco Fontana, an example of an extremely original way of photographing the female body. Images such as this are notable because of their formal value.

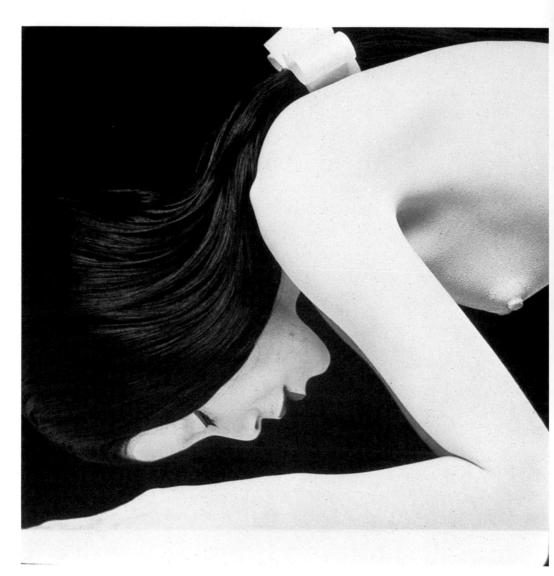

tions on the skin. For this reason it is widely used in nude studies. The contoured effect can be better obtained by arranging the light source at an angle up to 30 degrees horizontally and vertically.

Angled lighting of about 45/45 degrees is the classic type that brings out the depth and three-dimensionality of the body, making it almost statuesque. But it is also more critical and requires more accurate control of the highlight-shadow contrast, be-

cause the areas in shadow are more extensive and carry greater weight in the image. As a result, it may be better to soften the skin reproduction with diffusion filters.

A directional light throws sharp, vivid shadows and increases the modeling but has to be balanced with a fill light to give detail to the shadows. Diffused light from a large illuminating panel, for example, produces light, soft shadows with a more delicate and suffused effect, less contour, and no need for a fill

light. Ninety-degree side lighting leaves half of the body in shadow and can be used to great graphic effect, but you must check the position of the model accurately to avoid shadows that extend too far and hide the figure, throwing the composition out of balance. The outline of the body is emphasized more with this kind of light, so it must be suitably harmonious. It is advisable to have a contrasting dark background against the illuminated area, and a lighter background

Above: A very elegant and famous nude by Hideki Fujii in which the perfection of the form combines with a highly refined graphic taste. Opposite: The technique of backlight effectively emphasizes this nude figure. The colored strips of light filtering through the blinds are a graphic effect that has great impact in this beautiful image by Larry Dale Gordon.

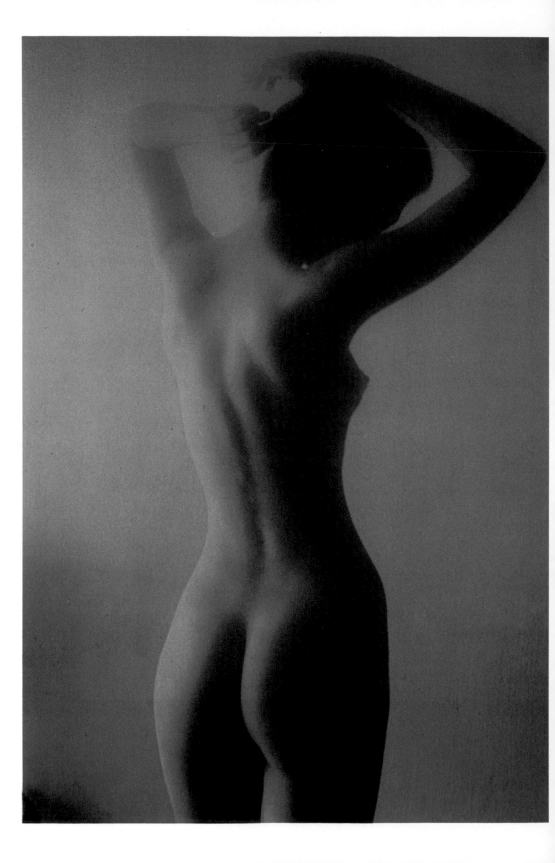

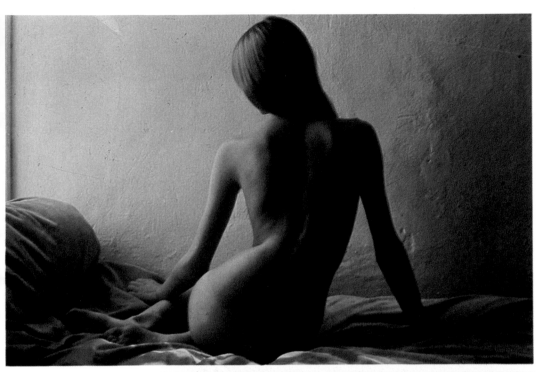

Above and opposite: Many of David Hamilton's nude studies of young women are done in natural diffused light, with his unmistakable, romantic, yet allusively erotic style.

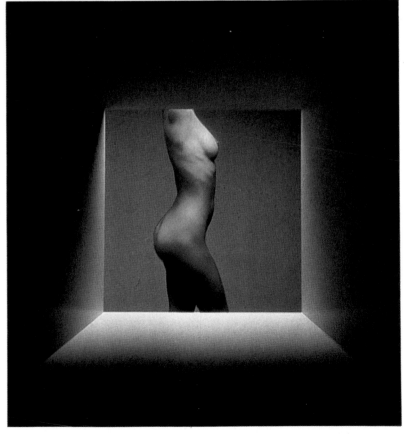

Right: A nude in profile framed in a highly original way by Jan Cobb. The figure is cleverly cut to make it comparable to a classical sculpture.

241

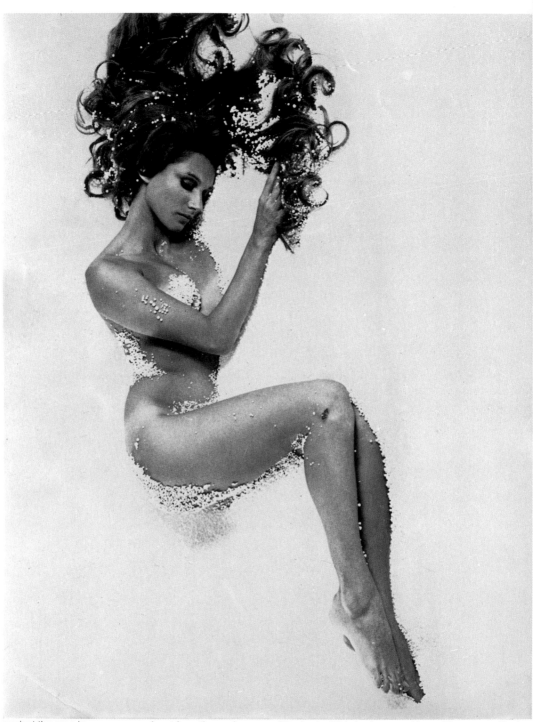

against the area in shadow. A backlit rim light stylizes the human figure even more, making it a veritable construction of lines of light on a dark background.

Apart from these classic lighting methods, you can use any of those described previously.

One variable to consider in the lighting arrangement is the position

of the body. If it is horizontal, the direction of the light will obviously have different effects. A top light will in this case produce effects similar to those obtained with side

Above: The actress Paola Pitagora in an elegant and sophisticated image. Right: An image by Christian Vogt, a master of the art of erotic photography.

242

lighting when the model is in a vertical position.

Natural Lighting

Shooting outdoors has the advantage of capturing a simple, natural, and relaxed atmosphere, free of openly erotic implications and revealing the beauty of the body as an expression of an extraordinary and wonderful harmony with nature. Two problems arise, however: the variability of the light and atmospheric conditions in general, and the need for privacy, which greatly limits the times and places available.

Natural lighting can also be used indoors, however. Its simplicity compared to artificial light allows you to concentrate on the image and makes things easier for both you and the model, who can change positions more freely and thus minimize exposure problems. Because of this, the most advisable technique, particularly in the initial stages, is using the light that enters through a window. Using sunlight diffused by a sheet also avoids attracting the unwanted attention of any outside "observers."

The Photographer and the Model

When you are lucky enough to have a model available, you need to program the session first of all, to have all the equipment ready, and to have thought out the sequence of shots, so that you do not waste valuable time or bore the model. You should also try to involve her actively in the creation of the images by explaining the poses you want to try so that she can find the most suitable and relaxed positions and stances herself. The participation of the subject in the ritual of creating an image is al-

most always essential.

Set aside a separate area for the model, so that she can get dressed, undressed, and made up. A mirror is a fundamental accessory that should always be available, even in the studio, so that she can see herself clearly and correct any awkward positions without being asked to do so. A relaxed atmosphere can be created with the right music.

It is usually easier to begin with close-ups and studies of the essential details to pick out the model's strong points and imperfections. The hairstyle becomes very important: long hair has its own charm and can be useful as an element of the composition, helping to vary the poses. The first session with a model is usually for producing test proofs and to get inspiration for later shots.

On the basis of the techniques used, nude

studies can be classified for the sake of convenience into the following categories: nude portraits, the body as a sculpture, and the full figure in a setting.

The Nude Portrait

A "nude portrait" can be defined as a nude image in which the description of the personality and individuality of the subject is the most important aspect of the formal study. That is to say, it is truly a "portrait of a woman without clothes," created elegantly and discreetly. This kind of "nude–not nude" portrait has always been very successful because it satisfies the vanity of the woman without compromising her reputation or the need for discretion. The body becomes the dress that reveals the intimate harmony of the person without revealing the areas of strong erotic

content. The model in this case can wear a bathing suit, but it must not be seen in the photograph, for the meaning of the image would then change completely. A portrait of a woman with bare shoulders is often the most effective, attractive, and at the same time simple and formally elegant without being compromising in the least.

The shooting techniques are basically traditional. The bare-shouldered portrait is a

Above: A portrait of a model with bare shoulders can enhance her charm and beauty. This photograph is of the actress Gloria Guida. Opposite: A splendid example of a "nude–not nude": actress Stefania Sandrelli photographed by Elisabetta Catalano.

valid solution for young women because it slims the neckline and adds grace and femininity to the shoulders. It is also a good way of learning to observe the significance

Above: A sculptured nude that stands out from the red background like a work in bronze.
Opposite: A dramatic image by Pete Turner. This male figure seems to express impotent force.

and graphic weight of the elements of the figure that come into play.

To create images with a more evident erotic content, however, while remaining within the bounds of reserve and discretion, you can photograph the full figure, putting the model into poses that allow her to keep her breasts and pubic region covered. Examine the pose carefully so that you enhance as much as possible not only of the face, but also of the body of the model.

If the eyes are looking at the camera, the image will be intense and intimate, whereas a shy and evasive look can convey embarrassment or modesty. An open smile tends to reduce the erotic message, but a tense expression reinforces it.

Diffused and basically simple lighting through one key light, whether natural or artificial, helps unify the image and makes it intimate.

The Body as Sculpture

Achieving the right pose is a difficult art, even more so with a nude, because each part of the body has a specific emotive and aesthetic meaning. Pick out natural and harmonious positions; these may come naturally to some people, but others may require accurate and controlled poses. To express the vitality of the body, adopt dynamic poses that show the muscles flexed. Even in static

poses they should be under some tension to look harmonious. Of course the photograph of a nude as an expression of natural beauty finds its most logical and certain field of aesthetic research in the young, whose bodies are characterized by taut, full, and smooth skin with no wrinkles, attractive proportions, thick hair, and agile, lithe muscles.

The classic positions of the nude are horizontal (with the model lying on a continuous background), vertical (model standing), and with the model seated, which is more suited to compositions with a different structure in which the body assumes dynamic shapes.

Do not forget that in a nude study, more than in any other type of photograph, the least disproportion is enough to make the image false, disharmonious, and unpleasant. Consequently, avoid all positions, distances, and lenses that create disproportion, except if you are deliberately aiming at a grotesque, disproportionate effect. Look at the human body with a critical eye, paying very careful attention to the position of the limbs in particular. They should be positioned in such a way that they do not look too thin or exaggeratedly square in proportion to the body as a whole. Position the arms and legs after establishing the head-body line, because this is the dominant element of the composition; the facial expression is the last detail to be decided.

When you want to create an image that inspires serene meditation on the human form, arrange the limbs to convey relaxation and balance, but avoid positions that create unpleasant effects.

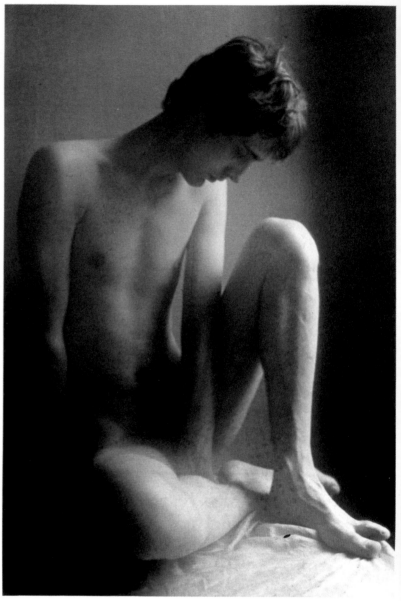

The arms and legs should not point toward the camera because in this way they look unnaturally compressed. It is better to have the knees and elbows bent slightly to avoid the rigidity of a straight position. If photographed in a standing position, the model should put her weight on one leg (which will therefore have to be straight); the other can be slightly bent, making the knees look more graceful. In practice, try to choose the position of the limbs by checking the image carefully through the viewfinder. The arms should be held far enough from the body that they do not look like a part of it. The position of the arms and legs is also important; having the toes pointed, for example, is a classic trick to make the female form look slimmer, even when

Above: An interesting nude study by Tana Kaleya, obviously influenced by the painter's art. The natural lighting in this interior setting plays an essential role in achieving this aesthetic result.
Right: Mother with children—a common subject, even in nude studies. She is Jane Birkin, and the photographer was Giancarlo Botti.

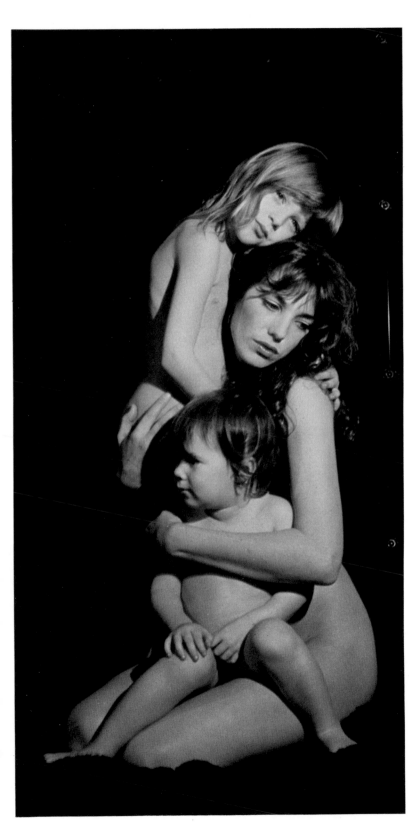

the model is sitting or lying down. When the extremities, the hands and feet, are excluded from the photograph, be sure that they do not look as if they have been cut off.

Finally, remember the importance of details which, even if they seem insignificant, often influence the quality and style of the image in a decisive way. As a rule, it is better to simplify the composition by removing all elements that could introduce confusion; nothing in the background should distract the attention or interrupt the lines.

The Nude in a Setting

In an environment, the nude can assume different but specific meanings. As you know, the background introduces precise symbols that are associated with the human figure. The nude finds natural and psychological justification only where you would expect to see it in reality: in the intimacy of a bedroom or bathroom, on the stage of a revue theater, or in the open air in the sun, on the seashore, on beaches or rocks.

In the last of these settings, the nude can be defined as naturist; it is a photograph of a nude body set against a simple background in everyday poses that suggest a calm indifference to nudity. The true naturist nude is particularly narrative in style and does not require any tricks or devices to emphasize both the beauty of the body and the erotic message. Because of this, the subject should not look "posed" at all. The image should be simple and spontaneous, taken in natural light at the most with the help of fill-in flash to bring out detail in the shadows.

PHOTO CREDITS

Photography agencies:
Action Press, Milan
Camera Press Ltd., London
Magnum Photos, New York
The Image Bank (T.I.B.)
Grazia Neri, Milan
Tony Stone Associates Ltd.,
London

The following abbreviations
have been used to indicate
the position of the photo-
graphs: t = top, b = bottom,
c = center, l = left, r = right.
The drawings on pages 176,
178 (top), 183, and 187 (left)
are by Piero Cozzaglio.

Edited by Carlo delle Cese
Designed by Raffaello Seattini
English language translation by Maria Piotrowska